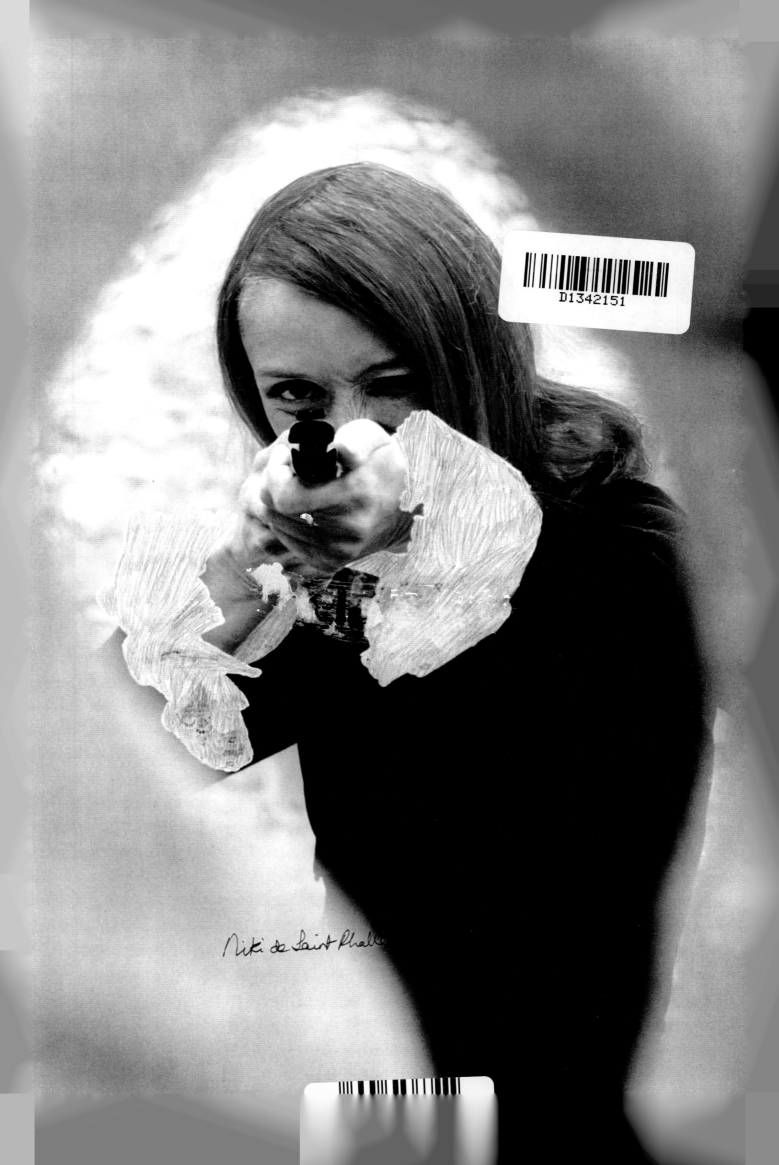

Niki de Saint Phalle

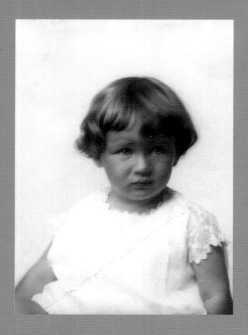

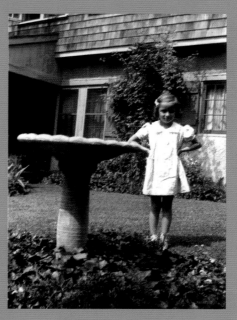

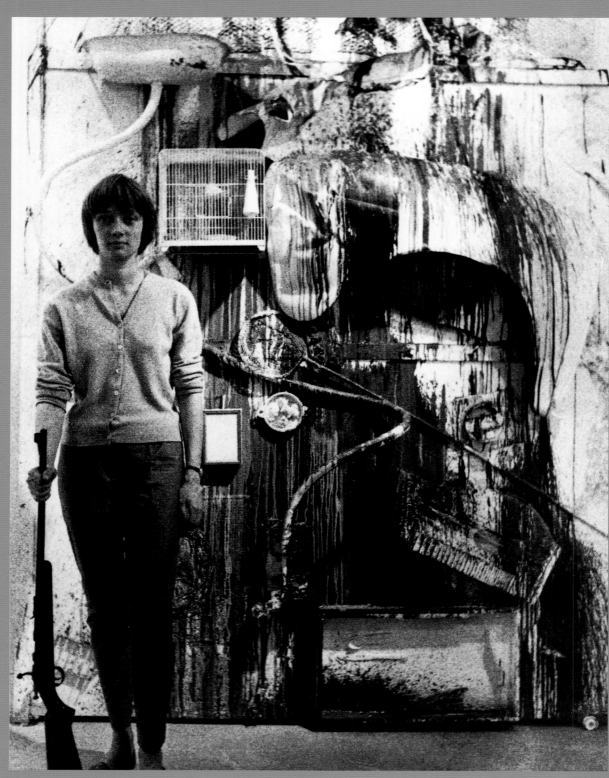

Niki de Saint Phalle and Jean Tinguely
in Gregy, April 1961
© Roy Lichtenstein Foundation

Niki de Saint Phalle striking a *Tir* (shooting
painting), Impasse Ronsin, Paris, 1961
© Roy Lichtenstein Foundation

Niki de Saint Phalle paints *Le Temoin* (*The Witness*), 1969

Niki de Saint Phalle and Jean Tinguely during the first showing of *Hon* (*She*)
© Moderna Museet, Stockholm

Niki de Saint Phalle, Jean Tinguely, and Per Olof Ultvedt working on *Hon* (*She*), Moderna Museet, Stockholm, 1966
© Moderna Museet, Stockholm

Niki de Saint Phalle on her chair, *Charly*, painting a smaller version of *Le monde* (*The World*). Her first furniture edition appeared in 1979

Jean Tinguely and Niki de Saint Phalle in Garavicchio, 1979

Overview of the Tarot Garden with handwritten notes by Niki de Saint Phalle

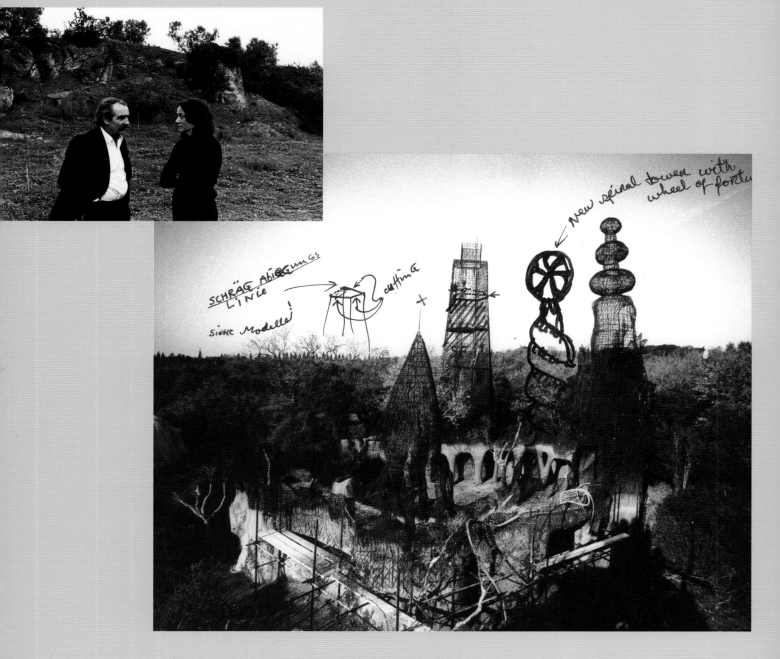

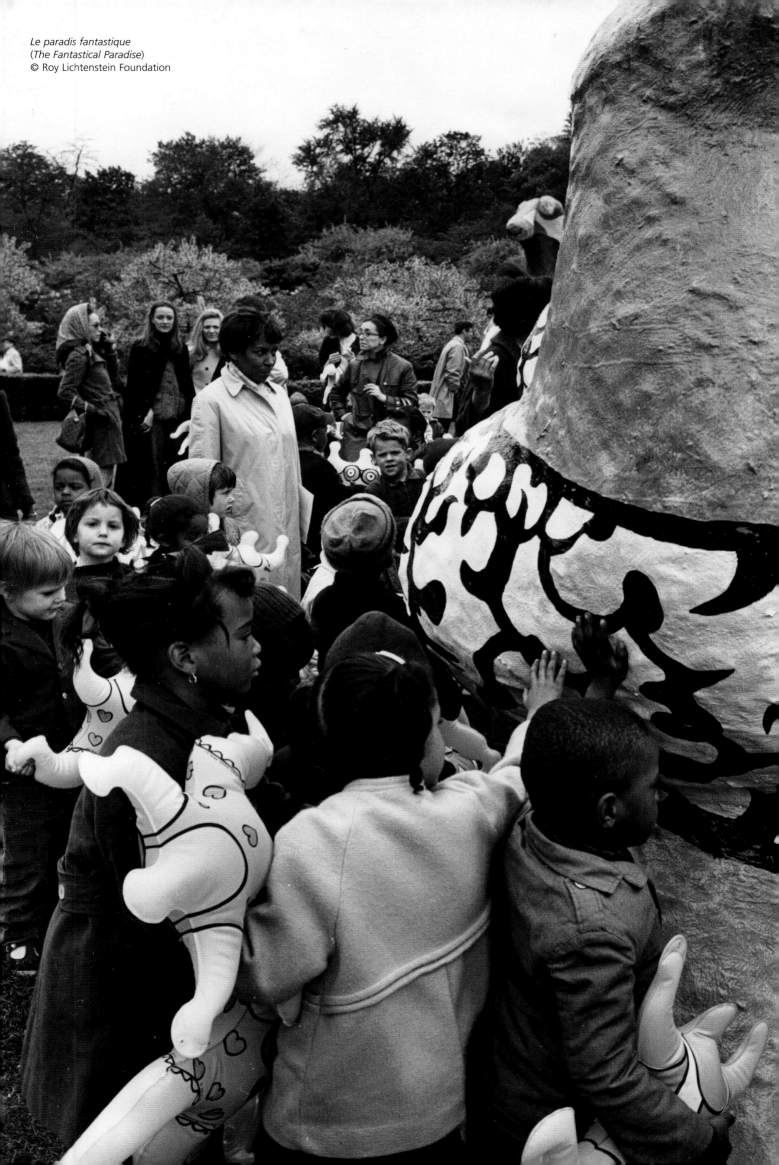

Niki de Saint Phalle in her studio in Soisy, 1980
© Niki Charitable Art Foundation,
All rights reserved

Niki de Saint Phalle and Jean Tinguely in front
of the fountain of Château-Chinon, 1988
© Niki Charitable Art Foundation,
All rights reserved

Niki de Saint Phalle and Jean Tinguely, Château-Chinon, 1988

Niki de Saint Phalle carves designs into a walkway at the Tarot Garden, 1990

Pontus Hulten and Niki de Saint Phalle at the Saint Phalle's retrospective exhibition, Bonn, 1992

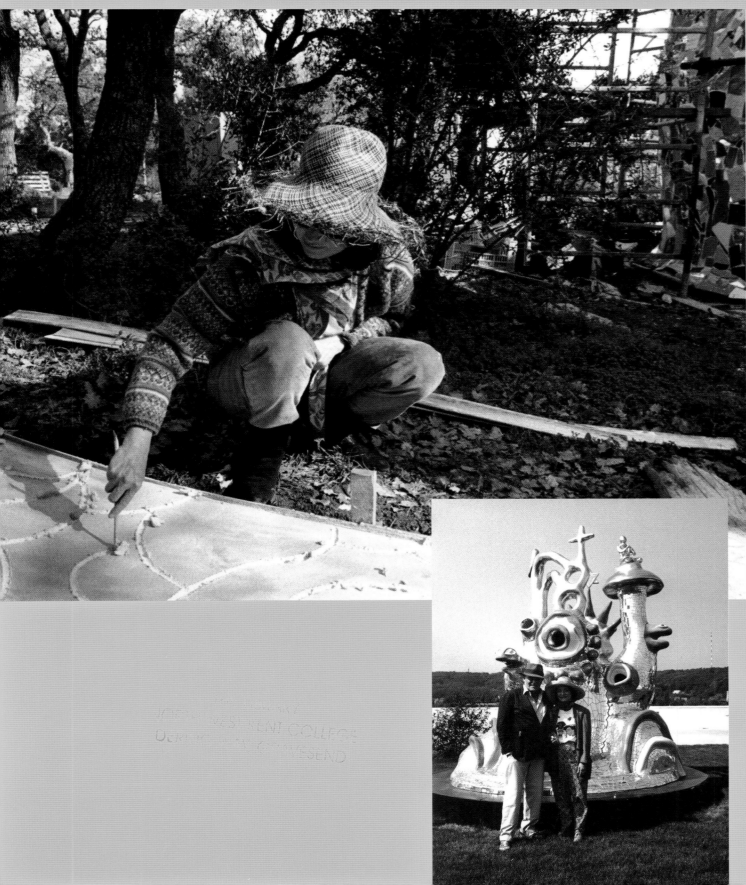

FONDAZIONE ROMA

President
Emmanuele Francesco Maria Emanuele

General Director
Franco Parasassi

Niki de Saint Phalle

edited by Stefano Cecchetto

SKIRA

Cover
Les trois Grâces
(Three Graces), 1994

Design
Marcello Francone

Editorial Coordination
Eva Vanzella

Editing
Timothy Stroud

Layout
Serena Parini

Translations
Emily Ligniti

First published in Italy
in 2009 by
Skira Editore S.p.A.
Palazzo Casati Stampa
via Torino 61
20123 Milano
Italy
www.skira.net

Printed and bound in
Italy. First edition

ISBN: 978-88-572-0461-1
978-88-572-0502-1

Distributed in North
America by Rizzoli
International Publications,
Inc., 300 Park Avenue
South, New York, NY
10010, USA
Distributed elsewhere in
the world by Thames and
Hudson Ltd., 181A High
Holborn, London WC1V
7QX, United Kingdom

Photo Credits
© Leonardo Bezzola,
pp. 4 (below), 6 (below),
9 (top)
Laurent Condominas,
pp. 6 (left), 8 (below),
9 (center and below),
27 (below), 29, 38, 44,
47–48, 51, 56, 60, 63
Galerie Alexander Iolas,
Paris, p. 40
Hans Hammarskiöld /
Moderna Museet,
Stockholm, pp. 4-5
Tim Herr, p. 192
Thomas Marlow,
pp. 119, 158
Ad Petersen, p. 36
© Giulio Pietromarchi,
pp. 71, 74
Shunk-Kender, pp. 2
(below), 3, 7, 22–25

Exhibition promoted and conceived by
Fondazione Roma Museo

with
Arthemisia Group

In collaboration with
Niki Charitable Art Foundation
and
Comediarting

Organization
Arthemisia Group

Exhibition curated by
Stefano Cecchetto

FONDAZIONE ROMA
MUSEO

Head of Museum Activities
Tatyana Kasyanenko

Organization Coordination
Sara Lombardo
Chiara Perazzoli

Head of Legal Affairs
Francesca Gabrielli

Head of Promotion and Image Development
Paola Martellini

Head of Human Resources and Logistics
Roberta Radicioni

Head of General Services
Roberto Sersanti

Head of Technical Services
Luigi Vanni

Head of Work Safety
Angelo Giuseppe Amodeo

Communication and Public Relations
Giovanni Rodia

ARTHEMISIA

President
Iole Siena

General Manager
Martina Fuga

Exhibition Director
Berta Tavoschi

International Relations
Katy Spurrell

Management Control
Margherita Alberton

NIKI CHARITABLE ART FOUNDATION

Bloum Cardenas
David Stevenson
Marcelo Zitelli
Jana Shenefield

COMEDIArting

Francesca Silvestri
Alice d'Amelia

Organization

Exhibition Coordination
Alessia Calzolari
Elena Calasso
Arthemisia Group

Promotion and Communication
Simona Serini
Arthemisia Group

Press Office
Alessandra Zanchi
Ilaria Bolognesi
Arthemisia Group

Art Director
Angela Scatigna
Arthemisia Group

Press Office Consultant
Antonella Fiori

Education Consultant
Francesca Valan

Realization

*Exposition and Lighting-technical
Project Realization*
Archiroom Architetti Associati, Venice

Exhibition Graphic Design Project
Sebastiano Girardi

Set-up
Gamma Eventi

Set-up Supervision
Ivano Martino

Exhibition Graphic Design
Gruppofallani

Conservation Revision
Immacolata Afan De Rivera,
Soprintendenza Speciale PSAE e per il Polo
Museale della Città di Roma

Shipping
Artería, Roma
Art Works, San Diego
Air Cargo Services, Le Bourget

Insurance
Paolo Moglia, insurance broker

Security
Sipro-Sicurezza Professionale

Lighting
Fratelli Cocca s.r.l.

Security System
Securtrack

Microtemperature Control System
Vitale impianti s.r.l. di Massimo Vitale

Ticket Office
Charta

Bookings
Ad Artem

Audioguides
Start

Bookshop
Skira

Education Services
Flumen

Catalogue edited by
Stefano Cecchetto

Essays
Marella Caracciolo Chia
Jacaranda Caracciolo
Bloum Cardenas
Sarah G. Wilson

All the works on display in this exhibition
are the property of the Niki Charitable Art
Foundation, unless indicated otherwise

The Niki Charitable Art Foundation provides
support for the exhibition of works of art by
Niki de Saint Phalle

Thanks are due to the Fondazione Giardino
dei Tarocchi for the loan of the work
Le Fou (The Madman)

*The organizers are grateful to all those
who contributed to making the exhibition
possible, in particular*
MAMAC, Nice
Sprengel Museum, Hannover
Tate, Liverpool
Francesca Pascale
Alba Martano
Mara Targhetta
Cinzia Taccone
Stefano Mancini and all the "guys"
from the Tarot Garden:
Claudio Celletti
Ugo Celletti
Marco Iacotonio
Piero Ottavi
Antonio Urtis

Art as Adventure and Research

The choice of the Museo Fondazione Roma to host, for the first time in Italy, a considerable number of works by Niki de Saint Phalle – an eclectic artist of unbridled creativity whose entire oeuvre strives to communicate the message that art is not a linear and straightforward course of growth and perfecting, but a continuous, untiring, unavoidable quest for sensations, experienced and to be communicated to viewers, seen as an arduous but fascinating adventure – is the umpteenth confirmation of the spirit that has always characterized this museum's cultural activities. It is a spirit founded upon the need to confront the artistic output of Italy with what the world around us constantly proposes.

Niki de Saint Phalle is a respected figure who has recently come to the attention of the broader public. She was an artist who poured mythology, creative energy, feminist ideology, furious passion, personal anxieties, political demands, a call for freedom and a breaking of the mould into her work – an oeuvre in continuous metamorphosis. Her world was anything but conventional; it was a forerunner in many cases of subsequent trends that used art to reawaken both conscience and will to become the protagonists of events instead of their victims. Along the course of her development, which the exhibition recreates with attention to the chronology of the events, two fundamental moments appear: the Tirs *(Shooting Paintings), the explosive and creative expression of the great unrest of those years, and the* Nanas *(Girls), in which the artist attempts to recuperate the realm of childhood and rediscover certainties lost in adulthood. In works resulting from her spiritual and amorous union with Jean Tinguely, in which her creative genius reached a pinnacle of vision and unpredictability, Niki de Saint Phalle narrates her sensorial and creative universe and her unfaltering passion for art as a tool in her research. Her art became the device she used to discover her own personality – a discovery that is possible only if the unique and unrepeatable "I" is related to the surrounding reality without fearing comparison with it and ready to accept the unavoidable repercussions.*

And it is precisely in this perspective, assisted by her origins, that the artist was able to establish a dialogue between two cultures that are different in many

respects – that of Europe, France and Italy in particular, on the one hand, and that of the United States on the other. In these three countries she left numerous examples of her ability to interpret the most profound spirit expressed in the history, customs, and art of their civilizations. In Italy, the noblest expression of this spirit can be seen in the grandiose Tarot Garden in Garavicchio (near Capalbio), in which, based on an ancient, established Italian tradition, Niki de Saint Phalle skillfully and admirably wed her artistic language, laden with a maternal yet powerful female presence, to the language of architecture, making her Nanas "livable" and inviting, in harmony with the surrounding landscape and with the playful and esoteric spirit typical of tarot cards. In the United States, and especially in California, the most important examples of her work are the sculpture garden in Escondido and the monumental sculptures in San Diego.

It is therefore with true pleasure that the Museo Fondazione Roma hosts the work of this artist, consistent with the cultural course and concept I established for this young institution: that is, the constant correlation between the art of or inspired by Italy and that of the surrounding world. It is a course distinguished by the courage and innovation of the choices made up to now, along with attention to the educative and social dimension of art, elements that have undoubtedly brought gratifying results, making the Museo Fondazione Roma, after only ten years, one of the most dynamic and propositional exhibition spaces on the already impressive museum scene in Rome and throughout Italy.

I take this opportunity to thank The Niki Charitable Art Foundation of San Diego and the other European museums that have made this important exhibition possible, and whose collaboration is further proof of the ability of the Museo Fondazione Roma to establish contacts and maintain relations with some of the most prestigious cultural institutions in the world.

Emmanuele Francesco Maria Emanuele
President Fondazione Roma

Contents

20 Niki de Saint Phalle
"A Dream longer than Night"
Stefano Cecchetto

30 Tu es moi:
the Sacred, the Profane and the Secret in the Work
of Niki de Saint Phalle
Sarah G. Wilson

42 The Arcana Garden
Marella Caracciolo Chia

54 Memories from the Enchanted Garden
Jacaranda Caracciolo

58 Niki & Jean
Bloum Cardenas

66 **Origins**

90 **Nana Power**

112 **Tarot Garden**

142 **Spiritual Path**

180 Biography

184 Bibliography

188 Solo Exhibitions

Stefano Cecchetto

Niki de Saint Phalle
"A Dream longer than Night"

Let us imagine that the entire real world is here, inside the vastness of the work, within the identification process between artist and art; and that the immensity of the great universal space may be used as a workshop, a laboratory in progress for the birth of new utopias.

Let us also imagine that art is a form of therapy that helps to shed light on the parallel universe of our subconscious, and that the artist is the medium who realizes this objective: hitting the mark, being right on target.

The proud willingness to create: singling out the target and then striking it, aiming, like a bullet, all the pent-up anger, all the desolate restlessness that pervades us, summed up in the decision of an instant, that stupendous and terribly dangerous moment of self-awareness.

Niki de Saint Phalle reached the apex of that moment when she caught sight of the liberating viaticum in art: the exalted and sublime gesture of shooting paintings with the fervor and trepidation of an outburst remains one of the most significant chapters in the course of her life and career as an artist.

Her desperate search: all the fantasies, the games, the fairy tales, the nightmares, and the hallucinations of existence are concentrated in a gesture, a single gesture that reaches unprecedented resonance to then fall back again in the countless folds of the abyss.

But the gesture is immediate, spontaneous, and cannot, must not repeat itself. Thus Niki began looking for *her* target, or better yet, *her* targets, in order to rediscover the sensation that art is not a continuous project that unfolds tranquilly and serenely from one point to another in time, following a course that can be reconstructed. Rather, it is an incessant series of attempts, of research and adventures that move in all directions; often they overlap, or at times they contradict or even destroy one another.

Origins

There is no trace in her family background that would suggest any contact with the art world and its expressions. The second child of an aristocratic dynasty of bankers, Niki was born in Neuilly-sur-Seine, France, in 1930. Her family soon moved to New York City, where she attended Catholic and public schools; she would spend her summers vacationing at her grandparent's castle in France. The social milieu she grew up in regarded the arts with respect, but also with a certain detachment.

The melancholic expression that comes through as she struggles to smile in certain photo shoots for *Vogue* and *Harper's Bazaar* or that dramatic tension that emerges from the cover of *Life Magazine* is a clue that reveals the confused and scared gaze of an eighteen-year-old girl incessantly searching for a secure road to take in life.

It would be her trip in Europe, in 1952 with her young husband Harry Mathews, that would lead her to discover another world: her visits to French and Spanish museums and the elegant charm of the Gothic façades of their cathedrals would make her fall in love with the thought and the refined, sophisticated magic of the art universe.

However, it was only after the serious nervous breakdown that struck her in 1953 that the artist would become aware of its nature and perceive that art is a

Niki de Saint Phalle and Jasper Johns,
Paris 1961
© Roy Lichtenstein Foundation

beginning of life; a therapy, a weapon to wield against social conventions, a means of expressing universal restlessness in an absolutely personal way.

Thus, amidst hope and desperation, faith and faithlessness, in the early 1960s her paintings entitled *Cathédrale* (*Cathedral*) were born: agglomerates of materials that enclose all the pain and anger accumulated over the years. At first sight, the *Cathédrale* works may seem monochrome, but instead they reveal the force of mysterious luminosity, and by means of an apparent play on light and shade, they take on the natural color of gloomy desperation.

The paintings Niki de Saint Phalle made in the 1950s and 1960s narrate the story of a tormented life and express, with power and extreme sharpness, the perfect symbiosis between the artist and the work, between thought and material: *The Zoo with You*, *Four Houses*, *Self-Portrait*, *Rocket*, and the series entitled *Study for King Kong*. These works are nothing but the seemingly ironic representation of an extremely complex and articulated inward journey.

Imbued with feverish torment, they echo the surrealist experiences of Miró, the subtly impressed wonder of solitude in the early works of Max Ernst, and the exotic and esoteric emblems of Victor Brauner.

Her own self-portrait, dated 1958, highlights the shards of a lacerated personality that searches to piece itself back together again through the imperfect collage of broken mirrors and ceramics; but within all this reflected pain, the *Self-Portrait* still contains her love and amazed admiration for the Catalan architect Antoni Gaudí and her fascination for the infinite visionary universe of his Parc Güell.

Whereas it is true that art is the deception that allures us and leads us to lose our way in its bewitching labyrinth, it is equally true that the artist is the guide who may show us a way out. In Paris, Niki discovered a world of mad visionaries, enchanters, and shamans who won her over with the power of ideas and the intellectual flattery of creativity.

From here, from the impetuous vortex of this metamorphosis, the artist learned new languages and began defining the iconographic repertoire of the themes she would later deal with; for many years her work would focus on violence (an extraordinary number of knives, pistols, and rifles appeared in her paintings of the early 1960s), emblems of a condition that was tolerated for too long, an explicit denunciation of the violence she herself experienced. Those monsters, or better yet, the disturbing figure of that "monster" drawn with furor in the *Study for King Kong*, would later be exorcised by the liberating act of a *Shooting Painting*, a well-aimed blow at the father figure.

But maybe it is also because during those years the phenomenon of protest and rage marked a new escalation that provoked violent rebellion among young people against aggression around the world: from Algeria to Biafra, and Czechoslovakia to Vietnam.

Against the backdrop of these international events and echoing her personal condition, it almost seems natural that sooner or later Niki de Saint Phalle would take a rifle from her arsenal and start shooting at her own paintings.

Shooting Paintings

The works made during those years with the "target reliefs" remain a brilliant in-

vention. It was in the early 1960s, the *Nouveau Dada* period, the iconoclastic movement that picked up again on the dadaist movement founded in Zurich in 1916 and which defined the act of artistic creation above all in the spectacular and theatrical element of the very act itself. In 1961 Niki organized a series of "actions" during which the artist, alone or together with colleagues, and at times even with the audience, used a rifle to shoot plaster reliefs covering containers of paint, which would explode and create a random, instinctive arrangement of color.

Aiming a weapon and then shooting at a work of art is a way of instilling it with life. Michelangelo struck his hammer against his statue of Moses, inciting it to speak. Niki shot her rifle to let off all her pent-up anger and spread color, to make the work "sing." The artist loaded the colors directly against the target and developed, through the rifle shot, the propulsive charge of instinctive creativity that is haphazard only in appearance.

In this context what remains significant is the combined "action" with the American pop artist Jasper Johns, with whom she executed *Tir de Jasper Johns* (*Shooting Painting of Jasper Johns*) in 1961, today housed at the Moderna Museet in Stockholm.

Facit indignatio versum: indignation provides the words, and in this case also the gesture. But art is a weapon that wounds only those who use it. It is a multiplier of risks, a digger of emptiness that attempts to reach the unexpressed depths

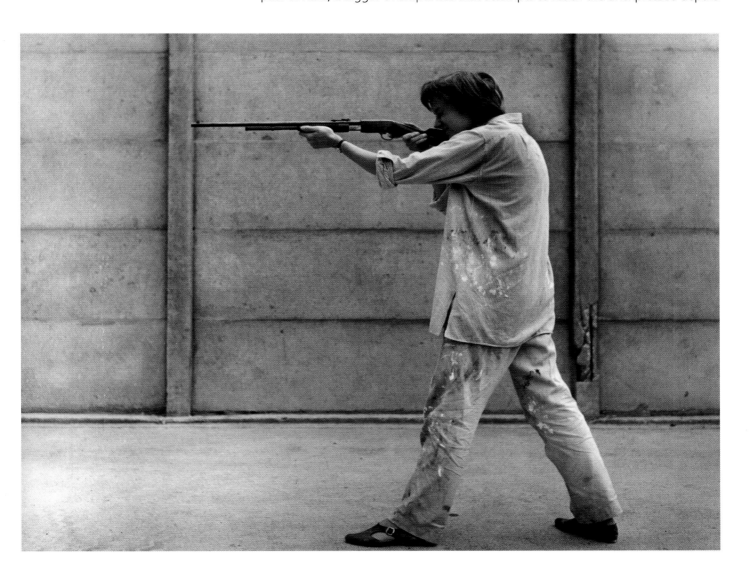

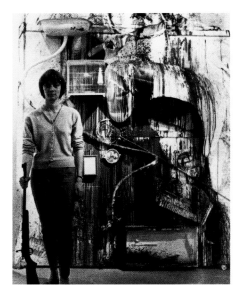

Niki in front of *Tir*, shooting painting-session,
26 June, 1961
© Roy Lichtenstein Foundation

of the subconscious: unrealized hopes, vague dreams, the restlessness of our sentiments, and those monsters that keep growing like beings within us. They are nothing other than the apparent distance between doubt and awareness.

Despite the profound transformation of her work, Niki nurtured the same outlook on the world: separated and divided things did not interest her. Instead, her universe belonged to the planetary imagination of great cosmic unison, where experiences intertwine in a close-knit network of intellectual and moral relations. The stories and efforts of everyday existence form, in her particular artistic expression, a single, large weaving of resonance.

The *Shooting Paintings* confirm the violence and sweetness of a curious destiny: the gesture, in its spontaneous execution, expresses the moment and place of a metamorphosis. The analogy of an image unleashed from that instantaneous impulse can be compared to cutting a new umbilical cord – it is the violent acceleration of rebirth.

The *Shooting Paintings* are also the poetic expression of disenchanted awareness: the series *Tir – Fragment de Dracula II* (*Shooting Painting – Fragment of Dracula II*) and *Tir de l'Ambassade Americaine* (*Shooting Painting of the American Embassy*), made in 1961, are paintings that gather, like a large sound box, all the sensations and stimuli of that period. During the 1960s, a time tormented by the proliferation of images and overflowing with creative fervor, Niki de Saint Phalle explored the potentials of her work and understood that what was taking place was a sort of mistrust in the communicative possibilities of art, crushed by the arrogance and omnipresence of the images of an apparent real life. This strange ambivalence, this incurable fracture became the trademark of that period, which is recognizable even today.

While the images "exploded," and were important and popular in the public opinion, many artists turned their backs on that visual inflation they no longer felt in touch with and began presenting white canvases, empty surfaces, frozen monochromes that describe the void.

Niki prepared her assemblies with plaster, a rigorously white material, and then arranged them like the center of a defined target, shooting them and making the color "bleed," causing lacerating wounds that could be healed only with great difficulty.

The act was decidedly liberating, and the comments arbitrary. The idea was that of uniting life and art directly, without compromise; noise and anger became the prophetic sign of a declared protest. The awareness of newfound femininity also passed through the creativity of the gesture, as the feminine universe asserted itself: *Les Nanas au pouvoir*, the girls who were about to take command.

Nana Power

The wave of violence came to a halt and *Les Nanas*, the girls, came onto the scene.

After the advent of the feminist movement, Niki de Saint Phalle explored femininity through the creation of a series of absolutely extraordinary sculptures. Out-of-the-ordinary works, that is, which remain outside any plastic notion of academism; sheer aesthetic invention that discovered its origins in an overall perspective on the subject.

The female figure became the absolute protagonist: her forms were liberated and exaggerated. The sought-after and intentional distortion of the subject maintains the same correspondence between form and content. Certainly not intending to shock, nothing in Niki's oeuvre is purely decorative. Quite the contrary: the manipulation took place as a response to a need within. *Les Nanas* are the result of Niki's absolute need to communicate the female universe in all its forms. The preliminary sketches of the sculptures are captivating, where the artist initiated a dialogue between the written word and the drawn form that would lead her to create silk screens of considerable expressive intensity: *Lettre d'amour a mon amour* (*Love Letter to My Love*) and *Why Don't You Love Me?* (1968); *Rain* (1970); *Nana pomme de terre* (*Potato Girl*) (1975); *Arizona Wildlife* (1978); up to the extraordinary series of the *California Diary* (1993).

The Cyclopean lightness of the *Nanas* defies all rules of gravity: there exist different possibilities of encountering destiny and Niki reflected in the mirror of her new creatures the possibility of taking a risk once again and finding once more the lightness of violated childhood, creating the figure of a protective doll, the guardian of a moral gravity and witness to familiar tenderness in a constantly precarious equilibrium.

The material double of this representation is an insolent ballerina who despite her exaggerated forms dances the imperceptible lightness of sinuous movements and exposes her colorful figure to the ironic sequence of all kinds of metaphysical

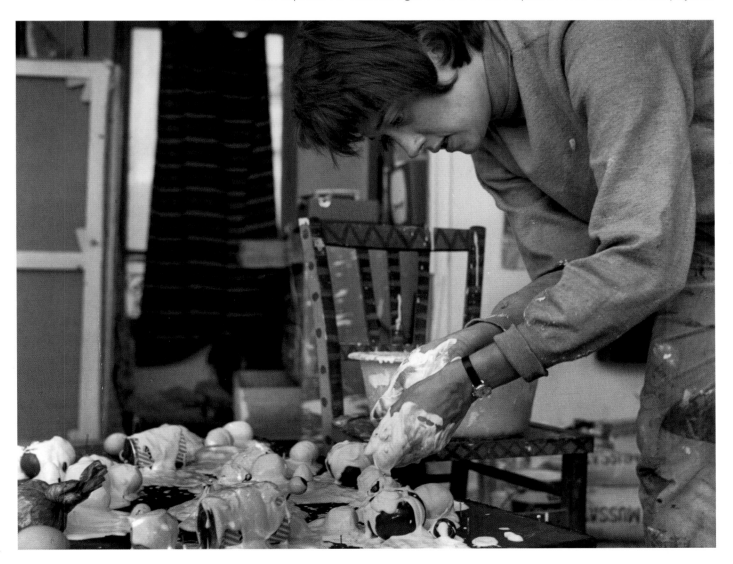

poses: *Nana Boule* (*Ball Girl*), *Ange Luminaire* (*Angel Light*), *Nana Cabine de Bain* (*Bathing Hut Girl*), *Nana sur le Dauphin* (*Girl on the Dolphin*), and the countless other versions of this immense horde of projections and shadows reflect the colors of life and lead to the impassioned search for that mysterious place where joy reigns.

The celestial messengers of her *Nanas* are playing with us and transport our world within another world, volatile and unpredictable, where everything is clearer on the horizon: the madness we experience, the tremendous separation we must endure, the storms and stillness that await us, the profound suffering and boundless happiness that penetrate us.

Spiritual Path

You Are my Love Forever and Ever and Ever… is the title of work that Niki de Saint Phalle made in 1968. It is a universal declaration of love: *l'amour, toujours l'amour*.

Work and life are inseparable for most artists, but for Niki de Saint Phalle this was an integral part of her life. Her life and professional relationship with Jean Tinguely significantly marked a considerable part of Niki's artistic course, and her passion for art is confirmed as the instrument for the search and discovery of a personality: "The collaboration between Jean and me, the convergence of our work, is a gift from the gods. Our shared activities have been vividly colored by our love, by our separation, by our friendship, and by the rivalry that has always existed between us."[1]

Niki and Jean, the explosive couple that revolutionized twentieth-century art; the ferment and passion of the senses, the creative genius of both that joined together in a relationship that led to the realization of increasingly visionary and unpredictable works. The ramifications of this relationship grew further over the years, to create a tight weave of "forms and figures," of opportunity and exchange, that strove to move the vitality of art.

In the lateral geographies of this intertwining, in the dynamics of all these relationships – with interlocking stories, with relations made of changeable shifts and seemingly ephemeral confines between inclusions and exclusions – there began to take shape the energy-filled profile of what might be defined as Niki de Saint Phalle's "artistic identity."

The origin of this identity was born out of the awareness that she was an artist and above all a woman, which found concrete realization in the work-emblem *Hon* (*She*), made in collaboration with the Moderna Museet of Stockholm in 1966. Beginning with Gustave Courbet and his most provocative painting, *L'Origine du monde* (*The Origin of the World*), Niki created, with Tinguely's collaboration, a monumental sculpture 28 meters long and 6 meters high. It is a gigantic pregnant *Nana* that carries in her womb a multitude of visitors.

"… *Hon* is reclining on her back, with legs bent, and in order to enter you have to pass through her sex, and on the inside the visitor will find entertainment of all kind. In one leg there's a gallery of imitation works by Paul Klee, Matisse, etc.… In one of the knees Jean has placed 'the lovers' bench,' a rather comfortable old velvet couch, found at a flea market; he has placed under the seat a few microphones to record the conversations and play them in other parts of the sculpture. Pontus wants to project Greta Garbo's first film in the left arm, which lasts fifteen minutes; there are twelve seats; inside the head Per Olof Ultvedt has built a wooden brain

[1] Niki de Saint Phalle, in cat. *Jean Tinguely, Una magia più forte della morte*, Bompiani, Milan 1987.
[2] Ibid.

26

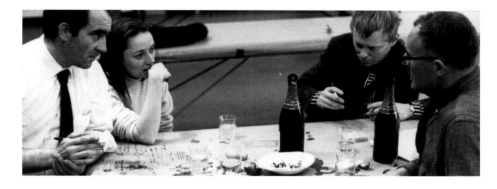

animated by engines.... The *Nana* is lying down and pregnant and, along a series of steps and stairs, you reach the terrace above the belly from which you can enjoy a panoramic view of the visitors ready to enter and of the flashily painted legs. Nothing pornographic, the *Hon* is painted like an Easter egg, with those same bright colors that I've always used and loved."[2]

Life and art come together; the spectacular and theatrical element of the act of creation encouraged a new public to make contact with the artistic universe, those many persons who normally do not visit museums. The work was imbued with a sense of exhibition that causes scandal, a sense of spectacle that moves the masses, the provocation, noise and anger of an action disguised as *divertissement*.

When Niki thought, her thoughts were already a story. It is not difficult to understand that her creativity experienced illumination when it took its energy from a sphere of action in which freedom knows no bounds: for her, art was not only the product of time passing inside a studio, but the outcome of encounters with the outside world; it is the force that emanated from the passing of her experiences.

The power of desire and the force with which she was able to express it instilled unprecedented vitality in all the formal solutions she used.

Niki de Saint Phalle met Jean Tinguely in 1961 in Stockholm, and he became her second husband ten years later, in July 1971. Together they established a sentimental and professional union that gave rise to works fascinating and absolutely exceptional in terms of both their dimensions and artistic invention.

In addition to *Hon* (*She*), both artists collaborated on the series of works that outline the course of *Le Paradis Fantastique* (*The Fantastical Paradise*): nine large sculptures made for the 1967 Montreal Expo; then came *Le Cyclop* (*The Cyclops*) in Milly-la-Forêt; the *Stravinsky Fountain* for the Centre Pompidou square in Paris; the *Château-Chinon Fountain*; and countless more, up to the spectacular *Tarot Garden*.

Working on large-scale works brought new sensations and created new visual experiences: the challenge became more and more stimulating, and both artists launched a violent attack on the conventional concept of art. Their approach to matter and form focused increasingly on blending concepts strongly connected with the plasticity of the work and the poetics of a different language, and was intended to narrate a story of renewed expressive romanticism.

The Tarot Garden

In 1979 Niki embarked upon a fascinating enterprise that would make a strong mark in the international art world: a series of gigantic sculptures inspired by tarot cards.

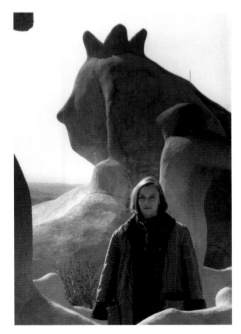

Niki de Saint Phalle at the Tarot Garden,
Garavicchio, 1987

After selecting a site on the Garavicchio estate owned by the Caracciolo family, and located in Capalbio in Tuscany, the artist conceived of an extraordinary itinerary where the twenty-two tarot cards, the Major Arcana, are represented by means of a few Cyclopean sculptures, about 12 to 15 meters in height. Covered with mirror mosaics, precious glass and ceramics, these works once again refer to the artist's considerable admiration for the Parc Güell in Barcelona by the Catalan architect Antoni Gaudí.

Niki set out on her adventure with Tinguely's assistance, preparing the sketches and building at her own expense the prototypes of what would later become the stunning scenery of her boundless imagination. Execution of the sculptures was entrusted to local workers, including a few laborers who subsequently became very important in Niki's life, and whom she always considered part of her family.

Thanks to the magical force of the monumental format, the work became all-encompassing: sculpture, painting, mechanics, craftsmanship, and architecture took form via the artist's unlimited creativity. The exceptional inventive quality of these installations is surprising.

The mediumistic symbolism of the tarot cards provides the expressive power in a fascinating walkthrough. The sculptures narrate a visionary world that unfolds across the park in a series of fascinating and extraordinary encounters: *The Magician*, his hand covered with tiny mirror tiles; *The High Priestess*, a small cascade of water flowing from her mouth over tiled steps and ending in a fountain where a wheel of fortune spurts more water at its center; *Death*, representing the eternal decay of the world, holding a scythe in his hand; and then *The Devil*, *The World*, *The Fool*, *The Pope*.

The jumble of these gigantic emblems turns the journey into an anthology, an inventory of the artist's personal myths. Representing dreams and ancestral fears, the game and its narration unfold like an endless losing and finding of the self.

Niki had finally realized her Garden of Eden; one rich with lavish salons and baroque façades, colored gems and bewitching sirens, because fairy tales require magnificence and joy, and also a delightful sense of *falseness*, without which they lose their oneiric charm.

The preliminary sketches for the sculptures are unusual, teeming with creative fantasy, and inspired the artist in the 1990s to produce the series of lithographs inspired by the tarot cards and her experience with the Garden. *Tarot Garden*, dated 1991, is the lithograph that initiated the sequence; it is a carousel of colors and symbols that presents all together the protagonists of this surreal journey, where even *The Skull*, which symbolizes *Vanitas*, is transformed into a sort of grotesque mask, and *The Tree of Life* shows both faces of its disturbing reality.

With their gigantic dimensions, Niki's sculptures attain "a magic stronger than death," to cite the title of a work by Jean Tinguely – that magic that only art can transmit, a magic that is absolutely "useless" and completely senseless, a magic that feeds only upon beauty, and thanks to which it becomes "indispensable."

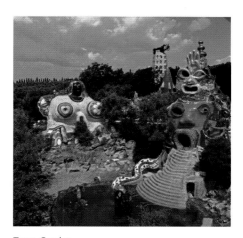

Tarot Garden

The initially iconoclastic artist gave way to the awareness of structured work, though always attentive to the coherence of a style aimed at developing themes that marked her evolution as an artist. It was the right time to follow illusions, to chase after the metamorphosis of space, to give concrete "shape" to ideas. The pack of disorderly animals that constitute *The Zoo with You* are no longer threatening but instead reassuring friends that accompany us across the path of fantasy. The flashy colors of this itinerary left their mark on her development as an artist.

The spectacular invention of forms became the poetical expression of a new figurative language. *Hippo Lampe* (*Hippo Lamp*), *Chandelier "Tête del mort"* (*Dead Head Candelabra*), *Les Obélisques* (*The Obelisks*), *Les Nanas Vase* (*Girl Vase*), *Lampe Angulaire* (*Angular Lamp*) are everyday objects that must be used as such. The parallel story between art and its consumption has been written time and again in manuals on aesthetics, but the artist who drew dreams revealed a tangible component. The woman of multifaceted intelligence and cleverness broke the pact with herself: the tragic rigor of gravity was softened in the infinite lightness of the game. The phantasms of the past were exorcised by color, and the horizon seems clearer, honest, and transparent.

California Diary

Niki's habit of writing a diary was a prelude to choices aimed at formulating an overview of her life.

Writing down her daily experiences became a way of analyzing existence through the ordered formulation of thoughts and emotions. Niki began recording on paper the significant moments of her day. This singular correspondence of words and drawings stemmed from her need to communicate to the entire world her passion for life, for love, and for her work.

In the early 1990s Niki de Saint Phalle lived for long periods in California in her home in La Jolla, and from there she began a series of works on paper – drawings and silk screens that would later become the series entitled *California Diary*. Everyday events became colored sheets of paper that express the happenings and sensations of her daily life. Jean Tinguely once said that Niki drew a lot: "seated, calm, reflective, she put her thoughts down on paper." Drawings and words that became weapons against pain and deception, tiny ornaments of an aesthetic course that would mark her entire life.

This was the inception of a few works that remain the melancholic arpeggio of the final years of her life: the poetical world of *Christmas*; the dizzying labyrinth of *Telephone*; *My Men*, which is a tiny inventory of the men in her life, restored confusedly to her memory in an expression of surprising creativity. And then there is the civil protest of *Black is Different* and the more intimist *Order and Chaos*; up to the all-consuming poetics of *Queen Califia*, where the rocky landscape of California is about to fall asleep at sunset and summons, before the night sets in, all the invisible protagonists of the tormented day.

The gigantic letters Niki created on paper would then be sent to the entire universe, entrusted to those seagulls who fly high above the sky of California. Her thoughts became signs and words that narrate a "dream longer than the night"; *l'amour, toujours l'amour, forever and ever and ever….*

Sarah G. Wilson

Tu es moi:
the Sacred, the Profane
and the Secret in the Work
of Niki de Saint Phalle*

The image is perhaps our sole remaining link with the sacred: with the *horror* provoked by death and sacrifice, with the *serenity* resulting from the pact of identification between the sacrificed and those who sacrifice, and with the *joy of representation* indissociable from sacrifice, its only possible passage…
Julia Kristeva, *Visions Capitales*, 1998[1]

I never shot at God…I shot at the church. I glorify the Cathedral.
Niki de Saint Phalle, 1981[2]

Niki de Saint Phalle's work is situated in a tradition which begins with the roots of the Catholic religion in Europe and extends to our contemporaries such as Orlan. The sacred and profane dimensions of her art were born of interior conflict and the politics of her times. At the end of her *annus mirabilis*, 1961, in which she invented her shooting paintings (*Tirs*) and cathedral pictures, and performed and shot in collaborative work internationally, she showed at the Museum of Modern Art, New York, in the highly influential 'Art of Assemblage' exhibition which opened in October (it subsequently toured to Dallas and San Francisco). And *Tu es moi, paysage de la mort* entered the collection of the curator's wife, Irma Seitz: a superb compliment.[3] At this exhilarating moment Niki was poised at the apex of an international avant-garde, on the cusp of neo-Dada and performance, at a moment of fête and celebration.[4]

Tu es moi was made in Paris at the moment of transition from landscape assemblages to the first target portraits in the Rue Alfred-Durand-Claye. A black sky with a dying red sun looms over a white horizon; the foreground is peopled not with the *personnages* of Jean Dubuffet's encrusted landscapes (which precede these formally), but with a pistol, hammer, scissors, razor blade, rope, a two-pronged fork, a rod and a dagger. A crime of passion? Or the instruments of passion evoked by the echo of those black-skied crucifixion landscapes where the sun is eclipsed at the darkest moment of Christ's agony? Each object, lightly inclined to the left, invites the spectator to pick it up with the right hand and strike, or fire. *Tu es moi* – You are me: the landscape as sign of Niki's own rage? Her subsequent turns are metamorphic: the move from sun to cathedral rose to circular target-head, from folded plaster landscape to crinkly shirt are evident. *Tu es moi* anticipates *Hors d'œuvre (Portrait of my Lover / Portrait of myself)*, the first target portrait, and the *Saint Sebastian* portraits which followed.[5]

The sun floats, disembodied, decapitated. The counterpoint to *Tu es moi*, possibly the first of the Death Landscape series, is *Collage de la mort*. A black sun is poised in a livid red sky; a doll's severed hand and a hatpin join the instruments of aggression. A stream of paint trickles like dried blood from the black sun into the landscape; it becomes the back of a looking-glass through which we cannot see, even darkly. The everydayness of the objects, already trapped, half-engulfed in a plaster burial, evokes the tradition of the *vanitas*. *Le soleil noir de la mélancolie*, the black sun of melancholy, is evoked as an act of mourning – or projection. For Niki, as for any young girl learning Gérard de Nerval's symbolist poem that introduces this black sun, an act of transference takes place: we imagine the mysterious Prince of Aquitaine in his abandoned tower, not as the poem's narrator, but as a

* First published by Tate Liverpool in catalogue to accompany *Niki de Saint Phalle* exhibition, 1 February – 5 May 2008
[1] "l'image est peut-être le seul lien qui nous reste avec le sacré: avec l'épouvante que provoquent la mort et le sacrifice, avec la sérénité qui découle du pacte d'identification entre sacrifié et sacrifiants, et avec la joie de la représentation indissociable du sacrifice, sa seule traversée possible": Julia Kristeva, preface, *Visions Capitales*, Paris, Musée du Louvre, 1998, p. 11.
[2] 'Je n'ai jamais tiré sur Dieu… Je tire sur l'église. Je glorifie La Cathédrale': Niki de Saint Phalle, in *Niki de Saint Phalle*, Paris, Musée National d'Art Moderne, Centre Georges Pompidou, 1981, p. 17.
[3] See William C. Seitz, *The Art of Assemblage*, New York, Museum of Modern Art, p. 122. The 'family resemblances' evident in the catalogue which affiliate Niki's work with Surrealist objects, with Kurt Schwitter's Merzbau, with Simon Rodia's Watts Towers, and contemporaries beyond the *Nouveaux Réalistes*, from Parisian Yolande Fièvre to Enrico Baj in Italy, have implications beyond the scope of this essay.
[4] 'Niki' is in no way belittling; to repeat 'De Saint Phalle' (as one would say 'Bourgeois' or 'Hepworth') is both wordy and portentous.
[5] It was surely the poet John Ashbery's review of *Hors d'œuvre* (shown at the Salon Comparaison no. 350) in the *New York Herald Tribune*, 8 February 1961, which generated Niki's American reputation.

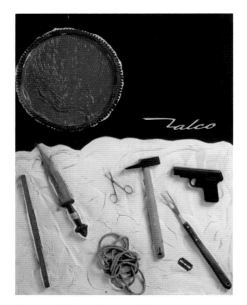
Tu es moi (*You and me*), 1960

romantic love-object.[6] We introject, as his melancholy becomes our longing, and his loss our forward-looking yearning. *Tu et moi* – you and me – an impossible dream?

But the Death Landscapes (their titles *Paysages de la mort* coming from *Natures mortes*, still lifes, 'dead natures') are highly aggressive. *Tu es moi* is also *Tuez-moi*: Kill me! Is this an imperative coming from the work itself, an exhortation to take up the pistol, the hammer, and smash the representational object to pieces? (In one of her films, Niki's repeated shots end with the crumpling of the complete armature of the *Tir* and its contents; like a dead body it slumps, bleeding, into the snow – an abject pile of mess and colored liquids.) Alternatively, rebarbatively, is the exhortation "Kill me!" coming from Niki herself?

In *Le Martyr nécéssaire* (*Saint Sebastien*) the dartboard replaces the head, suspended just above the empty shirt; a decapitation precedes the assault on the target-substitute. The work is an appeal to the female spectator, perverting the homoerotic, saintly subject of Renaissance art. Niki's art is an act of profanation. And what pleasure to reverse the Saint Sebastian trope, to aim one's own darts at this blank emblem of the male! The *précoce* precursor, subtitled *Saint Sebastian (Portrait of my Lover)*, with its Jackson Pollock shirt of spurts and drips, obliquely signals the impact of the great touring show, 'The New American Painting', which arrived in Paris in January 1959.[7] Pierre Restany's text, 'Tir a volonté' ('Shoot at will'), which presented Niki's work for the Galerie J in 1961, was typed over a fairground paper target spattered with holes (one recalls the ultimate Dada gesture of shooting at random into a crowd). He declared: "There's both the cowboy and Young Werther in this pistol history…the gesture of the assassin or the cuckolded husband becomes an invitation to a voyage…."[8] For Restany this is a man-on-man shootout: husband versus lover. Far from empathizing with Niki's desires, he does not even emphasize female agency.

The Baudelairean voyage Restany describes is into "a world of strange marvels where blood cedes its place to the richest of colors, where explosion creates new form, where the wound is poetry…".[9] In *Shooting Picture – Galerie J* (1961), created at that very moment, rainbow stripes trickle down from the surface: a parody of the exhaustion of the existentialist gestures of an international European *informel* (one recalls the similar results of Jean Tinguely's *Painting Machines* of 1959).[10] The equivalence between shooting a victim and shooting a painting – paint as blood – evokes the whole Western tradition in which the canvas stands in for the female body: nude, love object, goddess, Venus – or alternatively the raped Europa, the raped Lucretia, the raped Sabines…. Niki shoots the whole Western tradition in art. *Posséder et détruire* ('Possess and destroy'); such was the title of an exhibition summarizing this tradition at the Musée du Louvre in Paris.[11] A brilliant parody, then; but is she shooting at male artists or at a body not male but female?

Tu es moi – 'You are me': the victim as perpetrator, perpetrator as victim. *Tu et moi* – 'You and me' or *Tuez-moi* – 'Kill me'? How should we respond to Nanas such as *Pink Birth* where woman has moved from the rectilinear or altarpiece-shaped confines of the tableau to become all body, to acquire human, female form? *Tu es moi*. Was I this horrible, birth-giving animal splayed on its back, covered with blood, defined by reproduction, Niki asks? (*Pink Birth* was conceived and made at a time when

[6] Gérard de Nerval, 'El Desdichado', in *Les Chimères – Poèmes de Gérard de Nerval*, 1854.
[7] *The New American Painting as Shown in Eight European countries, 1958–59*, New York, The Museum of Modern Art, 1959. Paris was the last venue of the sensational tour.
[8] "il y a la fois du cow-boy et du werther dans cette histoire de pistolet… le geste de l'assassin ou du mari trompé devient un invitation au voyage…": Pierre Restany, 'Tir à volonté', Galerie J, 1961.
[9] "dans un monde d'étranges merveilles où le sang cède la place au plus riches couleurs, où l'explosion suscite la forme neuve , où la blessure est poésie": Restany, 'Tir à volonté'. See Elienne Lawson, 'Pierre Restany, Janine de Goldschmidt and the Galerie J, 1961–66: The Art of Making Nouveau Réalisme', MA thesis, Courtauld Institute of Art, University of London, 2002.
[10] At the time of the first Paris Biennale des Jeunes in 1959, Tinguely's cranky 'drawing machines' created a sensation on the esplanade of the Eiffel Tower.
[11] *Posséder et détuire, les stratégies sexuelles dans l'art d'occident*, Paris, Musée du Louvre, 2000, told a story where the classical tradition gave way to Antonin Artaud, the Viennese Actionists and Yves Klein. Curated by Regis Michel, this erotic pageant was by no means challenged or deconstructed.

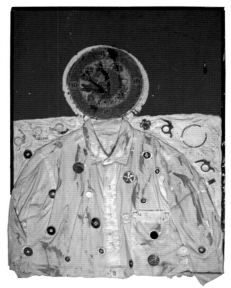

Hors d'œuvre or Portrait of my Lover, 1960

[12] Murielle Gagnebin, *Fascination de la laideur. L'en deça psychanalytique du laid* [1978], Lausanne, Editions Champ Vallon, 1994, p. 259.

[13] "L'accouchement c'est la femme virile. Elle porte l'enfant comme un sexe masculin. Mes naissances font de la femme une déesse. Elles deviennent à la fois père et mère." Restany: "Accoucher debout, dans un pré, comme la mère de Descartes! Quel discours! Quelle méthode! La femme virile de Niki nous laisse pantois, sans réponse". *Niki de Saint Phalle*, p. 44.

[14] See Sarah Wilson, 'Fêting the Wound'. Georges Bataille and Jean Fautrier in the 1940s', *Writing the Sacred: Georges Bataille*, ed. Carolyn Gill, London, Routledge, 1995, pp. 172–92.

[15] 'Dames' were not ladies, but prostitutes, so-called with the chivalry of those who accepted the inevitability of the situation.

[16] See Marjorie Garber, *Vested Interests. Cross-Dressing and Cultural Anxiety*, New York, 1992, pp. 126–27 on female fetishism and fetish envy.

[17] The Sadean vogue was enhanced, of course, by the writings of Georges Bataille and Pierre Klossowski. For a discussion of Fini, see Jennifer Thatcher, 'Menace à Trois: the Art of Leonora Fini, Niki de Saint Phalle and Annette Messager in the Context of 1970s French Feminism', MA thesis, 1998. See also Sarah Wilson, 'Axell: One+One', *Evelyne Axell, from Pop Art to Paradise*, Paris, Editions Somogy, 2004, pp. 23–40, and 'Rites of Passage: Myriam Bat-Yosef and Performance', *Myriam Bat-Yosef, Paintings, Objects, Performances*, ed. Fabrice Pascaud, Paris, Editions Somogy, 2005, pp. 92–107 (bilingual).

she was recovering from a secret abortion.) The red-haired Nana's body pullulates with menageries of plastic mammals crawling towards a huge spider and an empty breast overrun with vegetation; she sports man-made machines, trains, planes – a doll hangs from her vagina. Niki's birthing mothers may be virile in the classic Freudian sense, with the child as a penis substitute (*Tu es moi* –You are part of me), but they are also open wounds, corpses, redundant as they crawl with new life. *Laedere* – to wound – is arguably the origin of *laid* (ugly) in French.[12] Next to this terrifying and deathly image in the Paris-Stockholm catalogue of 1980 we read in Niki's deliberately childish hand: "Giving Birth: the virile woman. She bears the child like a male sex organ. My births turn woman into a goddess. They become at once father and mother." Underneath, a male curatorial note ripostes in print: "To give birth standing up, in a field, like Descartes's mother! What method! Niki's virile woman leaves us dumbfounded, without an answer. Is there an answer?"[13]

Niki, of course, conceived this birth-giving Nana not standing up (to give birth to the philosopher René Descartes, the father of French rationalism) but on a flat plane, like Robert Rauschenberg's ready-made patchwork quilt *Bed* (1955), trickling with colored paints, shown in Paris in 1959; or like her fellow Nouveau Réaliste Yves Klein's *Anthropometries* and *Shroud Anthropometries*, where positive and negative images made with 'female paintbrushes' involved real nude models. These girls printed their sticky bodies on canvas or loose cloth to make images then 'dematerialized' via the alchemical and sacred colors of blue and gold, and by erection of the work from the horizontal to the vertical, where they become disembodied forms, angelic flights.

Other dialogues are more disturbing, however. Niki's Nanas are direct descendants of Jean Fautrier's high-relief *Hostage* paintings, commemorating rapes and shootings, which celebrate the wound in Bataillean mode.[14] They also develop Jean Dubuffet's ugly and menacing parodies of the nude tradition such as *Olympia* and other works in his 'Corps de Dames' ('Ladies' bodies') series of 1950. (The link between Dubuffet and the writer Louis-Ferdinand Céline, who exemplifies the abject in Julia Kristeva's *Powers of Horror*, is direct).[15] Germaine Richier's larger-than-life *Hurricane Woman* (1948–49), with its brutalized bronze surface, also anticipates Niki; astonishingly, Richier polychromed her smaller sculptures before her death in 1959. This was the year of the International Exhibition of Surrealism in Paris, where the transformation of the nude into a cannibalistic feast – in the tradition of the vegetable allegories of Arcimboldo – saw Meret Oppenheim prostrated on a table and covered with fruit and food for the opening. An embodiment of Eros, and invitation to oral and sadistic aggression as woman to be devoured, she represented woman as fetish – and woman's own absorption within that fetishistic desire.[16] Surrealism was reaching a point of expiry and transformation in Niki's era, but Surrealist women of the 1950s and 1960s, from the mature sorceress Leonor Fini, to Mimi Parent or Bona, the poetess Joyce Mansour or the writers Annie Le Brun and Dominique Aury, were all subject to the spell of the Marquis de Sade. And the categories of muse, mistress, *femme-enfant* (child-woman) still prevailed. The encounter with psychedelia in the colorful drawings and body-paintings of Myriam-Bat Josef or the Pop art of Axell in Brussels demonstrated a feminist turn: these women were Niki's contemporaries.[17]

[18] Sartre's characterization of the viscous as the sweet and feminine 'revenge of the en-soi' in *Being and Nothingness* was challenged by Suzanne Lilar in *A propos de Sartre et l'amour*, Paris, Grasset, 1967, p. 77. See also Dorothy MacCall, 'Existentialisme ou Feminisme?', in 'Sartre', special number of *Obliques*, 1979, pp. 311–20.

[19] Niki's own mother, with her strict standards, high expectations and her condoning of her husband's infidelities, plays a significant role in *Traces. An Autobiography. Remembering 1930–1949*, Lausanne, Acatos Publications, 1999.

[20] The psychoanalyst Donald Winnicott explored the concept of the 'good-enough' mother; his 1951 article 'Transitional Objects and Transitional Phenomena' appeared in *La Psychanalyse*, no. 5, 1959 (review of the French Society of Psychoanalysis founded by Jacques Lacan and Daniel Lagache). Winnicott became known to a wide French audience through a special number of the review *L'Arc*, no. 69, 1977. See also Mignon Nixon, 'Bad enough mother', *October*, vol. 71, feminist issue (Winter, 1995), pp. 70–92: "Bourgeois subverts the name-of-the-father logic of Lacanian theory through a destruction-of-the-father, part-object logic based in the Kleinian model."

[21] I refer to Julia Kristeva's 'Giotto's Joy' and 'Motherhood according to Giovanni Bellini' – inspired by the example of Marina Warner's *Alone of All Her Sex: The Myth and the Cult of the Virgin Mary*, London, Weidenfeld and Nicolson, 1976. See Julia Kristeva, *The Kristeva Reader*, ed. Toril Moi, Oxford, Basil Blackwell, 1986, and *Desire in Language, a Semiotic Approach to Literature and Art*, ed. Léon S. Roudiez, New York, Columbia University Press, 1980.

[22] See Henri Alleg's torture exposé, *La Question*, Paris, Editions de Minuit, 1958, and Simone de Beauvoir and Gisèle Halimi, *Djamila Boupacha*, Paris, Gallimard, 1962, for the most notorious rape-case.

But a neo-Dada aggression liberated Niki's art from Surrealist affinities. *Tu es moi*, You are me, Niki declares – just as Gustave Flaubert identified with his most famous, sexually profligate creation, Emma Bovary, *Madame Bovary, c'est moi*. On the one hand, says Niki, addressing male artists, you create beautiful – or horrible – nudes because you are afraid of woman and her power, including her power of procreation. The idealized 'beautiful' image terrifies in its perfection, its unattainability; the apotropaic dimension of the nude is at stake here. The 'dirty' nude of a Dubuffet corresponds to the infantile wish to destroy, to defile, to scratch, to score, to cut up the body, the 'bad breast': see his *Piece of Butchery* or *Tree of Fluids* (both 'Ladies' bodies' series), where the image liquefies, spreading dangerously to the four corners of the canvas, threatening to engulf its creator in pre-natal memories.

Contemporary French culture exalted the glamour-puss, from Roger Vadim's creation of Brigitte Bardot as the ultimate, God-created woman in his film *Et Dieu… créa la femme* (1956), to Martial Raysse's Nouveau-Réaliste bathing belles. Compared with Niki's slim and fashionable body, whether beauty plate for *Vogue* or queen bee at the Nouveaux Réalistes' private views, the Nanas are the monstrous, ugly, misshapen 'other self', sticky with the 'viscous' feminine, abhorred by the existentialist philosopher Jean-Paul Sartre and even his feminist partner, Simone de Beauvoir, author of *The Second Sex*.[18] Is the Nana the 'bad mother', a fearful effigy for Niki herself, who left her own two children and her husband to work with Jean Tinguely? Does Niki shoot the effigy of the mother she once was, all 'earth mothers', or the 'bad mother' she fears?[19] Her problematic 'destructions of the mother' preceded by a decade Louise Bourgeois's *Destruction of the Father* installation of 1974.[20]

But Niki also expressed a political anger. The impact of the Nana's ugliness inverts and vilifies not only the cult of female beauty and fertility but the trope of sacred and virginal motherhood, the Madonna so central to the Western artistic tradition (explored later in the 1970s by Marina Warner and Julia Kristeva).[21] The title of her 1962 *OAS* altarpiece contains another pun: *Oeuvre d'art sacré* (sacred work of art) or *Organisation Armée Secrète* (the secret right-wing nationalist army). The altarpiece, gilded with an ecclesiastical pomp, is an act of sacrilege with its saintly effigies, its guns and its massacred innocents. Neither the French Church nor the Vatican denounced the Algerian slaughter; missionaries accompanied France's 'civilizing mission' in Africa from the start, while the concept of colonized territories as 'greater France' entailed lucrative rewards. The altarpieces evoke the Church itself as an ultimate patriarchal institution, one whose power over the most sacred rites of passage – baptism, marriage, death – evoked moral principles constantly abused. Niki's Nana altarpiece, *Autel des femmes* (1964), with its bride, its flying Nana stuffed with skulls and 100 franc notes, its flying military jets and capitalist skyscrapers, denounces the real and symbolic prostitution inherent in the system.

The models on the covers of *Vogue* or *Paris-Match* were now juxtaposed with headlines about systematic rape and torture by French soldiers in Algeria.[22] Here Niki's art becomes a voice of protest. She transforms the female body, which – as in medieval love poetry – represents the body of France into a militarized land-

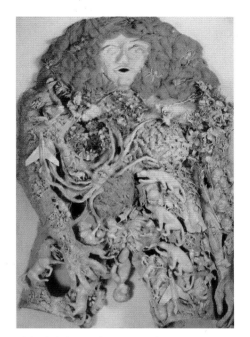

Pink Birth (Accouchement rose), 1964

scape, whether 'occupied' by American troops or shot and blown up, mimicking bomb attacks and police brutality in Paris. The almost sexual ecstasy that she describes while shooting, the 'sublime' moment followed by fatigue, disappointment, exhaustion, has arguably a counterpoint in the excitement, horror and disbelief of the militarized teenage conscripts, her counterparts in a 'France torn apart' by this unnamed war. (*La France déchirée* was indeed the title of a torn-poster show of 1961 by her Nouveau Réaliste contemporaries.)[23] The shooting-painting *Tirs* can become 'tears' of shame, pain, desecration, mourning or relief. In 1962, the year the *OAS* altarpiece was exhibited, Pierre Guyotat was expelled from the army for moral turpitude following two years in Algeria; his novel *Tombeau pour cinq cent mille soldats* (*Tomb for 500,000 Soldiers*) with its intense sexual scenes between combatants was banned from military barracks.[24]

What happens when the Nana becomes a man? Or to reverse the proposal: what is implied when the monstrous Siamese twin Nana, *Kennedy–Khrushchev*, becomes a woman? Created in 1962 in the Impasse Ronsin in Paris – where Brancusi once sculpted his smooth and beautiful birds – this most angry of Niki's shooting pieces asks the most disturbing questions. Completed with a shoot-out it anticipates the tense moment of the opening of the New York-Moscow telephone hotline in June 1963 and Kennedy's November assassination. Just as the Nana's body could become the equivalent of a country to explore, here again is the metaphor of the body politic, now signifying Cold War apocalypse. However, the two world leaders are humiliated not only via their stripping, but through their castration, through their feminization. The blackened pubis becomes a place of shame and ashes. *Tu es moi*: you have become me. The sexual humiliation of political victims, taking place at that very moment in the French-Algerian conflict, is acted out here as revenge. While a sister piece, *Red Witch* (1963), may take upon itself all the fairytale empowerment of the monstrous feminine, of the vampire killer, with *Kennedy–Khrushchev* the sexual politics at stake of feminizing the enemy – a practice re-enacted today between victors and victims – is ambivalent in the extreme: women's anger expressed through self-reflexive humiliation?

Niki's *Crucifixion* (*c.* 1965), made in the Chelsea Hotel in New York, is a suspended Nana – clothed, not naked, with its huge square body, tiny head in curlers, and residual arms. An *arcimboldesque* jungle top of vegetation, soldiers, dolls and animals, like a flowery blouse, is tucked into a huge pink spotted suspender belt; thick thighs turned outwards taper into black lace stockings and tiny stilettos. A female Christ: profanation, blasphemy, or a resurrected reversion to the goddess-mother? *Crucifixion* anticipates by a year Niki's *Hon* ('She') the massive, collaborative, splendid woman-cathedral created inside Stockholm's Moderna Museet in 1966. The associations of fertility shrines, ancient priestesses and the origins of the cathedral arch and brothel in the Latin word *fornix*, the sacred labyrinths traced on the floors of ancient churches, come together here – but so does the etymological link between women and evil, flaunted at the entrance to this fun-palace. On the garter of the *Hon*, by the vaginal entrance, Niki inscribed the motto HONI SOIT QUI MAL Y PENSE: Evil to him who evil thinks.[25] Celebratory, democratic – a group 'rebirthing' experience – the *Hon* was a world-

[23] See Laurence Bertrand-Dorléac, '*La France déchirée*: Hains et Villeglé', in *La France en Guerre d'Algérie*, Paris, Musée d'Histoire contemporaine (BDIC), 1992, pp. 202–203 (referring to Jacques Fauvet, *La France déchirée*, Paris, Fayard, 1957).

[24] Michel Leiris insisted on showing Guyotat's *Tombeau pour cinq cent mille soldats* (Paris, Gallimard, 1967) to Picasso. Guyotat's sequel, *Eden, Eden, Eden*, was banned by the French government from 1971 to 1981.

[25] Compare 'bad' as in the exhibition *Bad Girls*; the Middle English representative of Old English 'baeddel' has hermaphroditic overtones; the derivative 'baedling' means 'effeminate fellow, womanish man'; but bad can be positive, Dionysiac, humorous. See Laura Cottingham, 'What's So Bad About 'Em?', in *Bad Girls*, London, Institute of Contemporary Arts, 1993 (for etymology see p. 59, note 2).

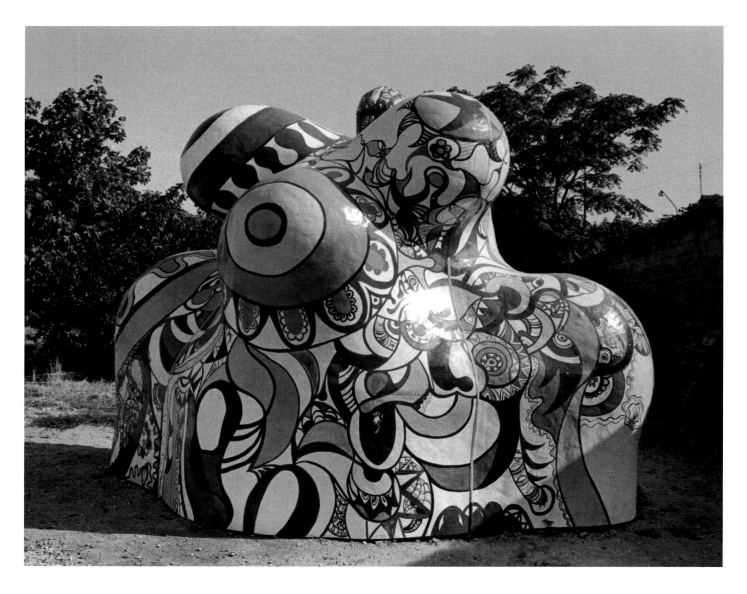

Nana maison I (*Girl House I*), 1966–67

[26] The commemorative Moderna Museet, Stockholm publication, *hon – en katedral*, with 'katedral' crossed out and replaced by '*historia*', recounts Niki's history, and the *Hon's* construction, exhibition, press response and demolition; with comparisons from the Venus of Lespuge to the Statue of Liberty, art-historical studies and an extensive quotation from Sigmund Freud's *Interpretation of Dreams*.

[27] See reprint of the two exhibition catalogues as *The Complete Book of Erotic Art*, compiled by Phyllis and Eberhard Kronhausen, New York, Bell Publishing Company, 1987.

[28] See Grace Glueck, 'Tinguely's Machines Menace Niki's Nanas in the Park', *New York Times*, 2 May 1968; 'La "Nana-Maison" merveilleusement tatouée', *Beaux-Arts*, Paris, 4 May 1968; and *Le Décor quotidien de la vie en 1968, expansions et environnements*, Musée Galliera, April–May, 1968 (with Arnal, César, de Rosny, Sanejouand, Tinguely, Xenakis).

[29] "…le plus important artiste féminin de l'époque": François Pluchart, 'Merveilleuse Niki de Saint Phalle', *Combat*, 11 November 1968.

wide press sensation, foreshadowing the spirit of the 1967 Summer of Love.[26] It anticipated a climate in Scandinavia in which over 250,000 people went to see the First and Second International Exhibitions of Erotic Art in Sweden and Denmark in 1968 and 1969, in public museums.[27] Its success led to Niki's commission with Jean Tinguely for the Paradise Garden on the roof of the barbican-like French Pavilion at the Montreal 'Expo 67', where 'Nana-kebabs' (*Nanas-en-brochette*) spun around joyously in the air. A tour followed: a treat for the Albright-Knox Gallery in Buffalo and then for lovers and Harlem kids in Central Park, New York. Together with the "marvelously tattooed" *Nana-Maison* shown in the Musée Galliera, Paris, these became Niki's contribution to May '68.[28] The *Nana-Maison* anticipated the sets for her play *ICH (all about me)* performed at the Kassel Documenta of 1968 in June. By November, with her show of an eighteen-part wall relief, *Last Night I Had a Dream*, at the Galerie Alexandre Iolas, Paris, she was recognized as "the most important female artist of the era".[29]

Though Niki's focus was now on large-scale sculptural projects, she participated in the tenth birthday celebrations of the Nouveaux Réalistes in 1970; Jean Tinguely's giant golden phallus exploded in front of a crowd of thousands. The sacred dimension was essential: the ghostly and magnificent night-time façade of Milan cathedral was the immemorial backdrop; the phallus ejaculated in

sound, smoke and fury, then imploded; the cathedral remained.[30] Niki's commemorative altarpiece shoot-out held in the long promenade of the Galleria Vittorio Emanuele – a particularly bloody event performed in front of horrified believers and the Milan police – magnified her first posed sessions in her white shooting outfit on the *parvis* of Notre-Dame in Paris, taking the place of the *jongleurs* of old; shooting the church, glorifying, identifying with the transcendent cathedral; never shooting at God.

Who was God? A white death mask, the decapitated *Gilles de Rais* of 1964, commemorates this associate of Joan of Arc, Satanist and child abuser, tried by ecclesiastical court in 1440.[31]

He seems to subsume in himself the heads of Kennedy, Khrushchev, Castro, Abraham Lincoln and Father Christmas, masks stuck to the 1963 study for the premonitory *King Kong* shoot-out (where the jets hit the skyscrapers). *King Kong*, we remember, is a love story. While Niki's own childhood traumas of the 'summer of serpents' was notionally repressed at this time, Gilles de Rais has a serpent on his brow; Georges Bataille's republication of the trial with the controversial editor Jean-Jacques Pauvert re-focused attention on the medieval atrocities in 1965.[32] In 1972 Niki started shooting the film *Daddy* with English film-maker Peter Whitehead: her family chateau setting situates the film directly in the pornographic lineage of the Marquis de Sade, Dominique Aury's *Histoire d'O* (1954), and Bernard Noël's *Le Château de Cène* (1969), but it is closer to a rampaging Ken Russell film fantasy. 'Agnes' (Niki) is played by Niki herself and actresses representing her at five, but also a provocative fifteen; mother Clarisse ("the one who did screw") was also a character. Whitehead – keen on the Electra complex – turned from documentary to psychoanalysis when shooting what he defined as a woman's means of revenging herself on her father's omnipotence ('Young Niki' replays 'blindfolding Daddy' before he is sexually humiliated and shot – with the *Death of the Patriarch* shoot-out painting as supplement); "we went back to the point when daddy did or did not rape her…perhaps she had tried to seduce him", said Whitehead. Niki concluded "I feel now that I am both man and woman".[33] Gestures towards contemporary anti-psychiatry which reflect the pansexuality of the times are more present in the film's carnival excesses than any psychoanalytic conclusion; but shown in London's Hammer Cinema with a revised world première at the Lincoln Center, New York, in 1973, this was yet another violent self-experiment which repeated – as did the *Tirs* – a self-catharsis.

Daddy, like God, never stopped haunting Niki:

Daddy was a church goer, said God could not be dead,
but his taste was not so Catholic with the girls he took to bed,
especially to virgins he played the host
whom he deflowered with the holy ghost
and for their first communion took their bodies and their blood

… Are you having a good time Daddy?[34]

30 See Jill Carrick, 'Phallic Victories? Niki de Saint Phalle's "Tirs"', *Art History*, vol. 26, no. 5, pp. 700–29, an article focusing on the Milan anniversary in 1970, which elevates psychoanalysis at the expense of the sacred and the blasphemous.

31 Kristeva makes a direct link between frenzied rites around decapitated skulls and the incest taboo in *Visions Capitales*, p. 27.

32 Gilles de Rais was tried in 1440 for having violated, tortured and murdered 140 children over an eight-year period, during Satanic rites. See Georges Bataille ed. and preface with Pierre Klossowski's translation from the ecclesiastical Latin, *Le procès de Gilles de Rais*, Paris, Jean-Jaques Pauvert, 1965.

33 Richard Roud, interview with Niki de Saint Phalle and Peter Whitehead, *The Arts Guardian*, 6 April 1973.

34 *Daddy – A Bedtime Story*, Argos films, 1972–73; transcription from video in St Phalle archives in Joanna Thornberry, 'Niki de Saint Phalle: Tirs and Transgressions', MA thesis, Courtauld Institute of Art, 1995, Appendix, p. 3.

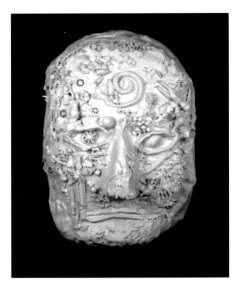

Gilles de Rais, 1964

[35] Hicks exhibited *Je savais que si je venais un jour, j'y passerai mes nuits*, 1972, wool and bobbin-work on linen, 4.70 x 9 m; *L'épouse preferée occupe ses nuits*, 1972, an 'envelopment' of wool, 5.20 x 2.60 x 0.20 m, artist's collection; in *Douze ans d'art contemporain*, Paris, Grand Palais, 1972, pp. 229–31; see also Sheila Strizler-Levine, *Sheila Hicks: Weaving as Metaphor*, London, Yale University Press, 2006.

[36] "Moi? Une sauvage? Elle a trouvé enfin une réponse, qu'une femme dans la civilisation des hommes c'est comme un nègre dans la civilisation des blancs. Elle a droit au refus, à la revolte. L'étendard sanglant est levé." Niki de Saint Phalle, Galerie Alexandre Iolas, 1965, in *Douze ans de l'art contemporain*, op. cit., p. 302.

[37] See T. Denean Sharpley-Whiting, *Black Venus: Sexualized Savages, Primal Fears, and Primitive Narratives in French*, Durham, NC, Duke University Press, 1999.

[38] In *Art News* 68 (March 1969 – February 1970), Nochlin cites two articles on women painters out of 81 major articles; in *Art News* 69 (March 1970 – February 1971), ten out of 84 (nine, including Nochlin's own, in the special January women's issue); and in *Artforum* 1970–71 five out of 74 articles on women. See Linda Nochlin, 'Why Have There Been No Great Women Artists? Thirty Years After', in Carol Armstrong and Catherine de Zegher, eds, *Women Artists at the Millennium*, Cambridge, MA, and London, MIT, October Books, 2006, pp. 21–32.

[39] For the Californian context see Meredith Brown, *School is a Place to Perform: The Art and Pedagogy of Judy Chicago's Women's Art Program at Fresno State College, 1970–1971*, MA thesis, Courtauld Institute of Art, 2007.

[40] Maryse Holder, 'Another Cuntree: At Last, a Mainstream Female Art Movement' (*off our backs*, September 1973), in Arlene Raven, Cassandra Langer and Joanna Frueh, eds, *Feminist Art Criticism. An Anthology*, New York, 1991, pp. 1–20.

[41] After the abortion debate in the early 1970s there followed the establishment of the MLF

The patriarchal assumptions against which Niki de Saint Phalle fought all her life were never more evident than in Paris in 1972, when she figured as one of only two women in the great retrospective held in Paris's Grand Palais, *Douze ans d'art contemporain*, popularly known as the 'Expo Pompidou' or '72 for 72', starring seventy men – a proportional representation that seemed entirely appropriate to the young exhibition organizers who still rule France's art establishment today. Left-wing feeling ran so high that many refused to participate in a 'State' exhibition (notorious for the violent confrontation between police and artists at the opening). Niki's commemorative Milan altarpiece was on show here, together with an upside-down Nana and the gothic, Miss Haversham-like *Bride*, which almost immediately entered the national collections. Sheila Hicks's large textile environments, displayed prominently and near the entrance, were also feminist statements, in their materials, their technique and titles.[35] But while Hicks chose anthropologist Claude Lévi-Strauss's text about her work for the catalogue, Niki added her own voice to appreciations by leading critics such as Pierre Restany: "Me? A savage? She has finally found an answer, that a woman in a man's civilization is like a black in a white civilization. She has the right of refusal, the right to revolt. The bloody battle-flag has been raised."[36]

Niki's sense of injustice rings with the contemporary resonance of the Black Rights movement in America: her great *Black Venus* (1967) would enter the Whitney Museum collection in New York: a celebratory, contemporary response to a theme with a long and vexed history.[37] (The Mouvement de la Libération des Femmes – the French Women's Lib movement – which demonstrated outside '72 for 72' was in its infancy). The proportional representation – two women, seventy men – corresponds almost exactly with the statistics Linda Nochlin gives, covering the context of publication of her pioneering article of 1971, 'Why Have There Been No Great Women Artists?'[38] But by now the American feminist context was exploding with the 1972 'Festival of Women in the Arts' at Cornell, the NOW conference on female sexuality, the Erotic Art Gallery. The discussion around overtly 'feminist' creations, the sexualized flowers of Georgia O'Keeffe, or Judy Chicago's classic *Dinner Party* 1973–79, became displaced by works that were more violent and more gender-sophisticated.[39] Bourgeois's *Cumulus no. 1*, with its white marble phalli, must be reimagined in its 1973 New York context of 'Metaphorical Cunts and Measured Cocks'.[40]

By the later 1970s, when Niki (like Jean Dubuffet) was involved with major monumental projects, feminism was finally making short-lived inroads into French art and society.[41] In 1979 the Galerie Yvon Lambert staged 'Artemisia', a homage to Artemisia Gentileschi, Niki's great precursor – a female artist raped. Artemisia's *Judith and Holofernes* (1567) seemed to the eyes of the late 1970s to transcend its Biblical subject matter with a personal energy of revenge. The show brought together conceptualism (Daniel Buren, Joseph Kosuth), Arte Povera (Jannis Kounellis), sensual painting (Cy Twombly) and staged photography (Duane Michels). In the catalogue to the exhibition, the philosopher Roland Barthes contrasted the structural simplicity of the core narrative with the variations through history of the apocryphal story of decapitation. It was artist Lea Lublin, however, who brought us back to Niki's similar beheadings, her open

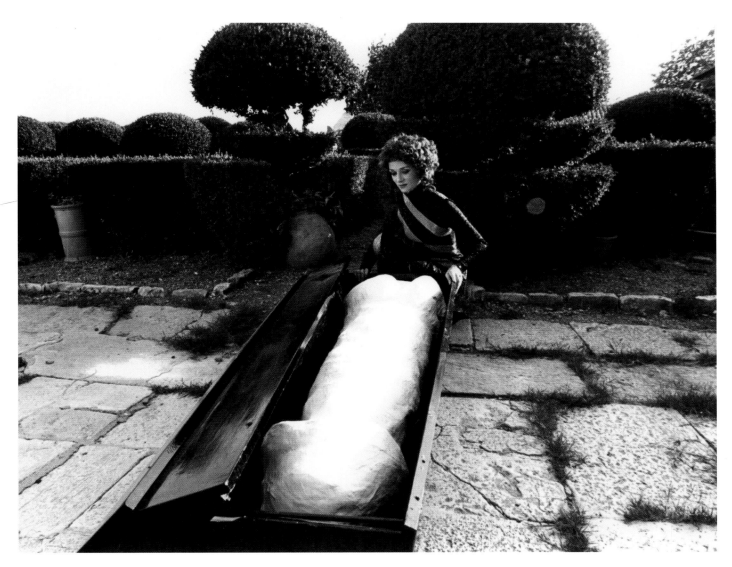

Film-still *Daddy*, 1972

(Mouvement de la Libération des femmes) and the group 'Psych et Po' (psychoanalysis and politics); the periodical *Les Sorcières* ran from 1976 to 1982; *La Spirale* was launched in 1972; and *Féminie-Dialogue* was held at Unesco in 1977. Following a Paris visit in March 1977, Lucy Lippard would curate *Combative Acts, Profiles and Voices*, at the A.I.R. Gallery, New York, including French feminist artists (but without Niki). See Thatcher, 'Menace à Trois,' op. cit.; the forthcoming PhD (University of London) by Rakhee Balaram, 'Femmes Révolutionnaires: Women's Art Theory and Politics in 1970s France'; Diana Quinby, *La collectif 'Femmes-art' à Paris des les années 70*, Paris-Sorbonne-1, 2003; and Marie-Jo Bonnet, *Le Femmes artistes dans les avant-gardes*, Paris, Odile Jacob, 2006.

wounds, her birth in death and death in birth: her *Tuez-moi – Tu es moi*. In Artemisia's beheading of her assailant, Lublin sees rape as a ghastly birth, the birth of the father:

Death scene, the staging of the body by the reversal of these fragments also shows up the scene of defilement, the rape scene, the castration scene, the birth scene, the birth…. In Artemisia G's picture, if the reversal of the centre of the painting moves and changes the image due to the course it takes from the murder to the birth it is because the two women in the picture, Artemisia and her double, hide a third who appears as the beheaded, bearded man. Within the limits of the picture's subject is the butchered, bearded man, the assailant of the biblical tale, the invader, the seduced and beheaded occupier, the father or professor of perspective, the disciple of the father-painter, the master of the laws of perspective, the rapist, the robber? Within the limits of the picture's subject is it the painter-woman who shows herself defiled, raped, sexed, bloody? Or her Other and her drives full of weighty prohibitions, of repressions, religious, symbolic, sexual? The desires and the ensuing unconscious processes unleashed, punishment, castration complex, guilt, putting to death, transgress the space of prohibitions, by denuding a body in order to show the course of desire and the limits of a symbolic space which cover it, which violate it, which erase it. Desires and prohibitions, prohibitions of incest, murder, guilt, throw us into the species' phy-

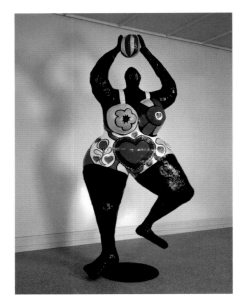

Black Venus, 1966–67

[42] Lea Lublin, 'Space Perspective and Forbidden Desires of Artemisia G.', in *Artemisia*, Mot pour Mot/Word for Word, 2, Paris, Galerie Yvon Lambert, 1979, pp. 51, 53 (bilingual, translation Diane Chrestien).

[43] Louise Bourgeois, 'Child Abuse', *Artforum*, vol. 20, no. 4, December 1982, pp. 40–47, and cover.

[44] Niki de Saint Phalle, *Mon secret*, Paris, Editions de la Différence, 1994 (written December 1992). See Thornberry, 'Niki de Saint Phalle', Chapter 1, and Natasha de Samarkandi's unpublished essay '*Mon Secret*, rereading Niki de Saint Phalle', with first translation of the text, Courtauld Institute, 2007.

[45] Pontus Hulten, ed., *Territorium Artis*, Bonn, Kunst-und-Ausstellungshalle der Bundesrepublik Deutschland; Bonn, Verlag Gerd Hatje, 1992, English version. Niki's *King Kong* altarpiece (pp. 316–17) was exhibited in the show, together with two objects by Meret Oppenheim and one piece each by Jenny Holzer and Rebecca Horn.

[46] Pontus Hulten, 'Working with Fury and with Pleasure', in *Niki de Saint Phalle*, Bonn, Kunst-und-Ausstellungshalle der Bundesrepublik Deutschland, 1992; English version, p. 13. (The show toured to the Glasgow, McLellan Galleries and Paris, Musée de la Ville de Paris in 1993).

[47] Barbara Rose, 'Earthly Delights', *US Vogue*, December 1987, p. 365.

[48] See the superb catalogue *Niki de Saint Phalle & Jean Tinguely*, *L'art et l'amour*, 13 April to 24 June 2007, Centro Atlantico de Arte Moderno (CAAM), curated by Alvaro Rodrigues Fominaya, with a text by Bloum Cardenas (English translations).

logenetic memory, its law, its taboos, and its traces which persist or which reappear there where they warn us of the appearance of their symptom.[42]

It was two whole years later, 1982, and an entire decade after Saint-Phalle's *Daddy*, that Louise Bourgeois – the first female artist to have a retrospective at the Museum of Modern Art, New York – launched her late career and the big bang of contemporary scholarship with her *Artforum* article 'Child Abuse'.[43] That moment might now appear reframed – or at least interestingly enriched – by looking at artists and criticism from Europe.

Niki's book *AIDS: You Can't Catch It Holding Hands*, published in 1986 while she was working on her Tarot Garden in Garavicchio, was subsequently translated into five languages. The desire to 'come out' on behalf of young victims of abuse was at the heart of *Mon Secret* (1994). Yet this confessional book, framed as a letter to her daughter Laura, in Niki's loopy, childish handwriting, remains an untranslated secret. Two decades after *Daddy*, she tells the story of the 'summer of serpents', her violation at the age of eleven in 1942. (*Tu es moi – Tu es à moi*: You are part of me – You are mine: the very core of the incest taboo.) It is the passionate denunciation of rape: the massacre of an innocent.[44]

The discretion of this 'secret' and the lack of critical literature on Niki until recently contrasts with the public visibility of her later works, the 'Niki' style associated with the products generated to finance the Tarot Garden (her ultimate monument to Gaudi and the Facteur Cheval) and herself. A visibility ratifying invisibility: never more so than when, in 1992, Pontus Hulten's retrospective *Territorium Artis*, inaugurating Bonn's major new art museum, looked back at the 'art of our century': ninety-six men, with Niki shown comprehensively on the roof of the building – the bride floating above the bachelors as in Montreal, 1967.[45] In his introduction for her Paris retrospective in 1993, Hulten declared: "She looks at what the great artists of modern art preceding her have produced. With innocence, like a blithe spirit, she borrows from them, as if she were picking flowers in a beautiful garden…".[46] The magnificent Stravinsky fountain, outside the Pompidou Centre, a Niki and Jean Tinguely collaboration, belies the uneasy consensus within. Why does Niki still need rediscovery in and beyond France?

"I always find it strange that though my personality, my accent, my attitudes are so American and I was raised in New York, no one thinks of me as an American artist, which is what I really am".[47] Is Niki far too French for a third generation of feminist art historians in 2008? (There is not a trace of Niki in the influential publication *Women Artists at the Millennium*, 2006). Are her love stories, her hate stories, and in particular her loving and working partnership with Jean Tinguely, too strong to rate in its often too separatist stakes?[48] Marcel Duchamp, Niki de Saint Phalle, Louise Bourgeois: all work with their twinned French and American identities, the clash of cultures and languages. As with Bourgeois, Niki's vivid personal memoirs add a supplement to the psychoanalytic interpretations we can bring to her works.

With *Traces, An Autobiography. Remembering 1930–1949* (1999) and with *Harry and Me, The Family Years, 1950–1960*, published posthumously in 2006, Niki was able to create her own family monuments. The Bad Mother is redeemed (Harry Mathews pays compliments to Niki's selflessness), her own strict

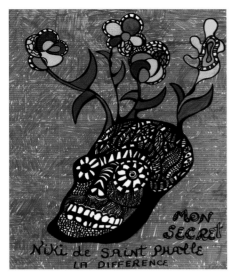

Cover of *Mon Secret*, 1994

mother is saluted, the wife, the good lover, the imaginative, violent child, the artist are celebrated, as is the determination to make paintings, assemblages, sculptures, grottos, gardens, homes, and, with the *Hon*, to make a cathedral out of herself.[49] The sacred and the profane, the masculine and the feminine, love and hatred, *Tu es moi*, *Tu et moi*, *Tuez-moi* – and the joy of representation (our sole remaining link with the sacred, as Kristeva says) all are here. In speaking, too, of "*serenity* resulting from the pact of identification between the sacrificed and those who sacrifice", Kristeva allows a conceptual space, the space of this pact, for the innocent, the celebratory and festive dimensions of Niki's immense later *œuvre*, produced with the convictions of an epoch whose mantras of love, peace, liberation, color are apparently so far from our own. Our preoccupations are darker, more cynical; we exist in the shadow of the black sun.

Bad enough, brave enough, good enough: Niki de Saint Phalle takes her place with the GWAs (Great Women Artists) of the twentieth century.

Thanks, as ever, to my students and to the staff of the Bibliothèque Kandinsky, Musée National d'Art Moderne, Centre Georges Pompidou.

[49] See Niki de Saint Phalle, *Traces*, op. cit, 1999, and *Harry and Me, The Family Years, 1950–1960*, Bern, Benteli Verlag, 2006.

The Arcana Garden

Marella Caracciolo Chia

Dear Niki, you asked me some time ago to write down a brief 'memoir' of that vivid period when you came to Garavicchio, our family country home, and started work on the Tarot Garden. "I would like to know what it was like for you, a young girl, to experience this adventure". Those were your words, more or less, a few months ago. I was delighted at the idea of going back in a structured way to those wonderful years of my life, that strangely exposed time in between childhood and maturity, which were permeated by the freedom of knowing you and spending time at the garden. I was twelve, when I first met you. You were forty-seven.

As I go back to that time starting in 1977, the year you first came into our lives, many images and feelings flood through my mind. I remember one time in Garavicchio, a small, white maquette on the table (the very first seedling of the tarot garden) and you explaining to my father, Nicola, and my uncle Carlo why they should give you a piece of land on which to build your dream project. You were so passionate in your elaborate explanations. Your hands, drawing large invisible shapes over the tiny maquette, and your words made the vision come to life within our minds. I think you charmed them also with your beauty, for the men in my family have always had a sensitive eye for beautiful women. By the end of the afternoon the land was yours. A long-forgotten piece of rocky soil in the deep mesh of unattended woods.

I remember your femininity and beauty. Your collection of dresses. Pink fuchsias, electric blues, polka dots, animal prints, reds, oranges, tartans. Everything you wore became an extension of you. You were like an alchemist, transforming objects and spaces that you came across. Sometimes you would give me a dress of yours to wear. It made me feel beautiful and strong just wearing it! And the hats, of course. A hat for every hour of the day, with feathers, artichokes, roses and other bits and pieces of things you liked. Thinking about you and the times spent at the Tarot Garden has brought back other seemingly unrelated memories. Memories of my life, in Rome, where I went to school. Those were the infamous 'lead years' *gli anni di piombo*, tainted by endless political tensions, terrorism, the death of Aldo Moro at the hands of the Red Brigades. Policemen armed to their teeth, machine guns strapped across their chests, were a common sight at nearly every corner. Violent demonstrations were a bleak weekly ceremony. Instead of reading Plato and Socrates, I remember being taught how to make a Molotov cocktail, a simple fire bomb made with gasoline and a glass bottle, by our philosophy teacher. And smoking joints in the corridors with the teachers during class breaks. It was a time of great social upheaval, too. The battles for and against abortion, the referendum for divorce. Environmental issues coming to the surface. Though it was an exciting time of change, I remember my deep feelings of rootlessness. The Tarot Garden became a sort of refuge for me, and you a helpful guide. All these things have been the foundation of what I regard as the very special friendship that grew in those years between you and me.

I have many good memories of time spent with you, in Garavicchio, as the Garden was taking shape. Winter afternoons walking around or having lunch

Tarot Garden

with members of the crew in the belly of the *Sphinx*, where you lived and worked for many years. Evenings by the fire. You offered so many answers. Do you remember the times I would ask you to read the tarot cards for me? Sitting in the dappled shade by the table just outside the sphinx, trembling with fear and excitement, I would ask the classic 'teen' questions... will I find love? Will I be happy? Will I find my guiding spirit? What shall I become? For every question you had an answer filled with wisdom and hope. Even the worst cards of all, the dreaded *Tower* or the ominous Moon, were made tolerable by your words. Death itself, on his ghostly horse, was never a clear-cut negative. "It marks a new beginning...life is perpetual motion, you cannot stop the flow, just learn to float" would be your words. You always saw the bright side of every situation. Even in the most complicated moments of your adventure with the Tarot Garden, in the midst of health problems or bureaucratic complications, you always knew how to keep your head above water. There was no fear allowed in your vision, only a sense of challenge and a good sense of humor. "If the worst comes to the worst you will have learned something important!" you would say. And of course you were right.

I have enjoyed these days spent basking in the sweet memories of my adolescence. I have enjoyed visiting with my mind the old places and the friends I have met through you, Antoine, Ricardo, Jeffrey, Venera, Philippe and Bloum. How much happiness you brought with you. How much space. I will always be thankful for that. You came into our lives like a Hindu deity, a feast for the eyes and the mind. You touched our lives. Especially mine.

Love always,
Marellina

Memories

There is not one particular moment, fixed in time, where I can place my first memory of Niki. I know I met her sometime in 1977, the year she first came to Garavicchio. I know my aunt Marella Agnelli was there. She was Niki's great friend and when she heard of the project (Niki was wondering where she could do it), Marella proposed Garavicchio, the property in southern Tuscany that her father had bought in 1960 and which now belonged to her brothers Carlo and Nicola (my father). Garavicchio is a yellow house on top of a hill surrounded by olive groves and overlooking a vast piece of land that stretches all the way to the sea. It is somewhere in between an old farmhouse and a very unpretentious villa. I think my grandfather bought it because, though it was close to Rome, it was isolated and in a wild and relatively untouched region: Maremma.

When Niki first came to Garavicchio she found a friendly and dynamic environment. My uncle Carlo, a publisher, had recently founded with his friend and collaborator Eugenio Scalfari the daily newspaper, *La Repubblica*, and was basking in its unexpected success. My father Nicola, a television journalist and historian, was becoming increasingly involved in environmental issues and was soon to become one of the leaders of the movement that led to the abolition of nuclear energy in Italy. Rossella, his wife, was heavily pregnant and about to give

birth to my brother Filippo, an event that was to bring great joy to our lives. And the presence of Violante, my uncle's lifelong companion and wife, added a dimension of warmth to the house and garden that bloomed under her attentive care. The atmosphere in Garavicchio was very fluid, youthful. There was no sense of private property. Friends (many writers and journalists) and family members would drop by, often unexpected, and take part in the delicious meals, cooked by Derna, or the long conversations which usually took place under the porch with the pergola, in summer, and deep into the small hours of the night. I remember animated discussions over politics, ethics, literature. Terrorism and divorce were the big issues of the day. Many jokes. Many drinks, especially whisky, many games of chess. It was a friendly atmosphere, relaxed but a little too cerebral, perhaps.

Niki was different. She was spectacular, something from another world. Unlike the slightly self-conscious simplicity of the majority of our guests, Niki exuded a love of ornament and excess. Multicolored silks and patterns adorned her perfect body. She always had odd bits and pieces floating about her a scarf by Jean Tinguely, a gigantic hat, a glittery hand-bag, a gold or silvery coat or anything that caught her imagination. She loved clothes that were shiny and visible, I guess, and funny. Her glitzy style reminded me more of a rock star than an artist. Children, adolescents, are very sensitive to beauty and style and I was awed by Niki's. At forty-something she looked incredibly youthful. She still does now that she is a great-grandmother! She had perfect skin, unblemished. I remember its transparency, the way it stretched evenly on the surface of her fine bone structure, and the thin blue veins beneath it, on the temples, the neck and hands, giving one a false impression of fragility. This brittleness in body was further enhanced by the fact that she had been very ill and was recovering from a debilitating lung ailment caused by years of breathing the fumes of synthetic paints, something that also apparently caused bouts of painful arthritis in her hands. Her eyes were beautiful. Green cat eyes full of irony and humor. I was also struck by her voice, a surprising blend of deep, husky tones and high-pitched laughter.

I don't remember the first day because, as memories often do, it has melted into many other days similar to that one. She probably arrived in the morning with Marella. She would have walked into the bustling atmosphere of the kitchen and met Derna, the cook, and Grazia her daughter, who in the course of the years would become an important point of reference for Niki. Then she would have gone into the house, through the dining room and, since I think it was a warm day in spring, through the garden and onto the porch. There she would have found the rest of the family and some guests. In the dappled shade of the porch, looking onto a lawn and two beautiful linden trees, they would have chatted, drinking a glass of fresh tomato juice and eating some hand-cut prosciutto and cheese. I was a shy twelve year-old and an only child (my brother was not yet born), and would have listened. As was usual, there were certainly some dogs on the scene.

After lunch and some good wine, we all went for a walk to explore the territory in search for a spot where Niki could build her sculpture garden. I remember

there were two choices. The first was a large, natural amphitheatre not far from the main road leading up to the house. This is an imposing site, with lots of rocks piled next to one another in a massive semicircle. It is easily accessible but with no views of the surroundings. The other place was in a smaller area higher up on the hill. Like the first spot, this too had the shape of a natural amphitheatre, but smaller and enclosed by a thick vegetation of oak trees and wild shrubs, mostly juniper and broom. If one stood at the highest point, however, one could take in a wondrous view of the fields and the sea beyond. This is a very special place, where I spent many of my early childhood wanderings. A secret place, somewhat forbidding to a vivid imagination. Many nooks and crannies in which to hide. I think Niki liked the idea of weaving her sculptures into the richness of this Mediterranean vegetation. I also think the history of this particular spot appealed to her. Some years earlier, two Etruscan tombs had been discovered on this same spot. This infused it with a mysterious, ghostly aura that Niki liked. I believe she felt inspired by this link with the mythical Etruscan people and the fact that it had been a burial ground, a sacred place. Death leading to life. All this would have appealed immensely to her symbolic imagination. It gave to the whole project an extra dimension, linking it to the world of myth and the supernatural.

I am afraid that this 'magic' element is what attracted me most, at first, to Niki. She seemed like a messenger of a free-roaming spirituality: a welcome alternative to the rules of the Catholic faith I was accustomed to. At that time, like most healthy adolescents, I had a severely split personality. On one hand I declared myself to be an atheist. On the other, I was a closet Catholic, reciting my prayers secretly every night before going to sleep. I also dabbled with the occult and was fascinated by astrology and reincarnation. I found food for thought in the family library, at Garavicchio. There is a whole wacky section, in our library, devoted to occult sciences. We owe this to a great-great-grandmother, British, who married a Neapolitan aristocrat, my great-great-grandfather. She was a vegetarian and a devout Buddhist who had the determination to create a home for stray cats and dogs in mid-19th-century Naples! Other books, on theology, reincarnation and astrology, are the legacy of my grandmother, Margaret Clark Caracciolo, mother of my father and of Carlo and Marella. I spent many wonderful hours of the night in this library, smoking cigarettes and reading everything esoteric I could lay my hands on. When Niki arrived, she was a live alternative to these dusty books. She seemed to embody many answers to my questions. I became a captive of her practical vision of spirituality. I loved the idea that we are like racing horses and that life is like a racetrack with many obstacles we have to overcome. The Tarot Garden itself was, in my memory of conversations with Niki, a sort of initiatory journey.

Most important of all, Niki read the Tarot cards to me. I think our friendship blossomed during these frequent readings. When she was living semi-permanently at the Tarot garden, it must have been around 1979, I would go there as often as I could, during weekends and holidays, and confide all my secrets. She loved listening to my hopes and tribulations! In fact I don't think I ever found such an attentive and wise listener. That, of course, (I was fifteen) was the time of my first devastating crushes. Unlike friends and family, Niki had no prejudices. Her

vision seemed to me clear and good-natured and the Tarot Garden soon became my favorite hiding place, my refuge. I would spend hours pottering around there, playing with Niki's colors, reading her books, walking around. I was not alone in doing so. Federico, Grazia's son, who is younger than me, loved spending time with Niki. Also Edoardo, my cousin, would come and talk to Niki and walk around her garden. As it grew and blossomed with sculptures, the garden became more and more welcoming.

The Tarot Garden was our private theater, our stage. There was always something happening, people coming and going, fascinating characters. I remember Edward James, coming in from his self-proclaimed reign in the Mexican jungle with his young Indio toy-boy. He was one of those Somerset Maugham type sophisticated Englishmen, well bred, well-read who had ended up in the tropics and in doing so escaped the restrictions of his upbringing. In Mexico he created a fantastical architecture, a sort of temple in the woods where he lived like a pagan king surrounded by servants and wild animals. A world of his own.

Then I remember meeting that wiry, electric Scottish painter, Alan Davies, who looked as if he had dropped out of Woodstock's 1960s acid culture…. He had a long white beard, wavy hair and a somewhat psychedelic look in his eyes. He lived inside the *Magician* and painted the walls with his esoteric symbols. This was long before New Age. Then, of course, there was Jean Tinguely, who oc-

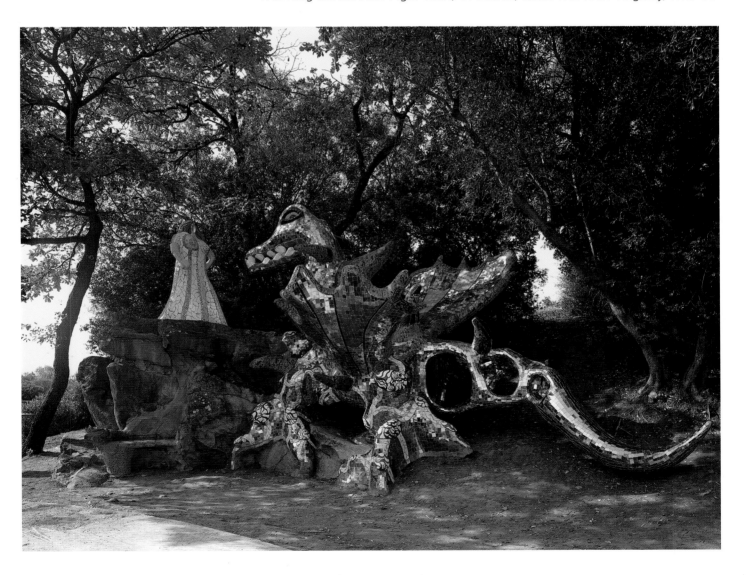

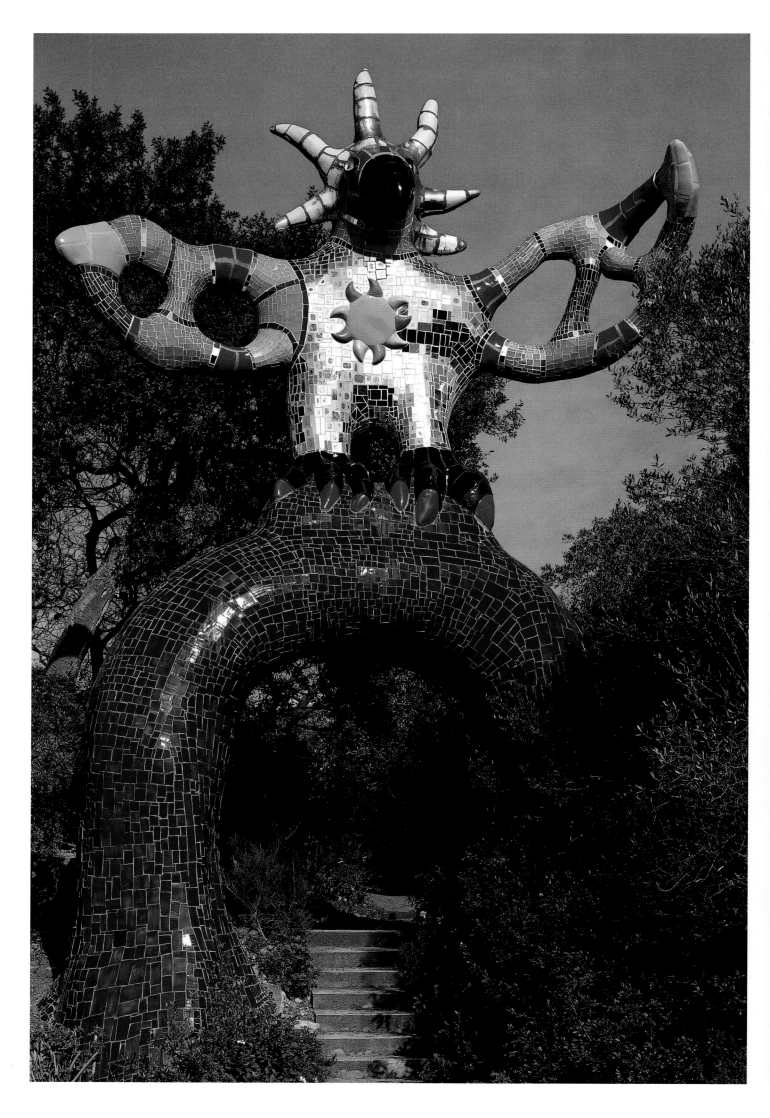

casionally came to Niki's Tarot Garden to install one of his sculptures, give some advice or simply fix something and lend his technical expertise. He was a dynamo of energy, a very different energy from Niki's, very manly, restless. I remember his love of fast cars, motorcycles, engines. He was like a boy, taking things apart, rebuilding them, making them work. He liked to surround himself with big, hairy, devoted men who spoke little but got the job done. I think he trusted men, although he loved women. And they liked him.

But the greatest adventure of all was seeing the garden grow. Every Friday afternoon, as we would arrive by car at Garavicchio, my father, Rossella and I would try to discern changes in the structure. At first it was a complex iron grid. A marvelous welded web, like gigantic spaghetti twisting and turning amongst the trees and rocks creating wonderful forms. The *Emperor* came first, its big mouth opening wide into a cave. A large staircase, in iron, unraveled out of its mouth and all the way down into what would become the fountain where the wheel of fortune is placed. A gigantic iron snake stretched out on the left. Above the head of the *Emperor* was a smaller head. This was the *Magician*. A hand grew out of its brain, imagination. I seem to remember that Niki identified with this figure most of all. Week after week, other figures began to emerge: the *Empress*, in the shape of a gigantic sphinx with massive breasts and a small, dainty head, then the *Sun*, in the shape of a bird-totem spreading its wings over the arched entrance. People loved this iron structure, so transparent, so anthropomorphic. I even think my father tried to convince Niki to stop there and keep it that way. Its tangled web tied in perfectly with the surrounding vegetation. You could climb into it, penetrate it and yet see through it. Children loved it. Niki liked it too, but then decided to go on. I remember when a thin iron mesh was placed on the grid and then Jean Tinguely arrived with his macho team and poured tons and tons of liquid concrete. It was like a pagan feast.

At first Niki wanted to leave out the strong artificial colors and materials of previous works. She loved the idea of experimenting with natural materials, organic colors. I remember her looking at some local stones. She looked into the possibility of using round pebbles from nearby riverbeds. I think that this was when the idea of creating a mosaic first occurred. Using natural materials turned out to be far too expensive, so she eventually resorted to doing her own tiles. An oven was built on site and tiles began to be churned out at a dizzying rate. There was a very experimental attitude to her work, a sense that no one really knew where the adventure would take her. Humor was a major theme. Niki decided to cover the sphinx-shaped *Empress* in pink tiles. All pink, except for the head. At one point, she even raided all the drawers of women in and around Garavicchio. She was after their old linen, ancient bits and pieces of lace. These findings were dutifully surrendered, but not without suspicion. They were laid onto the soft, unbaked surfaces of the tiles and pressed into until their intricate pattern left their imprint. Then they were fired and painted pink.

I fell in love at the Tarot Garden. I was fifteen and Antoine, a tall, handsome, blond, blue-eyed Adonis, was twenty. He was working on the garden for the summer. It must have been the summer of 1979. Antoine was desperately good looking (or so he seemed to me). He was a broody soul and seemed angry with the

whole world, something which added remarkably to his charms! We talked in broken English tinged with French. He came from a complicated family background (one grandfather was Matisse, he said, the other was Duchamp, but I never found out if it was true or not). He had had some problems and accepted Niki's job offer in order to escape. He had also worked in a circus, which made him particularly irresistible to my eyes. He was a whip expert, and a very skilled one too. He could cut an apple in two with his whip. He never used it on me, though! He was also a compulsive reader, though it was the same book he read over and over again. It was by Blaise Cendrars. He said that book contained everything he needed to know about life. A copy was slowly disintegrating in his pocket. The summer Antoine spent at the Tarot Garden was also my last summer at home.

I fell madly in love with him and would spend every spare moment I could visiting him at the sculptures. He taught me to weld iron. We worked on the *Magician* together. He made me weld the magician's right eye and eyebrow and a part of the hand. I loved it. I wore an orange welding suit and a mask to protect my eyes from the glare and the sparks. I remember the hot glare of July, the humming of the birds, the buzzing of the flies in between the deafening noise of welded iron. I remember the minutes of complete happiness as we relaxed after a long day's work on the small terrace of the *Magician*. The hard iron grid seemed to hold us up, above the rest of the world. Taking in the stunning view of fields, hills and sea, we would fill our young lungs with cigarette smoke and the smell of juniper from the woods around us. I never showed my feelings. Antoine left one afternoon at the end of the summer.

I have always admired Niki's dealings with men. I have met many men with her in the course of these twenty or so years. Most were young and attractive and more often than not they were creative and independent. I remember Constantine, a talented British writer. Very aristocratic and rich. He must have been twenty-three or twenty four at the time. Niki was in her late forties. He was utterly devoted to her, and full of charm. The age gap did not seem relevant. Having seen and heard about many broken-hearted women in my surroundings, and many Don Giovanni men, I found this vision refreshing. Here was a beautiful woman who did not fear her years, who looked at life on her own terms and did not necessarily need men, although she undoubtedly liked them around! Some of these were talented and amusing. Others were completely star-struck by her. These ones did not tend to last very long. Perhaps the only times I saw Niki in a more conventional role, as a woman, was with Jean. It was a sort of charade, I think. We could sense his imminent arrival just by looking at her, all made up, beautifully dressed and somewhat aloof. I think there was some sort of play-acting that went on between them. She played the Damsel in Distress and would ask for the assistance of her Prince Charming. He would storm up in one of his powerful racing cars, a couple of assistants in tow, and an aura of perpetual motion. I don't have many memories of him, though I remember his rugged good looks, his unabashed masculinity, his total lack of innuendo and conventional politeness. He liked his cigarettes. He had a raucous laugh. He would walk around the Tarot Garden inspecting things with a critical eye. Niki would

Tarot Garden
Wheel of Fortune

walk near him in silence. He would repair things, at times. Often he would reveal his admiration.

I met many wonderful people at the Tarot Garden. I remember Ricardo Menon, Niki's long-time assistant and friend. He was a boyish Argentinean who lived for some time, one or two winters, in our house in Garavicchio. That was before the *Tower* in the garden, where he lived for a long time, was built. He was charming and gay, although this last detail never went down very well with the women who lived and worked in Garavicchio. Derna in particular, the seventy-something year-old cook, simply refused to believe it! He brought a lot of laughter into the house during those winters. He died in 1989 and his photograph is in the chapel Niki built in the Tarot Garden.

Once with Giulio Pietromarchi, my childhood friend and author of the many photos in this book, we spent a week in Paris at Ricardo's tiny apartment in the Rue de Seine. We were fifteen years old and that was our first trip alone. We lost all our money gambling at the Marché au Puces, and had to take the metro back home without a ticket. We got caught and had to give our last liras to an angry man in the metro. We phoned home in desperation and Niki, who was at Garavicchio at the time, came to our rescue. She phoned some of her favorite restaurants in Paris, and told them to wine and dine us at her expense, and in great luxury, during the rest of our stay in Paris!

Then there was Niki's family. Laura, her quiet and thoughtful daughter, and Laura's son Philippe, who became a friend over the years during his many visits to the Tarot Garden. There was Bloum, Niki's wild and warm-hearted granddaughter. And of course the crew: Marco, Ugo and Tonino. At first Niki had difficulty communicating with this team of local people so she decided to learn Italian. She played diligent student for many months, going all the way to Capalbio where she found a schoolteacher who gave her lessons. She had her books and did her exercises until she felt free to communicate anything that would be useful for the making of her garden. This is a small detail but one that always impressed me. Niki had a will of iron and a quiet determination in everything she did. The way she overcame difficulties (and there were many along the way) was a great inspiration. Nothing was impossible, nothing out of reach.

This creative energy of Niki's is contagious. It tends to include people rather than exclude. This is why there are always so many people around her. Friends, assistants, family. People love to lose themselves (or maybe find themselves) within one person's charismatic creative energy. In March 1999, I went with my father and Rossella to visit Niki in La Jolla, California, where she is now working and spending much of the year. She says the weather there is ideal and makes her feel quite healthy. We stayed in her Spanish-style villa not far from the ocean. Niki bought it because it had a huge ballroom, created in the early 20th century by some extravagant English admiral who loved to dance. She made this space into her studio. Doors and windows open up onto a patio filled with palm trees and cacti. Here, like elsewhere, I recognized the classic Niki environment. Controlled disorder everywhere, drawings lying on various tables, maquettes, testimonies of many ongoing projects. Here, like elsewhere, I recognized the signs of true devotion in her assistants, many of whom I had never met. In the midst

of all this bustling activity with people coming and going, Niki seemed almost untouched. I have always been fascinated by her relationship with her surroundings. On one level she puts few filters between herself and others. I have always seen her live and work in large sunlit spaces where people, whether assistants, friends or passers-by, feel free to roam around, chat, look and leave. Here in La Jolla it's the same. Many people come and visit Niki. On this particular occasion Bloum, Niki's spirited granddaughter and friend, is here with her incredibly bright and handsome son Djamal. I suspect Djamal is the apple of Niki's eye. He plays rambunctiously with her colors and papers, climbs on her sculptures, capturing her attention with some incredible stories of extraterrestrial attacks, and makes her laugh.

Laughter is a sure key to Niki's heart. She loves to laugh! Once, during a bout of painful arthritis, she managed to find, God only knows where, a doctor who said that the only cure was laughter. She bought one of those dreadful laughter bags and recruited whomever she could find to lend a supporting laugh. I will never forget the experience, the slight embarrassment of finding myself with part of my family, some astonished members of Niki's crew, some children and some serious guests all trapped in the belly of the sphinx listening to the laughing bag and trying to imitate it. Cold, polite smiles of circumstance turned into surprised merriment. Niki had no restraints and led the way with loud cackling bouts of giggles. In no time we were all howling with laughter, almost wetting our pants. Niki recorded this laughing session and from then on used it regularly twice a day to laugh away her pains. She swore by it. I would join her for these laughing sessions whenever I could and was never alone in doing so. When Niki lived in the *Sphinx* she spent practically all her time in the garden. In the daytime workers would meet there to drink coffee or discuss the project, what had to be done. There seemed to be no filters between herself and the garden. I can imagine a similar intensity must occur while shooting a film or staging a play, except that work on the Tarot Garden lasted twenty-three years and is not over yet. Never will be either, says Niki. Every time she comes back she adds or changes things a little. And the crew is happy. They love the energy she brings to the garden.

I have always been fascinated by Niki's ability to bring out the best in people. She found many young people in nearby Capalbio and she infused in them a curiosity and a devotion to their and her work. Made them feel part of something special. Marco was almost a boy when he came, and had a naughty reputation amongst the locals. He became one of her most devoted assistants and is proud to show people around the garden. Ugo was a middle-aged postman when Niki arrived. He started working on the garden in his free time and became so obsessed with the complexity of the tile work that he apparently stopped delivering the mail regularly. When he finally retired he was happy because he could finally spend all his time at the garden.

When they are near Niki, people feel free to be themselves. I, as an adolescent, would lose all pretences and uncertainties as soon as I entered the garden. I will never forget the joy of afternoons spent in the *Sphinx* smelling Niki's

scents, working with her colors, trying on powders, drawing, eating, walking, talking. She has the generous capacity to make everyone – EVERYONE – feel not only welcome and at ease, but useful. She likes to talk with people and ask their opinion and bounce ideas off them. And we all had the feeling that we were part, a small part perhaps, of that ongoing creative process that was life with Niki. It has been a wonderful blessing, for me, to grow up knowing her. She has been my bridge to the outside world and made my departure from the safe shores of childhood a little less final. Things have changed in Garavicchio. The generation of my father has grown a little older. My brother is no longer a baby but a 23 year-old student. The family has extended and many new faces and squeaky little voices have found a place under the shade of the porch. The garden is a favorite place to go. I am no longer the somber adolescent Niki knew, but a mother and wife. Yet, every time I go back to the Tarot Garden (and I go whenever I can) I find my own childhood spirit unchanged. I realize, walking around this captivating garden, that she was and is a great model. She has taught me independence and the importance of avoiding facile definitions. "This is a great time to be a woman," I remember her saying to me once, "you can be whatever you like." It's been good to grow up knowing Niki.

Jacaranda Caracciolo

Memories from the Enchanted Garden

Niki de Saint Phalle arrived for the first time in Maremma, on our Garavicchio estate, on a cold afternoon in the spring of 1979. She had come from Ponza, where she had passed a few days on vacation. She had a sun tan and was, as usual, quite elegant, wearing a sophisticated green leather trench coat. My father, Carlo Caracciolo, and his brother, Nicola, were waiting for her. They didn't really know Niki and yet they were anxious to meet her. As it turned out, for Carlo and Nicola, Niki's visit was the prelude to an adventure that would be exciting to say the least. While convalescing in St Moritz some years earlier, the artist had met Marella Agnelli, Carlo and Nicola's sister. Niki told Marella about her desire to find a place where she could build her dream: a gigantic sculpture park inspired by Gaudí's mythical Parc Güell. Listening to the artist's stories, Marella became excited and spoke with her two brothers about it. They all agreed that Niki's imagination could find its proper setting at Garavicchio, the family's property located a few kilometers from the town of Capalbio in Maremma.

This idea, which today may seem trite, was revolutionary at the time. Today, Capalbio is the epicenter of an intense socio-cultural and sophisticated life, with many exhibitions, openings, and parties being held during the summer months. But back in the 1970s, the place was just an out-of-the-way corner of Maremma, a few kilometers from some fashionable sites at the time, like Porto Ercole and Porto Santo Stefano, two fishing towns located on opposite sides of the Monte Argentario peninsula. As a child, Carlo always used to tell me that when his father Filippo had decided to buy that hill of stones and olive trees close to the sea he was considered a true pioneer. Vacationing in Garavicchio was itself considered an extravagance worthy of consideration. The idea of building a park with gigantic sculptures inspired by the Major Arcana, which would later be visited by tens of thousands of people from all over the world, was unthinkable. Yet on those days in the spring of 1979, while Carlo, Nicola, Marella, and Niki strolled along the dusty paths of Garavicchio, the miracle began to take shape. They still weren't aware of it, but that somewhat casual encounter would give rise to a cultural partnership and to the birth of what is today considered one of Italy's most important contemporary works of art: the Tarot Garden.

During that first visit, Niki attentively inspected the hill of Garavicchio as she searched for a spot suited to her needs, until one morning she stumbled upon the old stone quarry next to the centuries-old olive grove that covers the entire hillside. The quarry is a gigantic amphitheater that provides a perfect backdrop to the enormous creatures Niki had in mind.

The adventure had begun. Niki left but had promised to return within a few short weeks. And that's how it went: in November the bulldozers started tearing away the brush around the quarry, closely following the directions of Niki, who was more energetic than ever.

Beginning in the early 1980s Niki spent much time at Garavicchio; here she became part of the everyday life of the small country farmhouse where, even today, we spend every weekend and our vacations. At first Carlo and Nicola asked Niki to stay in their home; she was assigned a lovely room overlooking the sea,

furnished with flowered curtains and two large canopy beds. On account of his work, Carlo lived in Milan and Rome, so he would be around only on the weekends. Grazia, our governess, the daughter of Canzio and Derna, our estate's longstanding farmers, took care of Niki. Indeed, she was the one who, with admirable precision, oversaw Niki's daily routine. "She always woke up at 8 am. She'd come down for breakfast and then go to work at the quarry, always in a good mood," recalls Grazia. "She would appear for half an hour at 1 pm, just to have a quick bite, and then she'd disappear again." That's how everyone at Garavicchio – from the farmers to the gardeners – became accustomed to seeing that petite figure, wearing gaudy pants, polka-dot or striped socks, and a big hat full of flowers, on her constant trips back and forth between the house and the work site.

In the first few years Niki's dedication to the garden was total. She was surrounded by assistants and helpers, and every now and then her husband, Jean Tinguely, would arrive. He'd stay a few days, work incessantly, and then leave. Little by little, like in a dream, Niki's gigantic creatures began to take shape: the *High Priestess*, the *Magician*, the *Sphinx*, and so on. In order to satisfy the growing needs of the work site, a kiln was built where the Roman potter Venera fired the tiles that were used to cover the Tarot sculptures.

Exactly three decades have passed. During this time, every year up to the day she died, Niki and her team gave life to works that were more and more amazing. Today, our chicken coop has taken the place of the kiln. And over the

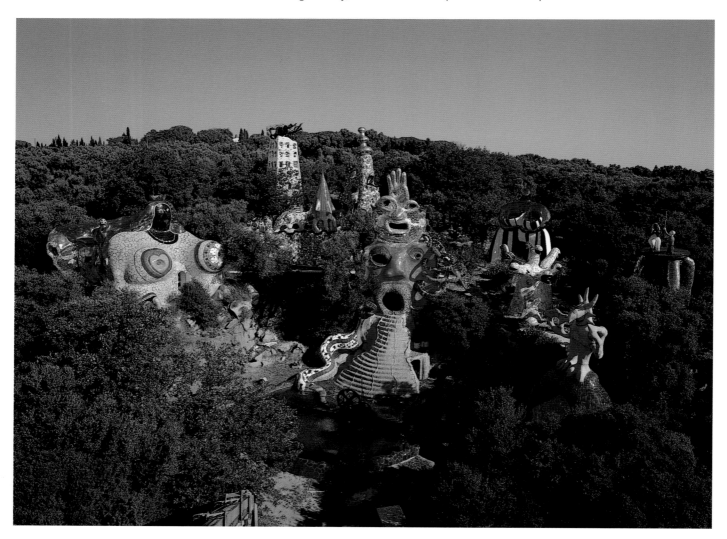

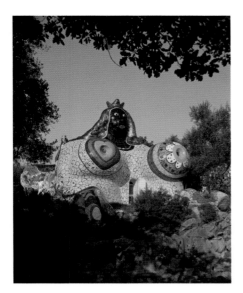

Tarot Garden, *The Empress*
© Niki Charitable Art Foundation,

years the Tarot Garden has become a cult destination for art lovers and the curious.

For us here at Garavicchio, it's still a corner of paradise we run to when we want to escape from reality. A small iron gate still stands at the edge of the garden, which allows entry even when the park and the ticket booth are officially closed. For my children Alessandro, Sofia, and India those stolen visits to the Garden were unique, unforgettable experiences that marked their childhood. Even today, during winter weekends, they often ask me: "Can we go down to the Garden?" They spend their afternoons hiding along the colorful paths with the giants whose every detail they know.

This is an epic work my father was extremely proud of. I remember that even after the majority of sculptures had been completed, when Niki would announce her arrival, Carlo would get all excited. For him and for us the visits of our artist friend were always occasions to celebrate. We would decide the menu days before, and Carlo would always come home from work, wherever he might be. For him missing one of Niki's visits was simply unthinkable. He liked hearing her speak, as she narrated her stories and described her adventures. And she would always surprise us. Like when she spent almost an entire weekend making plaster casts of Carlo, Nicola, and Marella's faces to put into a portrait gallery of those people who had helped her make the Tarot Garden. I remember with affection when in 2000 we decided to celebrate Carlo and Niki's birthday together. She was born on October 29, while he was born on October 23. Carlo was given a gigantic white truffle and we prepared a huge banquet with risotto, fondue and *crostini* to eat, and Dolcetto d'Alba to drink. The atmosphere was joyous. Carlo, Nicola, Marella, and Niki laughed as they recalled the good old days and the beginning of their strange adventure. That was the last time I saw them all together. Two years later Niki died. Last year my father Carlo passed away as well, after a long illness. So this year when Bloum, Niki's granddaughter, arrived at Garavicchio for the yearly board of administration reunion of the Foundation that manages the Garden, only Nicola, his wife Rossella, and I were present to welcome her.

That evening, as we sipped a bottle of Brunello di Montalcino, I chatted for a long time with Bloum. We had a stream of ideas and projects to ensure the Tarot Garden remains a meeting place for art lovers and enthusiasts of Niki de Saint Phalle's work. Just as Carlo and Niki had taught us.

Bloum Cardenas

Niki & Jean*

To Laura, Philip, Myriam, Milan and Jean-Sebastien

This project started some years ago, Niki was still around and I had talked to her about my wanting to make a book about her and Jean. Basically it was about a love story of which the children were collaborations. My intention was to present them the way I experienced them from my time as a child to adulthood, in the spirit of art and love.

The summer after Niki died I approached Ulrich Krempel, director of the Sprengel Museum, and suggested that we do an exhibition in collaboration with Niki's American foundation (the NCAF) and the Tinguely Museum to show the world how great they were, how they worked and how they loved each other as well as life.

Later I did the same with Andres Pardey of the Tinguely Museum. Both Uli and Andres jumped at the chance and this is how this exhibition and book came about.

For me it is a way to give thanks to Niki and Jean for the wonders they brought into my life.

I don't claim that my vision is an objective one; it is mine and mine only. Probably childish on a few levels, but it is sincere, loving and grateful.

Niki and Jean were both very important people to me in very different ways: both were my guardian angels. I loved them dearly and miss them very much. They truly were magicians in my life, mythical figures.

Niki was my grandmother and Jean was my first love as a little girl; at the age of two, I already loved him very dearly and was incredibly jealous of the attention he gave Niki.

So this project is a little about sharing my love and profound gratefulness towards them.

As a child, I tried sharing my wonderful magical world a few times with other children, but none ever believed or could understand what I was talking about (a huge head in the middle of the forest with a big tongue as a slide, wheels that made the head work, balls raised that would go through it slide down, one huge ear moving, etc.), all against the background of a lot of noise. Eventually I kept it for myself, bringing only my very closest friends (one or two), who came from crazy families and would be able to handle it. La Tête (the Cyclop) became my real imaginary castle, proving to me that the rest of the world was much crazier than mine.

As a teenager I fantasized on the couple Jean and Niki represented, powerful and in a strange kind of way very honest with one another, the Bonnie and Clyde of the art world, as Niki used to say: it was crazy violence but also crazy charm and seduction, just very different. I was aware what an odd couple they made but it was a strong and united one even if they each had numerous other lovers. And in a way it shows in their work: they were very opposed to each other, they tried to tame and charm each other and seduce each other simultaneously; there is always a sense of show. Bang!

After they separated, they retained their playfulness and passion for art. Both had chosen to be masters of their lives and nothing else, they were their own musical conductors.

* Text written on the occasion of the exhibition: *Niki & Jean, L'Art et l'Amour* Sprengel Museum Hannover, 25 September 2005 – 5 February 2006 Museum Tinguely Basel, 29 August 2006 – 21 January 2007

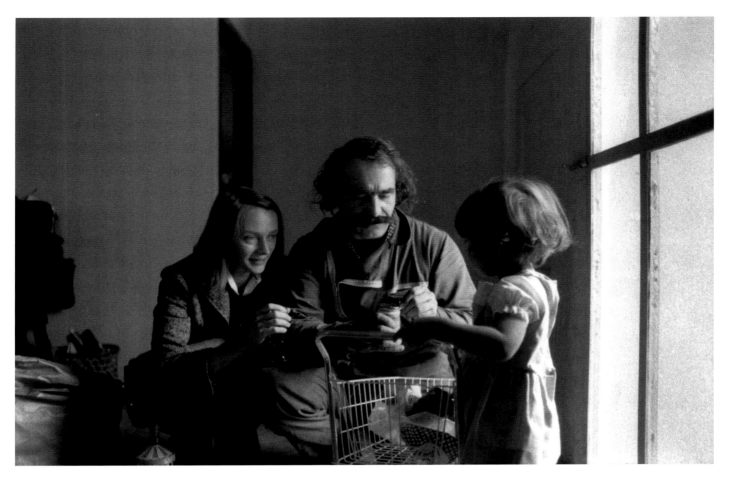

Niki de Saint Phalle, Jean Tinguely
and Bloum Condominas
© Laurent Condominas

Just their appearance together was a clash: Niki in her Dior clothes specially made for her and Jean with his worker look in his blue overalls: the refined, beautiful aristocratic woman and the sexy, brilliant workman: both had something to prove to the world, and it was big and universal, primal and philosophical.

It wasn't the right look in the 1970s to be sexy and feminine, to pay attention to how you looked and have a personal sense of fashion. You were supposed to look like a tramp, and she was told it would probably harm her credibility. She didn't look like a serious artist.

Jean was a dandy too but in a different way, with his blue overalls. He wore a thin black and white scarf (Dior also) and the black and white striped socks from Basel Carnival (he was part of a Clique). The great collector from Bern, Ebi Kornfeld (a member of the same Clique), a friend as well as being Jean's commander in the army during World War II, gave me some Carnival socks like Jean's, which I wear for luck when I feel I need it.

In the years I knew Jean, he either wore his overalls or a very modest suit in some kind of nylon to keep the proletarian look that contrasted very well with Niki's elegant attire. Today when I walk into my studio, I put on a pair of his old overalls.

When I first wearing them a few years back I was very confused for a few weeks. I didn't quite understand what was going on. Suddenly I could smell him. A smell I hadn't been around in years. It took me some time to realize that it was my body heat that was spreading Jean's smell all around me.

I'm not very sure of the chronology of things as a lot of it is related to my early childhood. My parents and I moved house a lot. When I was very young I spent

what must have been a summer or some months with Jean and Niki at the Commanderie.

Every morning Jean and I would wake up and prepare breakfast for Niki and take it to her in bed. One day I had a fit and expressed my envy and jealousy to him about Niki (which he found very cute and later on would have me tell his girlfriends). Why was he doing all this for her when I loved him more?

In those days Rico Weber was still both their assistant and Seppi Imof was Jean's. They would sit me on the kitchen counter and squeeze a whole tube of Cenovis (a Swiss version of Marmite) directly into my mouth.

Niki was the Queen, but I was the baby-queen and had a wonderfully privileged situation. Highly respected people in the adult world treated me like a princess, for example Ponthus Hulten, who would carry me on his shoulder to pick flowers in the garden while all the other nuts were searching for the Templars' lost treasure.

It was truly wonderful, I'll always be grateful for the love and magic I received from these truly passionate people. Ponthus will always be a sweet memory to me. People were afraid of Jean (even my mother) but he was only love to me. I am aware my perception is warped, but this is how I remember it. Niki (with Jean and Ricardo) will forever remain the most generous person I've ever known, Rico the most nostalgic, and Seppi the most unchangeable.

When I was little I was closer to Jean than to Niki, I simply adored him. I was glued to him as much as I could. I went with him everywhere in his Mercedes at 130 mph. Jean was all action and movement all the time. It was great for a kid. I called him *Le Roi des Suisses* (King of the Swiss) because he was always surrounded by the all-star Swiss team: Rico Weber, Seppi Imof, Paul Wiedmer, and big Mike. They all did whatever he said, however crazy, things like "Weld this huge piece of metal here before lunch" (50 feet high).

We would go to Carrefour (a huge supermarket) together and he would buy only useless stuff but tons of it. I was hoping every time to get a Barbie doll but he and Niki were very much against it, so it never happened, I couldn't understand it. I tried telling Jean but it was useless, it never worked. Going to Carrefour with him was fun and fast, it was surreal: the only useful things bought there were garden related, the rest was crap.

We would go to the wrecking yard in Maisse at the house of this wonderful couple called Les Duperches. Most of the metal from the Cyclop came from their place. He was super kind and she was beautiful. Ever since, the smells of rust and damp have remained very nostalgic for me.

I was so angry when I found out that Jean had a child! Worst of all he was almost my age, what treason!! I remember when I met Milan. It was at one of Niki's birthdays in Soisy. I was very upset at the idea but when it happened I understood I had not lost my special place in Jean's heart.

Then Milan and I became family.

Niki always said it was hard to be a grandmother at forty. Particularly when you look so good and young as she did. But even if it was a problem to her vanity, it never got in the way of our relationship. I have believed for a long time now (and she knew this), that I am one of the people who enjoyed a very close relationship with her. We tried to protect each other from ourselves and forgive the things that others would not accept. And we were always happy to see what we had in common. Of course there were times when we were especially close, times when we took our space from each other.

In about 1974, Niki filmed *Camelia ou Le Reve Plus Long que la Nuit* at the Commanderie. All the friends of Jean, Niki and my parents, people I loved, were in it together. But they were acting and I was very young so the difference wasn't always clear to me, except for the fact that there was a cameraman whom all called Zizi (Claude Zizerman), which means 'peter' in French, so it was almost like a joke.

One of my parents' roommates (also Niki's lover at one point) was the artist Pierre Joly. He was a Lizard man, Niki was the Pimp, and the Client was Andree Putman whom I adored and called my Baby. Marina Karella, whom I love like a godmother, was the Witch, and one of the girls in the brothel was one of the three women I considered the most beautiful in the world, a role model in femininity.

My father was Death and my mother was Camelia (the principal character all grown up). Everybody else I knew. Jean had an army composed of Ponthus, Seppi, Rico, Roger Nellens etc.

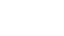

Luginbühl scared me for life: there is a scene where he roasts a doll; I figured he must be really crazy to roast a doll! A child would have made more sense. Also Ursi (Lughinbul), a sweet and delicate woman with such an Ogre, how did that work? And I have never been able to remember Sam Mercer as anything but the Cardinal since.

As I was so young, when Jean's army tied my mother to a tree it was very difficult for me. I couldn't understand. I was very upset with them; this was my mother! They felt bad and did not enjoy having to do it over and over again as I would burst into tears every time.

Niki tried to have me in a scene. I remember Niki telling me what to say, sitting next to the camera, facing the young girl that played Camelia and I, but I could not remember my lines, Niki was disappointed. Something I never liked.

Everybody was somewhat nuts. Jean and Niki's good friend, Roger Nellens, would come from Belgium and cook for everyone. He made the best Chocolate Mousse in the world, and during the film he would make it in a bathtub. He cooked for the whole crew.

Niki had made a wonderful Dragon in his yard in Knokke-Le-Zout (Belgium) for his son Xavier. Many years later Jean made a big lamp and seats to go inside of it.

One thing leads to another. I'll never forget the day I realized they were famous. It must have been in 1984 or 1985 and Keith Haring was visiting. He kept taking

Polaroids of them and was acting like as though he was their groupie, while I was a groupie of his.

So many times I had tried to show off by talking about that crazy couple, but no one ever knew what or whom I was talking about. Suddenly here I was with an artist I had admired for a few years and he was acting with Jean and Niki the same way I was with him. Some years later Keith stayed in Niki's Dragon in Knokke and asked her permission to paint the inside of it, which of course she gladly accepted.

A great side of Niki and Jeans was their belief in young artists. They would always buy art from struggling artists they met and respected, or when they saw something they liked. They also created many artists with their example: friends, assistants, collaborators, lovers, and family members.

Once Niki told me if she could do it all again she wouldn't have told Jean about all her lovers. As they were in constant competition they were also competing on

that level. Niki said she suffered a lot from that, it was a twisted game, and it was also an epoch. The lovers came and went but Niki and Jean's relationship lasted, even when they were no longer a couple they would talk about being buried together in the Père Lachaise cemetery in Paris. They would get very excited about that and would see it almost as a project. They trusted each other more than anyone else for their art. It was always clear that whoever died first would be responsible for the other's work. On that they were deadly serious.

Eva Aeppli (Jean's first wife) was a very important and close friend to both and so was her husband Sam Mercer. Niki loved Eva. To me Eva was a strange creature as she had power over both of them; I think she was the only one. I loved her paintings because I found them very funny and graceful, as well as scary. Eva was an enigma, so I just figured that you had to be cary careful what you did around her because to have such power over Niki and Jean you had to be a very powerful magician or sorceress.

Constantine M. was one of Niki's great loves, and this was how I realized Niki and Jean were no longer really a couple. Constantine was in her bed and Jean was not only OK with it, he really liked and respected him (which was not the case for many others). Niki had left the Commanderie and was living in Soisy, a place she and Jean had had since 1964, and which had become their art store. Niki was very happy in those days.

Niki and Jean's love was pretty much of their time, but it was still quite peculiar. Jean remained king. They were separated and they each had their lovers, but when Jean came over to Soisy (Niki's house) he was still the master of the house, which must have been difficult for Niki's men. He would sort of test them, lie down on Niki's bed, and prepare his stationery to write letters which he then put in HIS drawer, in Niki's studio.

Lovers came but Jean remained. Of course this would get on Niki's nerves but sometimes it was also convenient. Micheline Gygax (the mother of Jean's first son Milan) and Niki would call each other to warn of his coming in order for each of them to get rid of lovers they didn't want Jean to meet.

There was a lot of love but of course there was a lot of pain. I'm not 100% sure but what I remember is that when Micheline got pregnant Jean ran to marry Niki after 12 or 13 years of being together. When Niki found out about the scheme she was hurt, as anybody would be. But she also tried to divorce him and he never accepted. In many ways they were each other's strength.

Niki was always a great example to have growing up. Sometimes she was very forward: she would say, "Look at this dumb thing I did, don't ever do that" (sign a very long and complicated contract without really reading it), or "Look, they think because I'm a woman I'm dumb so we can do whatever we want" (not so). She showed me over and over again how things are not what they seem. But with Jean they protected each other in different ways from the outside world. Their different intelligence and sensitivities were beneficial to each other in many ways. On other levels it was difficult.

Now that I am an adult and I've had the opportunity to talk to some of the people who were there then, I realize I was the only child in a crazy world of adults who were all big children and who believed in their dreams and made them hap-

pen: this is the wonderful gift Jean and Niki gave to me, the notion that you can have crazy dreams, and that the really foolish thing in life is not to make them come true.

Finishing these memories has been difficult. All this is so personal and so many will have a different take on it. But most importantly, sharing what has been such a private treasure in my life is not easy. Slowly the witnesses disappear and all those private moments too.

Finishing this text means allowing myself to write down that they are no longer around and no longer creating whether it is art, crazy stories or just confusion. That they are no longer my private world.

Losing Jean, saying goodbye to him in the hospital made me grow up. It was a pivotal moment in my life and a life-changing experience. Niki's death made a grown-up and a warrior out of me.

I miss them enormously and feel their protection in little signs, but I do not feel them present. They were so much everywhere in my life that their loss is very clear to me: they are gone.

To end this nicely: when Niki died there was a ceremony in Paris, it was very moving as there were many faces from different times, many people who loved her. On my way to Saint Merry (the church behind the Stravinsky fountain), I met Myriam Tinguely, Jean's first child. Myriam was not only my biggest source of comfort that day, but she was also the one to bring me magic: before the ceremony she introduced me to Jean-Sebastien, her little brother. This was wonderful and a message of life and passage. Later that month, Myriam came with Milena (his mother) and Jean-Sebastien to Soisy, where he played all day with my son just a year younger than him.

Thank you.

Orig

gins

The Zoo with You, 1955–57 circa
Oil on canvas, 207 x 103 x 4 cm

Four Houses [On the Coast], 1956–58 circa
Oil, clay, and various small objects (metal
covers, etc.) on wood, 200 x 107 cm

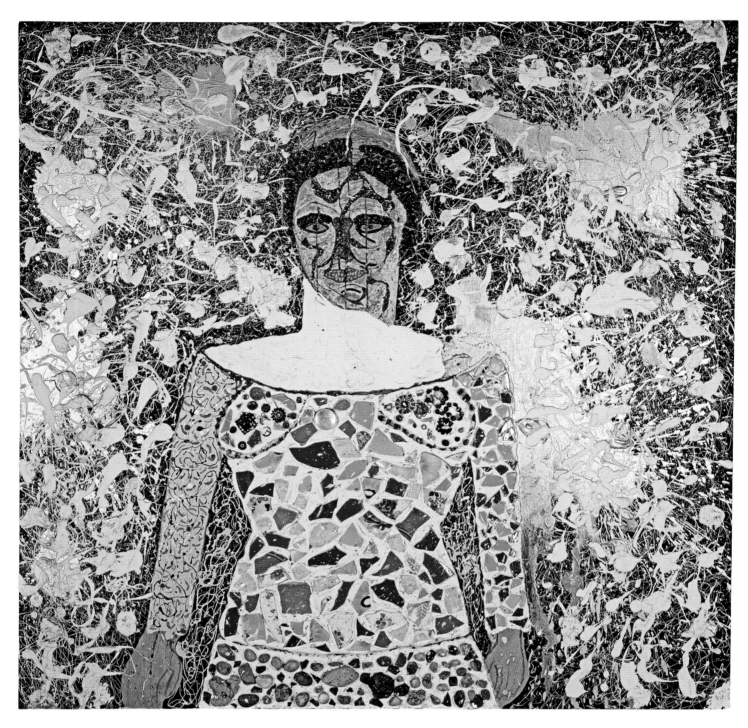

Autoportrait (*Self-Portrait*), 1958–59 circa
Paint and various small objects (pebbles, coffee
grounds, pottery shards, etc.) on wood,
141 x 141 cm

Rocket, 1958–59 circa
Oil and various small objects (coffee grounds,
stones, corks, nails, pieces of wood and
crockery, etc.) on plywood door, 204 x 80.5 cm

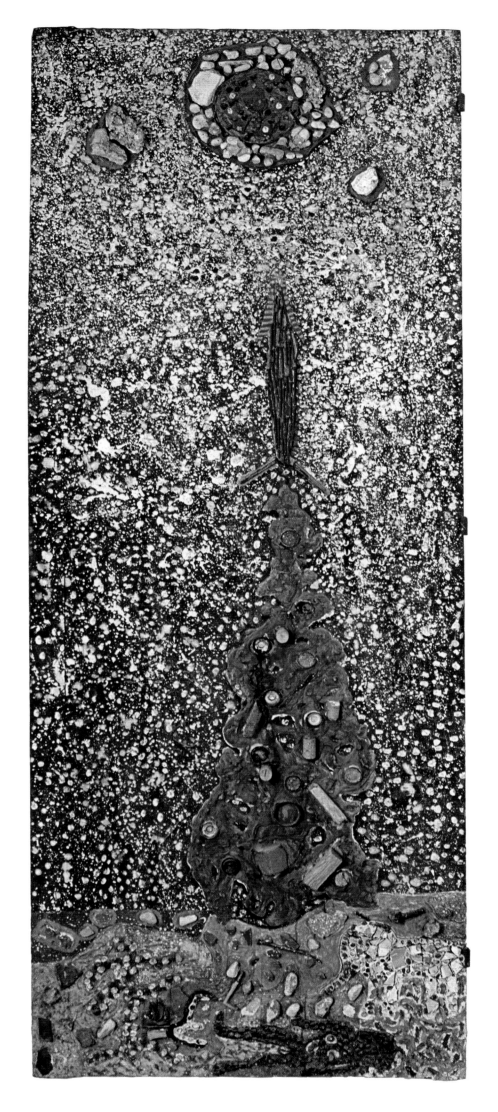

"I am condemned to show e

Every thought every emotion

visible and becomes a color,

rything. That is my task.

feel and think is made

texture, a subject, a form."

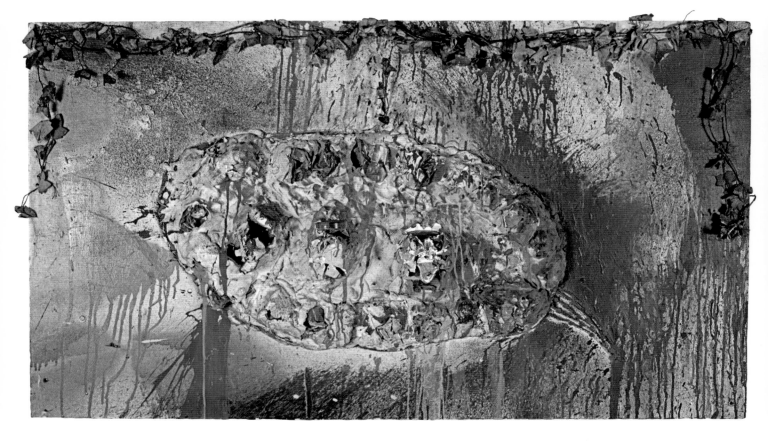

Tir (Fragment de Dracula II) (*Shooting painting
[Fragment of Dracula II]*), winter 1961
Plaster, paint, various objects on plywood,
87 x 150 cm

Dracula (Fragment de Dracula I et Dracula II)
(*Dracula [Fragment of Dracula I and Dracula II]*),
winter 1961
Objects (bicycle wheel, umbrella, bowl, small
figures, plastic flowers), paint on plywood,
105 x 112 cm

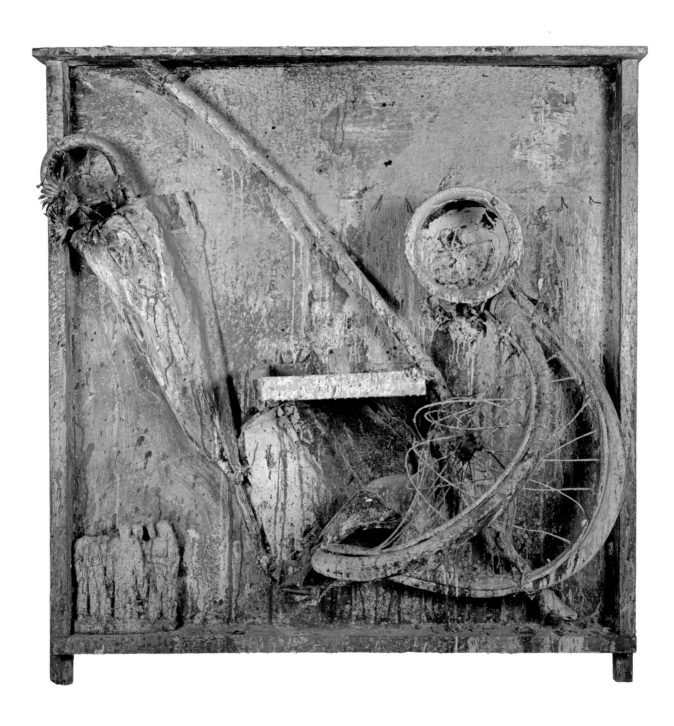

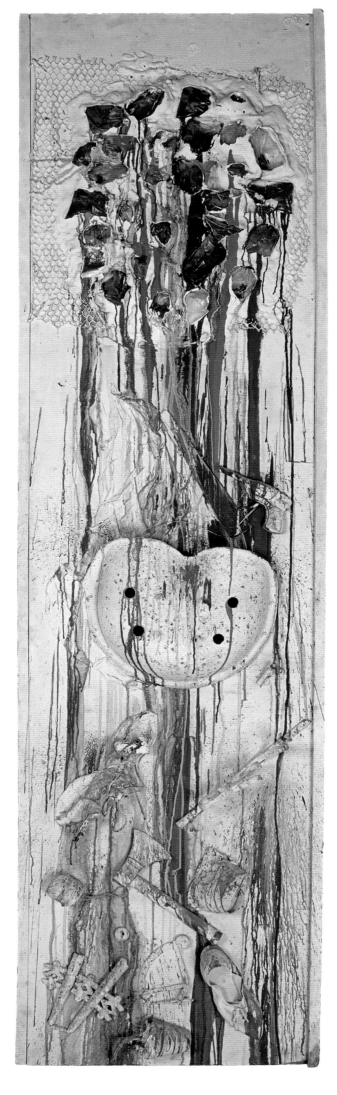

Tir de l'Ambassade Americaine (*Shooting Painting American Embassy*), 20 June, 1961
Wood, plaster, various objects, paint on wood, 245 x 66 cm

Cathédrale (*Cathedral*), 1962
Various objects, plaster, paint on wood, 196 x 129.5 cm

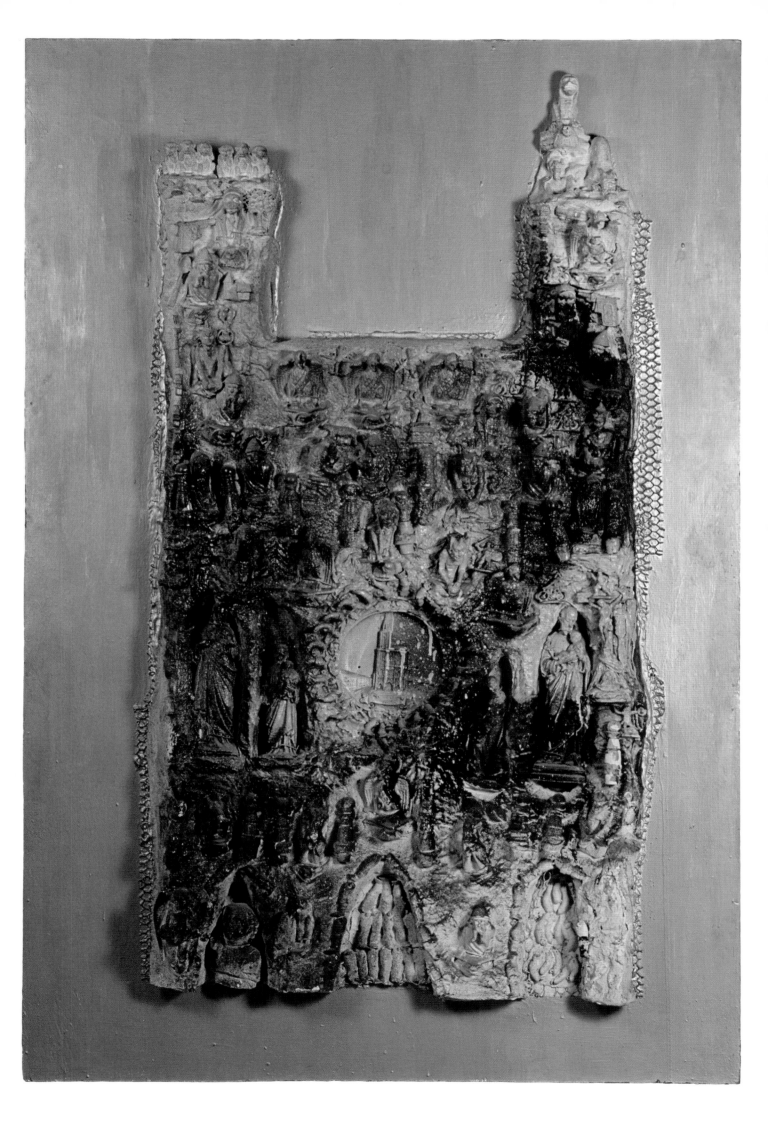

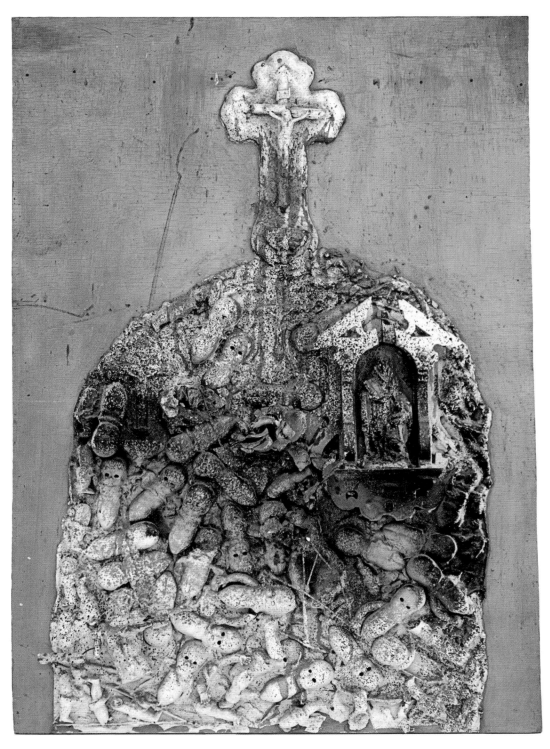

L'autel des innocents
(*Altar of the Innocents*), 1962
Various objects embedded in plaster
on plywood, 100 x 70 cm

Autel doré (*Gilded Altar*), 1962–95
Gilded and varnished bronze, elements bathed
in gilded bronze, 160 x 111 x 17.5 cm

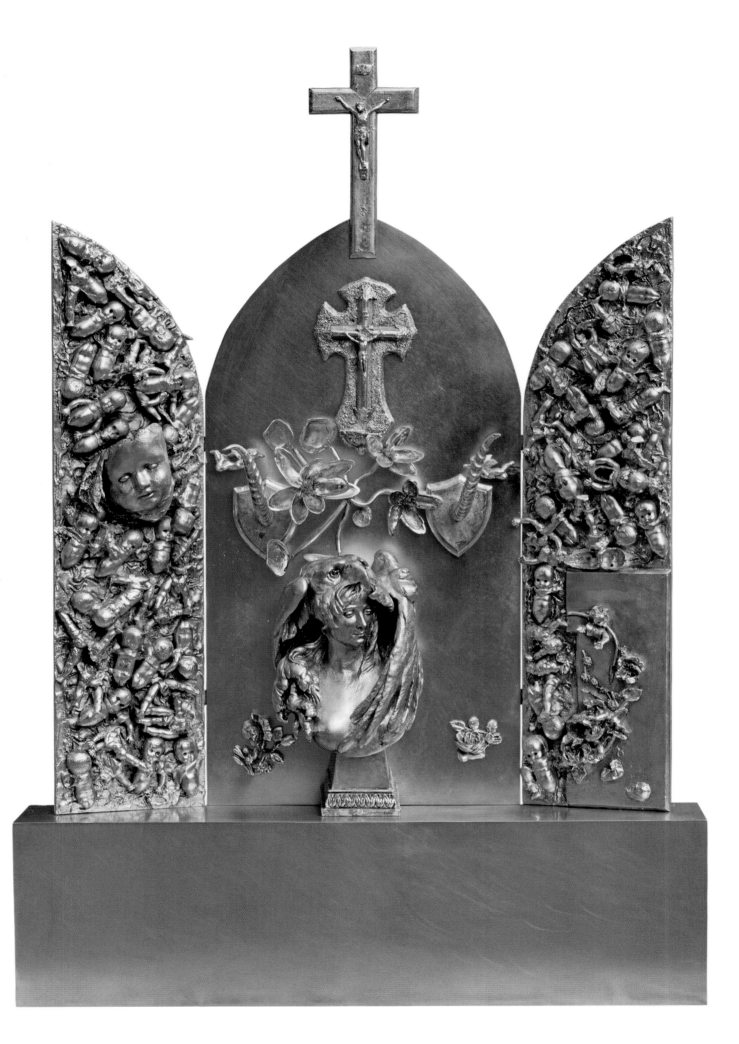

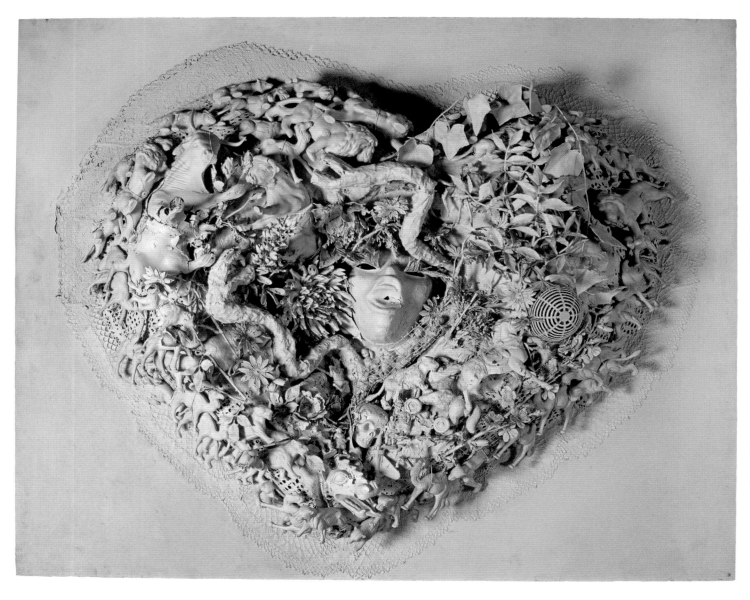

Coeur (Heart), 1963
Objects, paint, wire on wood, 110.5 x 135 cm

Motorcycle Heart
(Study for King Kong), 1963
Objects, plastic, paint on wood, 198 x 122 cm

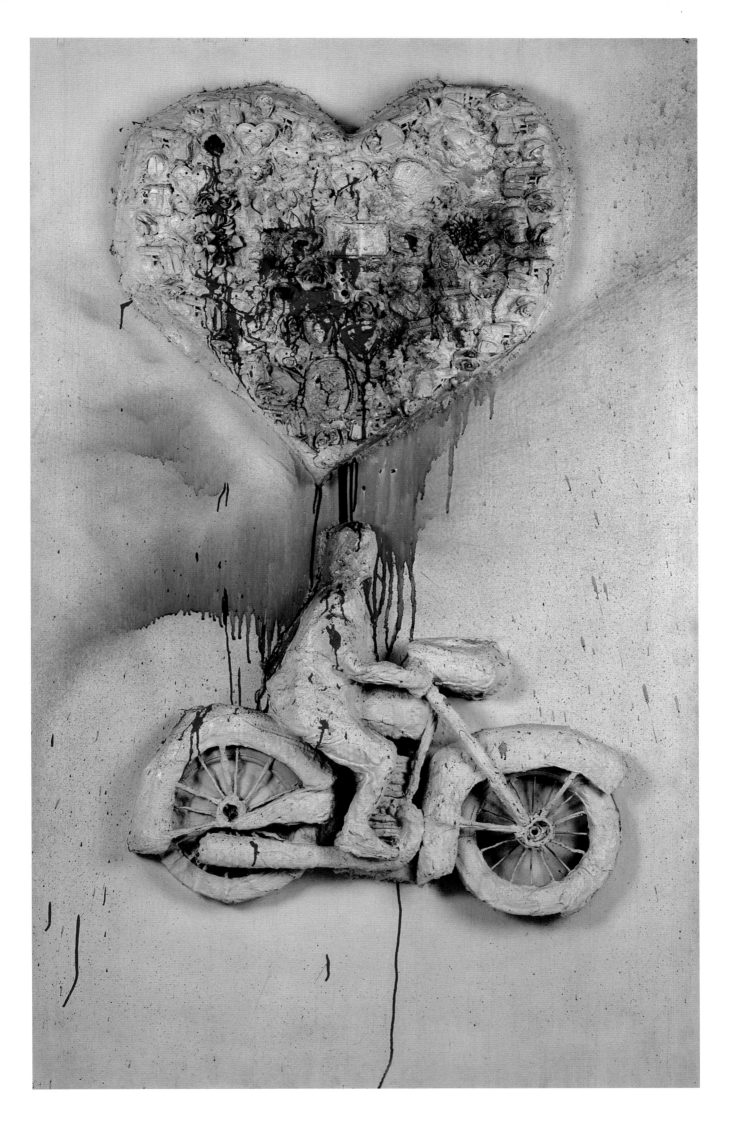

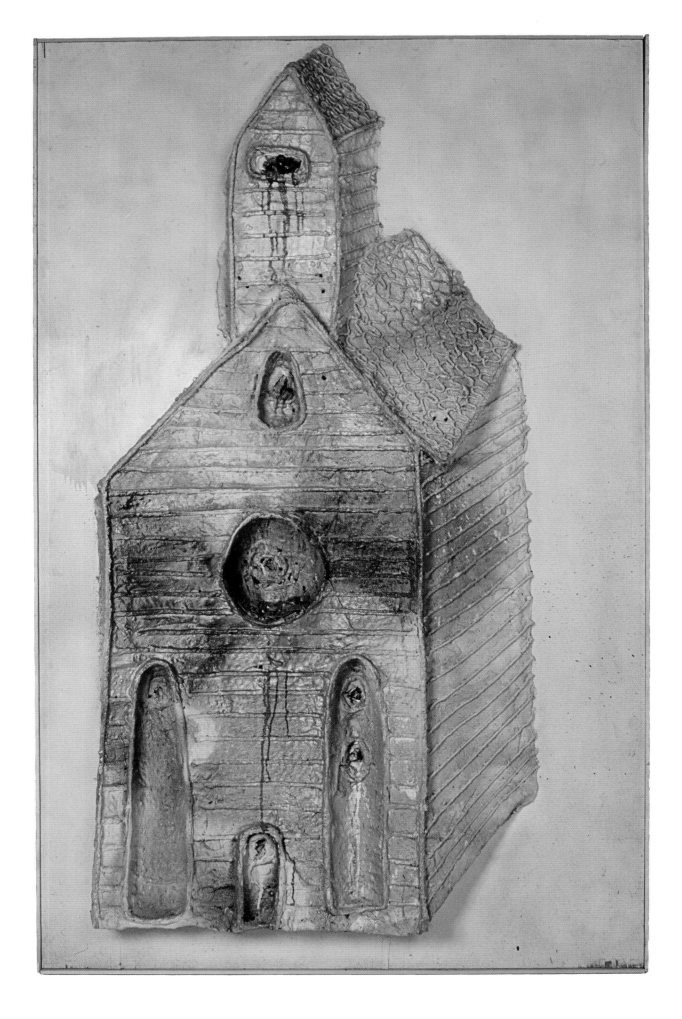

New England Church
(Study for King Kong), spring 1963
Plaster, paint on wood, 200 x 130 cm

Study for King Kong
Pencil on paper, 355 x 434 mm

Study for King Kong
Pencil on paper, 355 x 434 mm

Study for King Kong, 1963 circa
Pencil on paper, 355 x 434 mm

Study for King Kong, 1963 circa
Pencil on paper, 355 x 434 cm

Study for King Kong, 1963 circa
Pencil on paper, 355 x 434 mm

Study for King Kong
Pencil on paper, 355 x 434 mm

[Etude Femmes enceintes, mariée,
accouchement, femme de dos] (*Study*
of Pregnant Women, Married, Childbirth,
Woman from Behind), n.d.
Felt-tip pen on paper, 305 x 458 cm

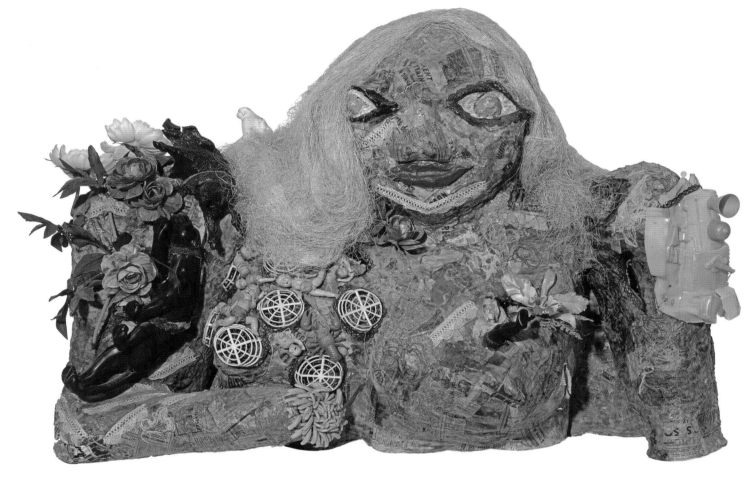

Marilyn, 1964
Objects, paint, wool and wire,
82 x 127 x 42 cm

Lucrezia ou the white goddess
(*Lucrezia or the White Goddes*), 1964
Objects, paint, wire on panel, shooting,
180 x 110 x 38 cm

Nana

Power

[Femme quatre bras, trois jambes]
(*Woman with Four Arms, Three Legs*), n.d.
Colored pencils, felt-tip pen, ink on cardboard,
208 x 179 mm

Louise, 1965
Wire, fabric, wool, 70 x 70 x 26 cm

[Nana baigneuse] (*Swimmer Girl*),
1965–67 circa
Black marker on note block paper,
270 x 210 mm

[Nana Waldaff] (*Waldaff Girl*),
1965–67 circa
Black marker on note block paper,
270 x 210 mm

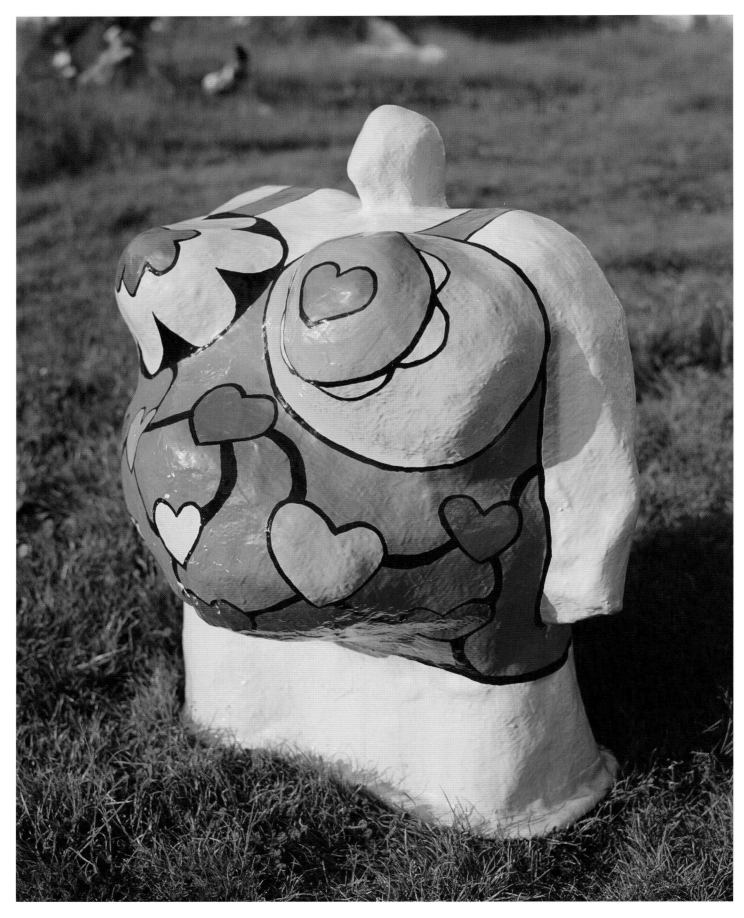

Nana boule (orange) (*Girl Ball [orange]*),
1966–67 circa
Polyester paint, 100 x 105 x 80 cm

Nana assise (*Seated Girl*), 1965
Wool, papier-mâché, wire, 100 x 140 x 140 cm

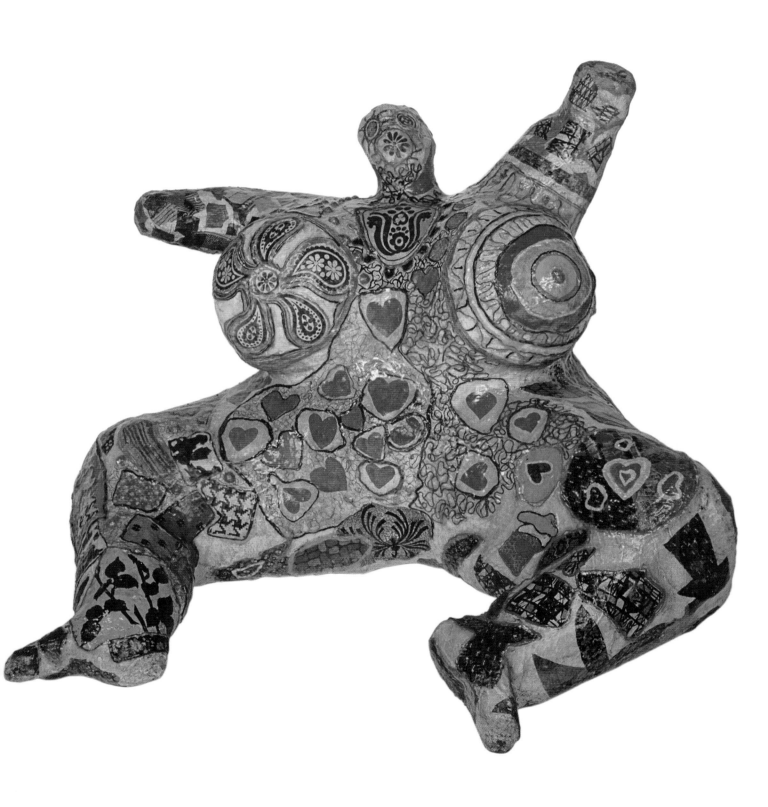

"My first Nanas were made

weren't very big, though most

of movement in their poses. S

their heads, others appeared

People told me that my early

Pattern Painting. I don't ag

My Nanas represent the unior

of wool and fabric. They
of them had a great deal
ne ran, others stood on
as pregnant women...
Nanas were the mothers of
ee. Surface alone is boring.
of content and form."

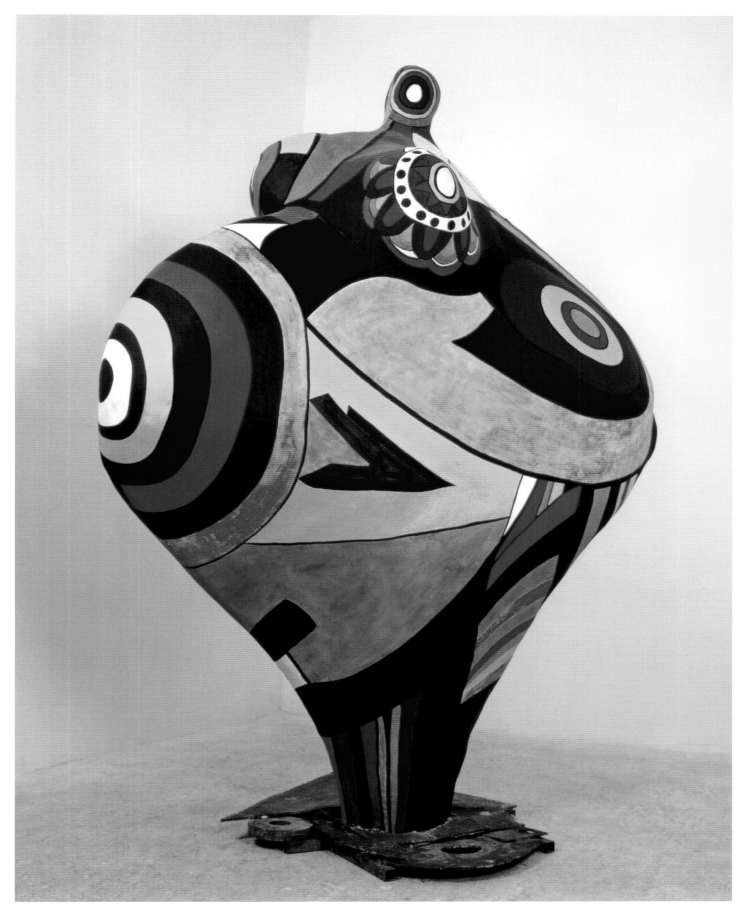

Gwendolyn, 1966–90
Layered polyester, glazed paint on metal base
made by Jean Tinguely, 262 x 200 x 125 cm

Big Lady (black), 1968/1992/1995
Polyester, acrylic, glaze on metal base,
247 x 157 x 80 cm

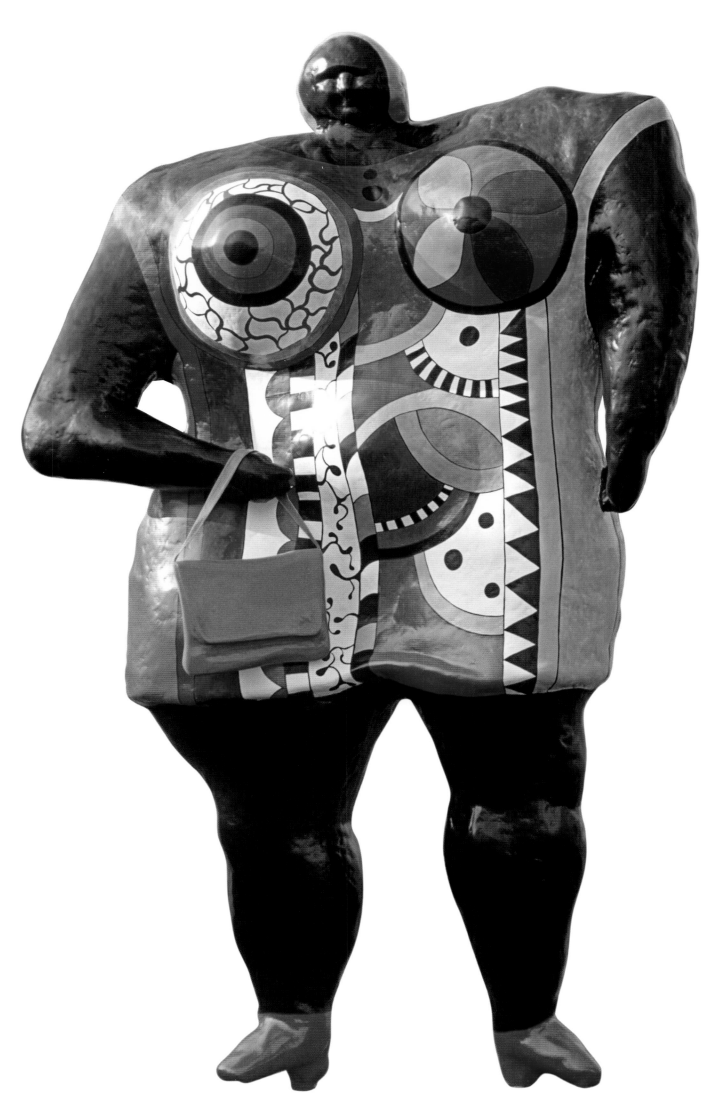

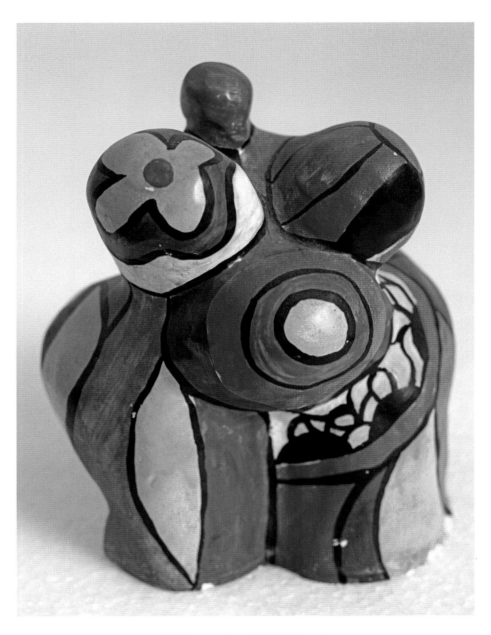

Mini Nana maison (*Mini Girl House*),
1968 circa
Polyester paint, 16 x 15 x 9 cm

Mini Nana acrobate (tête bleue)
(*Mini Girl Acrobat [blue head]*), 1969
Polyester paint, 19.5 x 21 x 9 cm

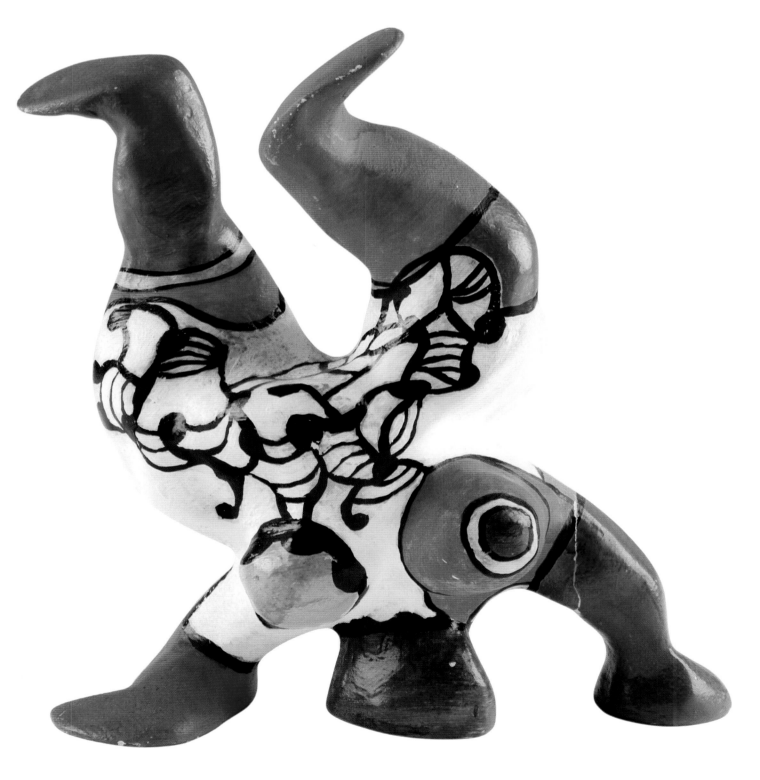

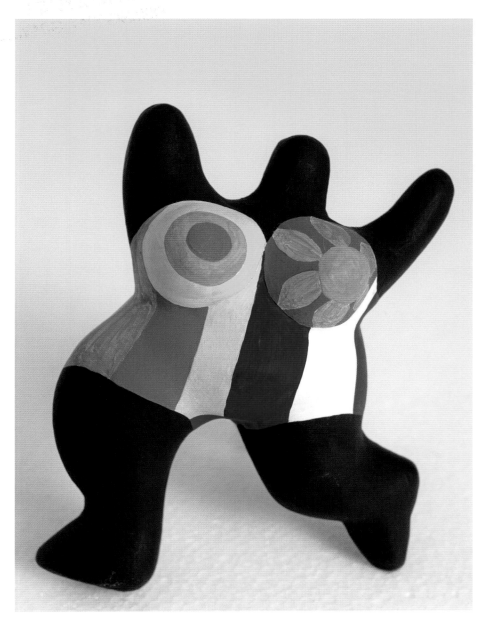

Mini Nana qui court (noire)
(*Mini Running Girl [black]*), 1970 circa
Polyester paint, 20 x 16 x 10 cm

The Unicorn, 1994
Stratified resin polyester, polyurethane paint,
and flash bright acrylic varnish on metal base,
96 x 38 x 138 cm

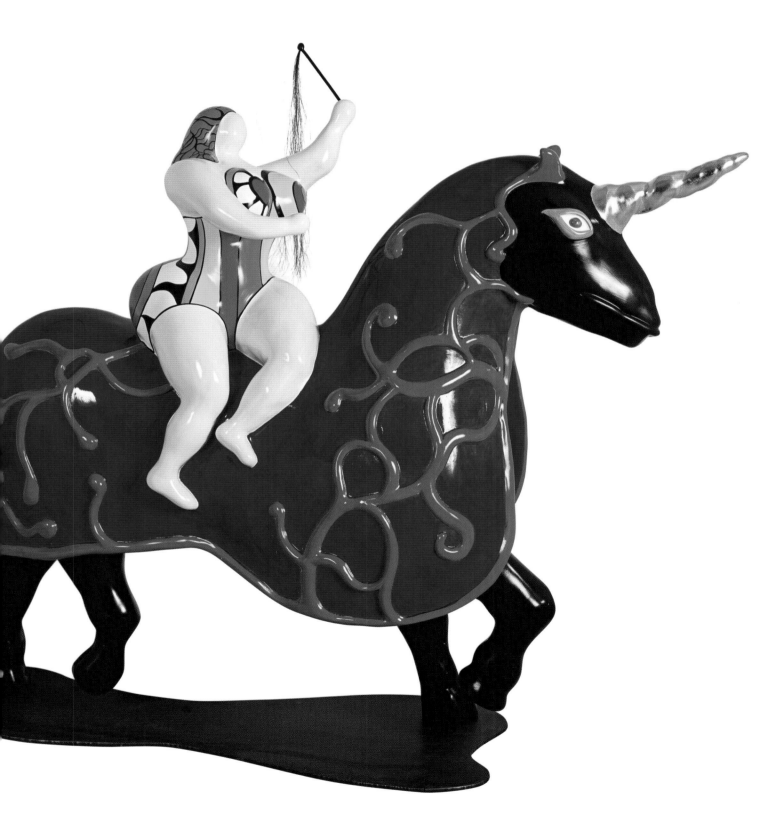

Nana pomme de terre (*Potato Girl*), 1975
Lithograph, 51 x 67 cm

Dawn (Noire) (*Dawn [Black]*), 1993
Polyester paint, 140 x 113 x 37 cm

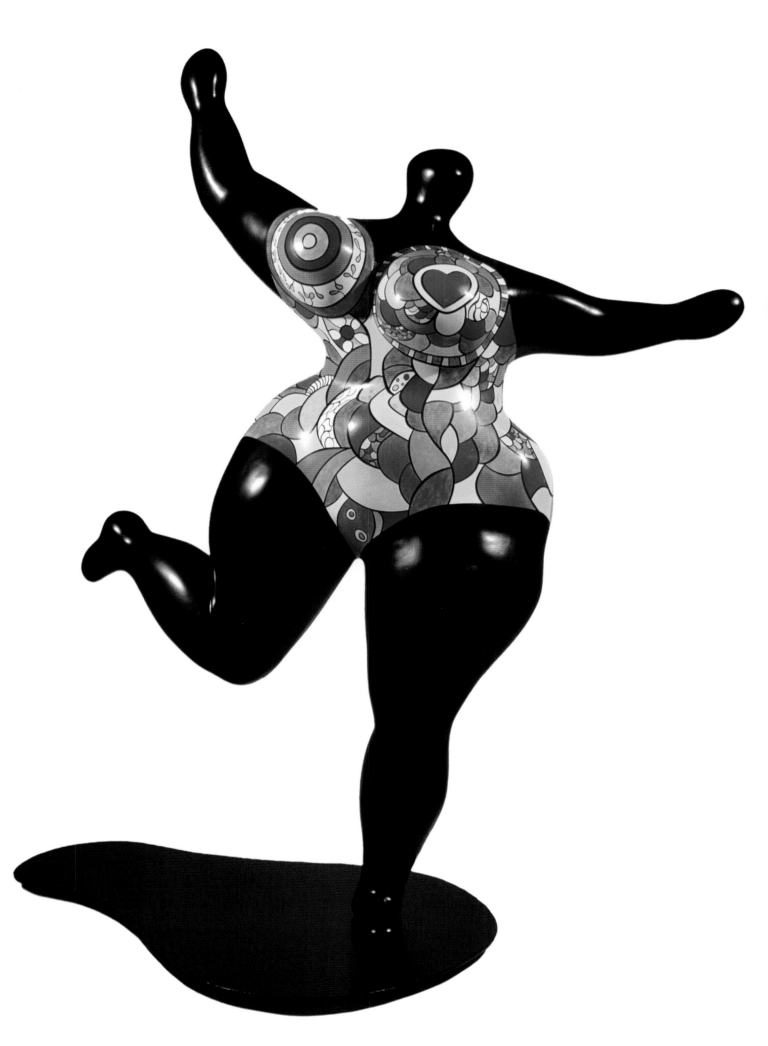

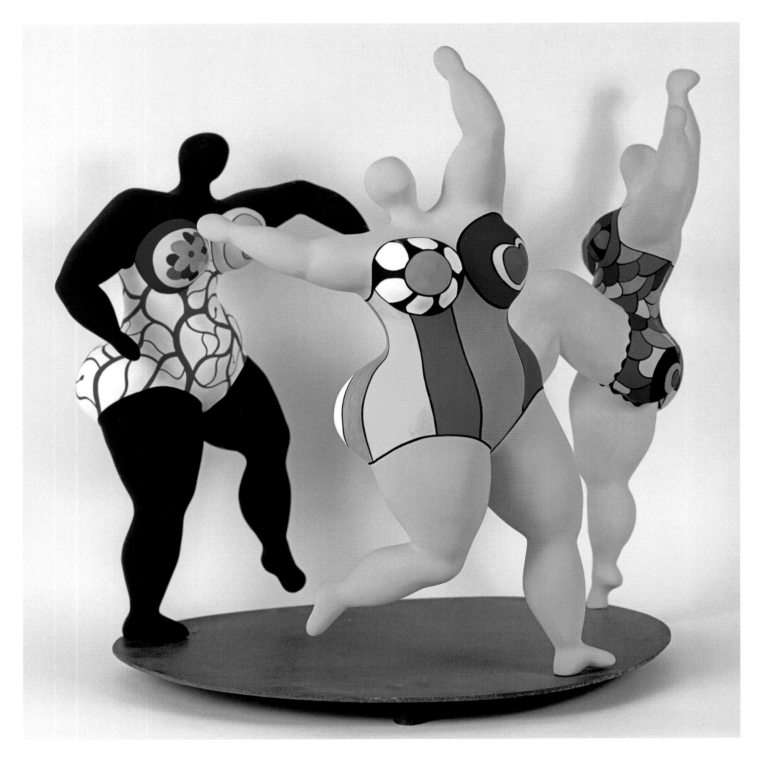

Les trois Grâces (*Three Graces*), 1994
Synthetic resin and vinyl paint, 66 x 79 x 89 cm

Nana sur le dauphin
(*Nana on a Dolphin*), 1994
Layered polyester resin, flash paint without
glaze on metal base, 83 x 27 x 76 cm

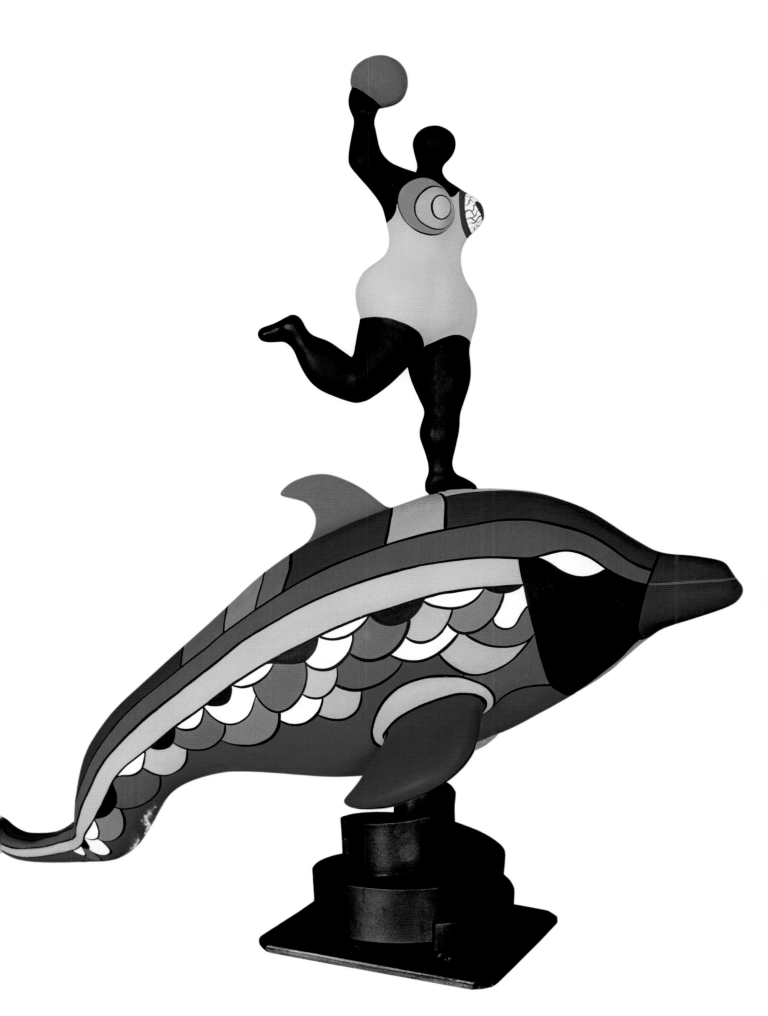

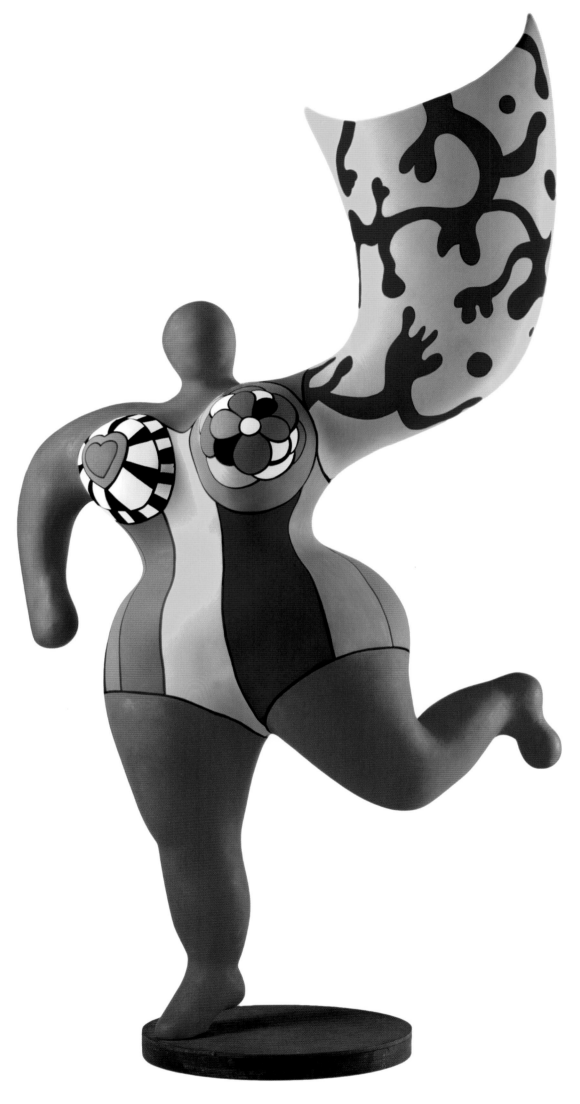

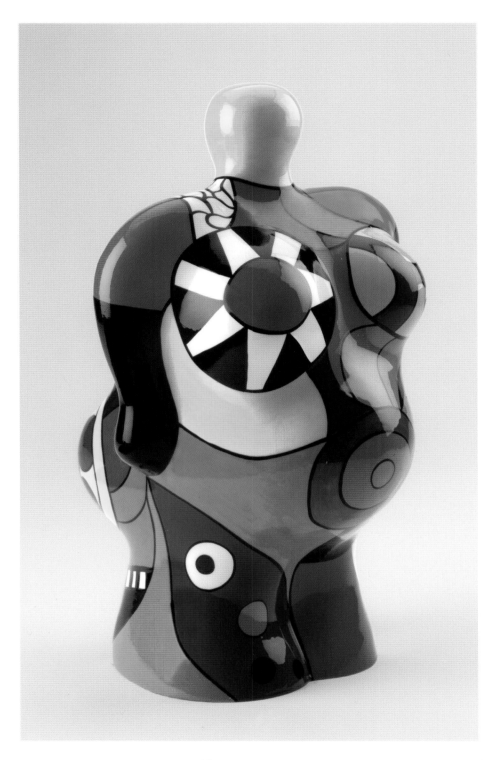

California Nana vase, 2000
Polyester paint, 33.6 x 20.2 x 19 cm

Ange Luminaire (Angel Lamp), 1995
Polyester paint resin, metal base, light fixture,
98 x 55 x 37 cm

Tarot C

Garden

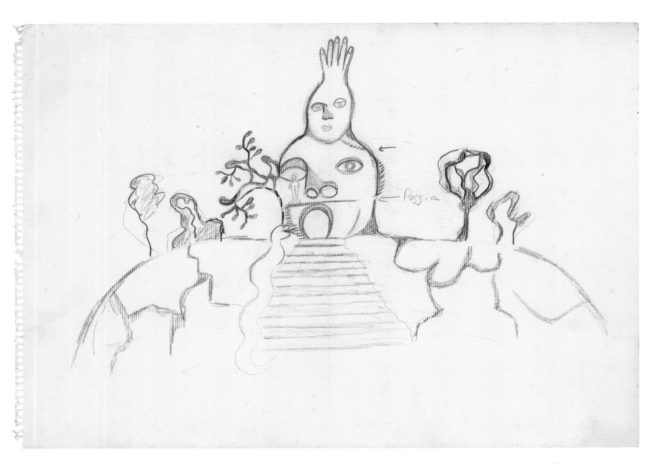

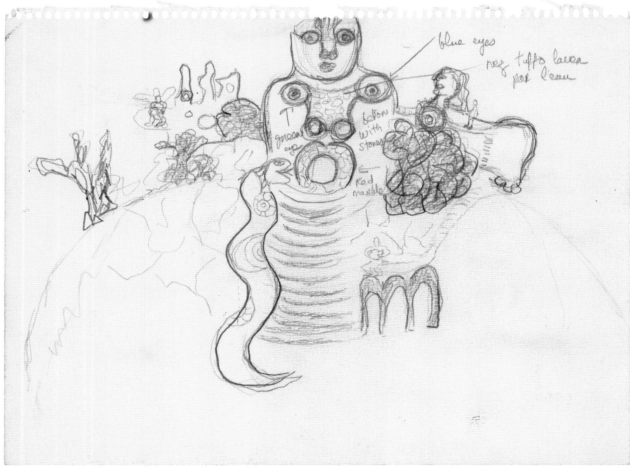

[Le Magicien, la Papesse]
(*The Magician, the High Priestess*), 1979
Colored pencil on note block drawing paper,
320 x 450 mm

[Le Magicien, la Papesse] (*The Magician,
the High Priestess*), 1979 or 1989
Black pencil on note block drawing paper,
240 x 319 mm

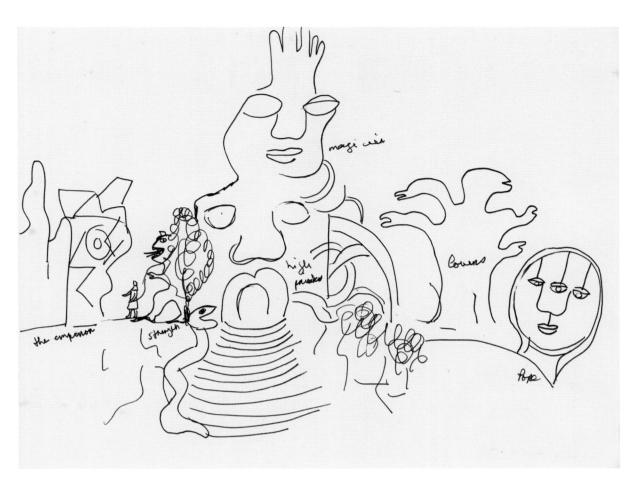

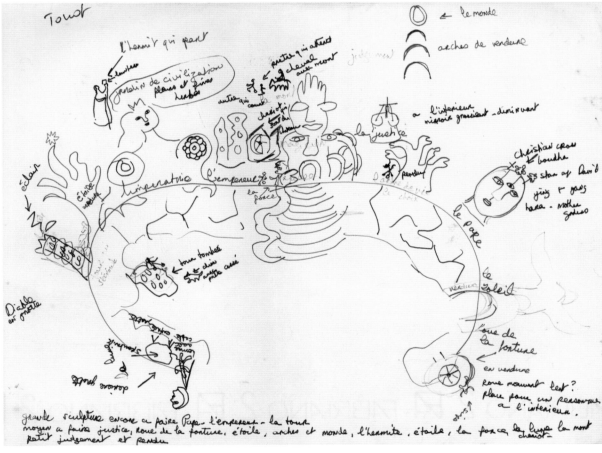

[Le jardin des Tarots]
(The Tarot Garden), 1982
Black fine liner on paper, 240 x 317 mm

[Le jardin des Tarots]
(The Tarot Garden), 1982
Black & blue felt-tip pens on graph paper,
240 x 340 mm

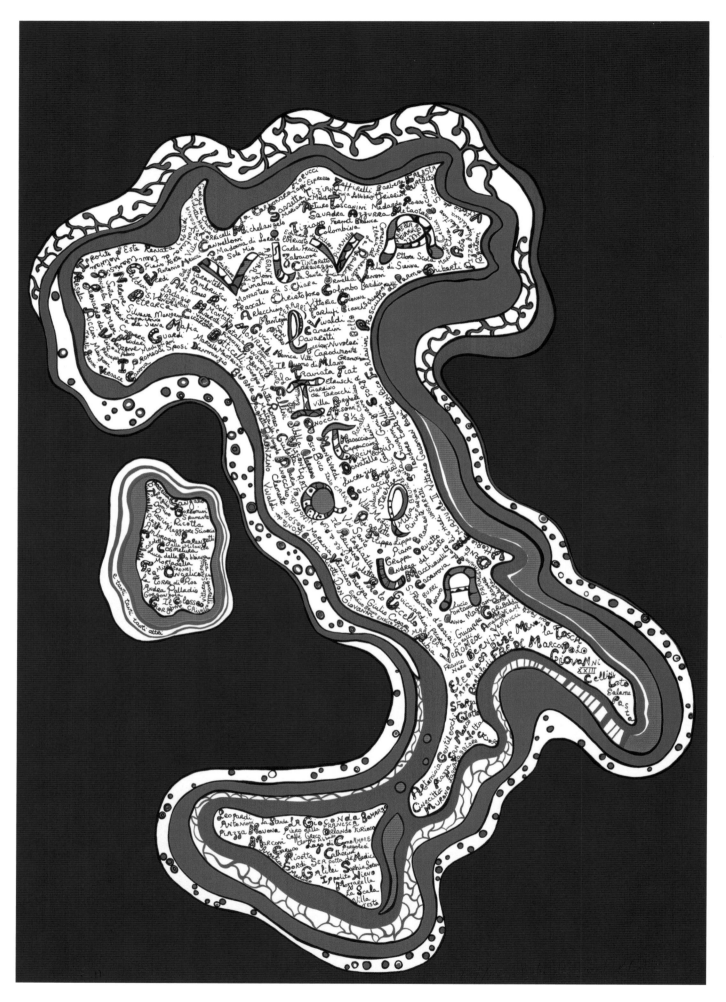

Italy/Viva Italia (Italy/Long Live Italy), 1984
Silk screen print, 98.5 x 68.3 cm

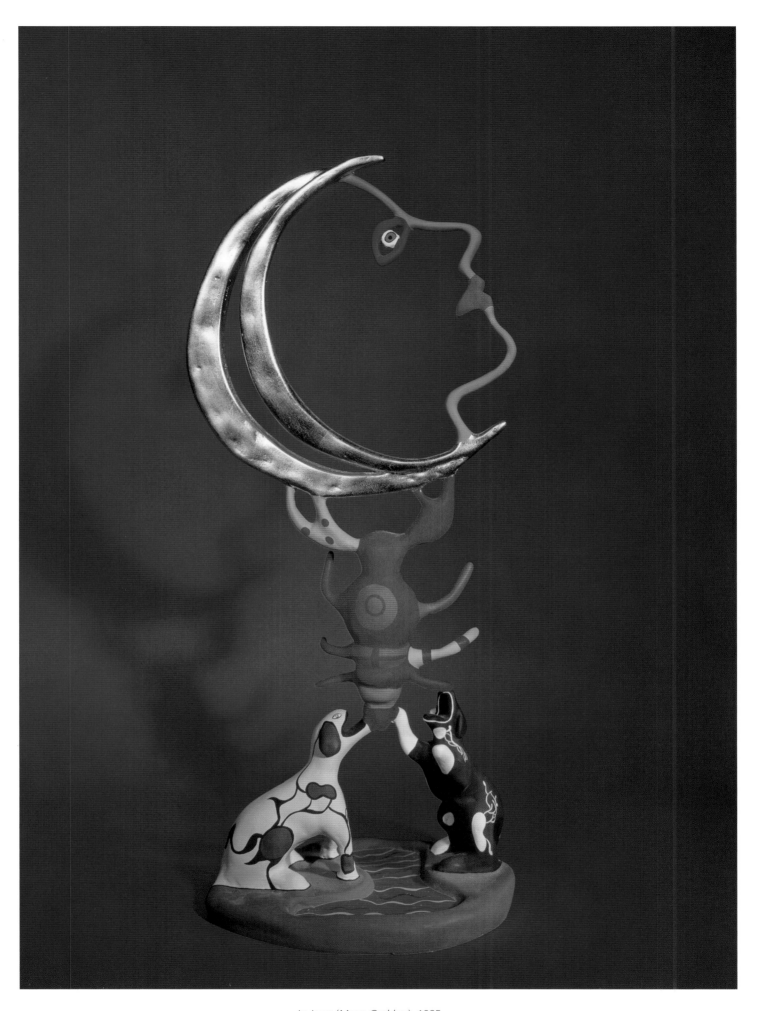

La Lune (*Moon Goddess*), 1985
Polyester paint, 68 x 31 x 23 cm

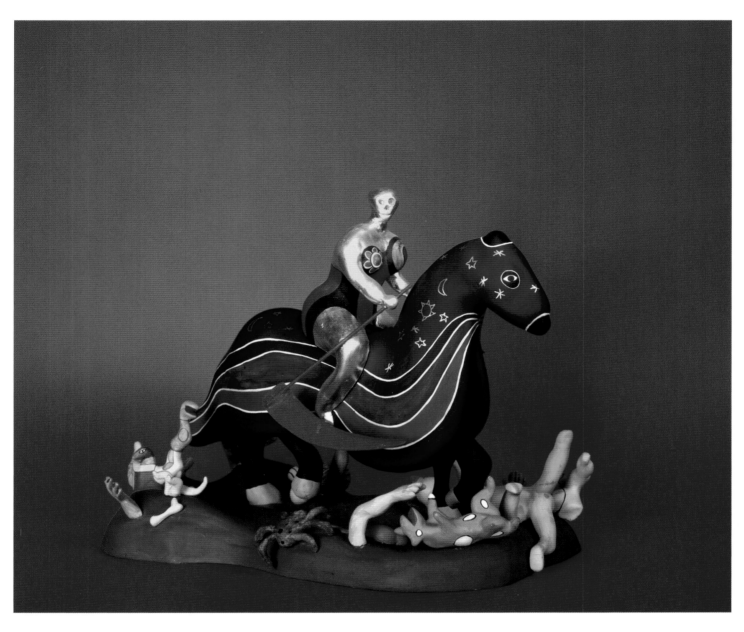

La Mort (Death), 1985
Polyester paint, 29 x 48 x 36 cm

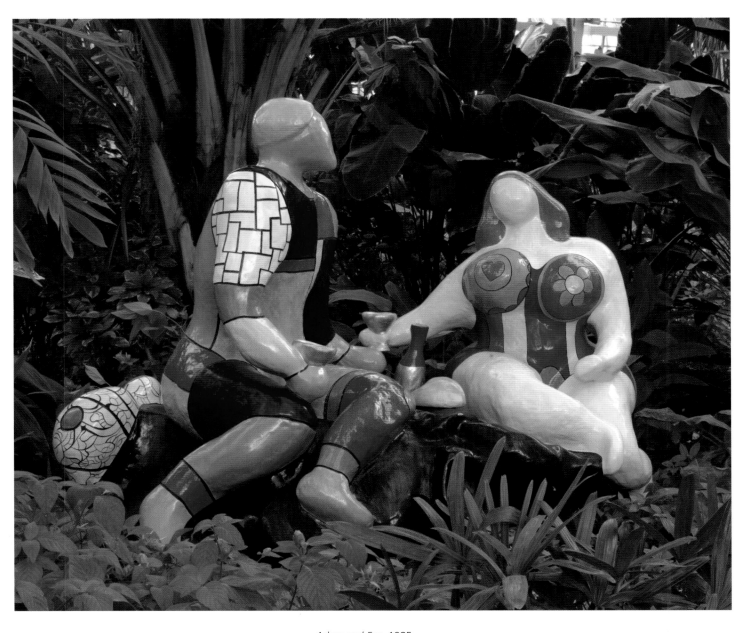

Adam and Eve, 1985
Polyester paint, 170 x 200 x 150 cm

"As in all fairy tales, before my path dragons, sorcerers Temperance."

finding the treasure, I met on

magicians, and the Angel of

Tree or L'Arbre de la vie
(*Tree or Tree of Life*), 1986 or 1987
Silk screen print, 48.5 x 63 cm

La Force (*Strength*), 1987
Layered polyester and color acrylic glaze,
36 x 52 cm

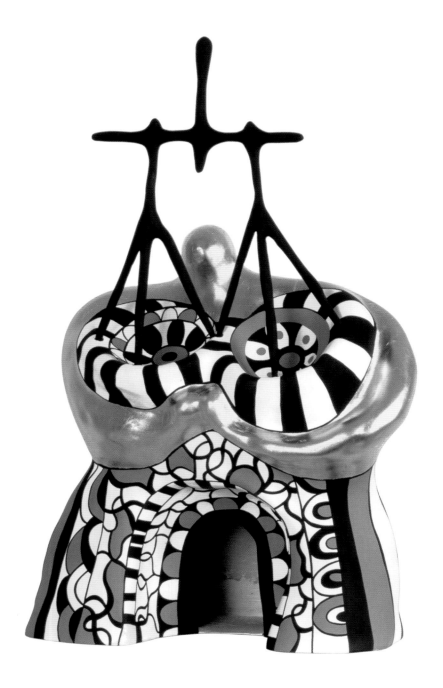

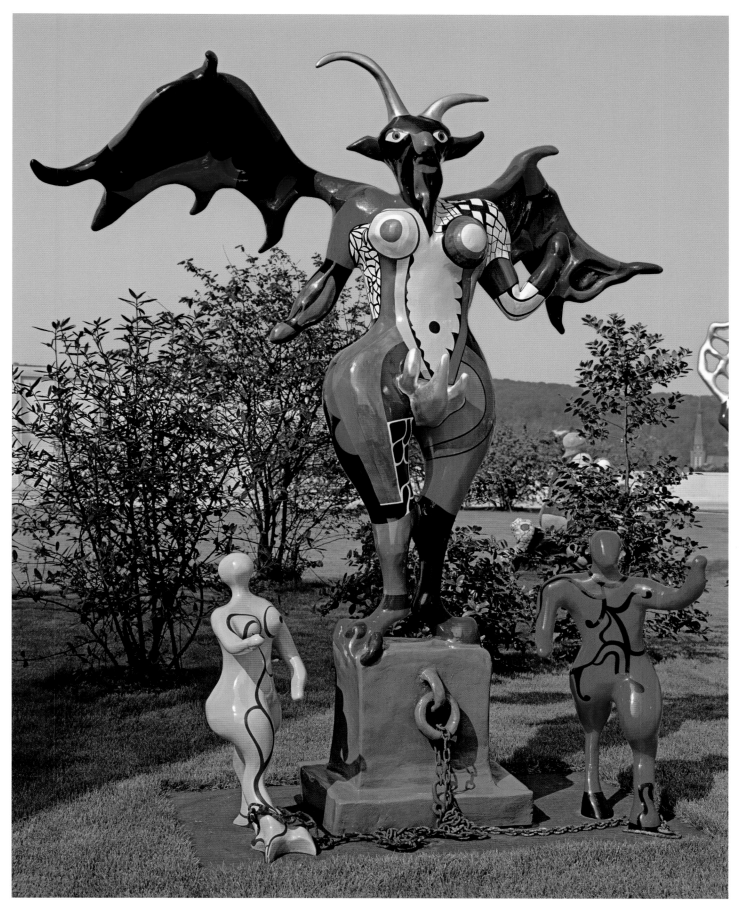

Le Grand Diable (*The Devil*), 1989
Polyester paint, 250 x 150 x 96 cm

La Justice (*Justice*), 1990
Polyester paint, gold, 38 x 33 x 23 cm

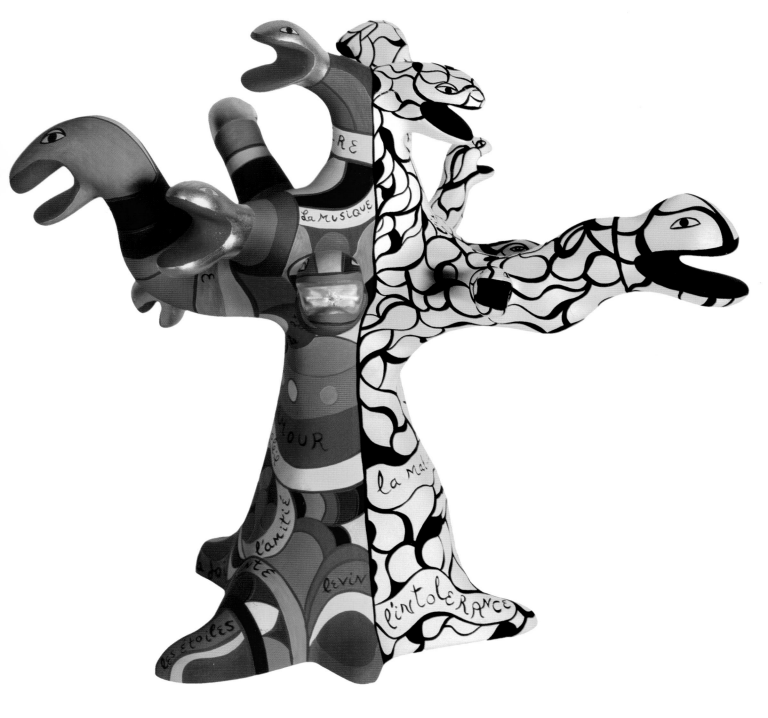

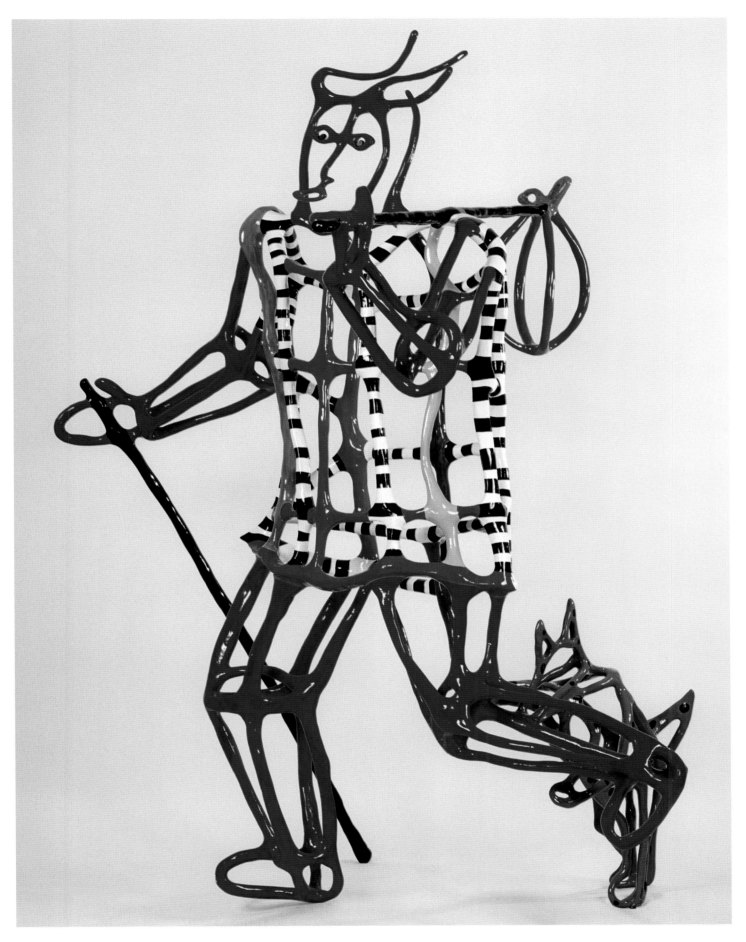

Le Fou (*The Fool*), 1990
Polyester paint, 218 x 165 x 150 cm

L'arbre de la vie (*Tree of Life*), 1990
Polyester paint, gold leaf, 40 x 45 x 31 cm

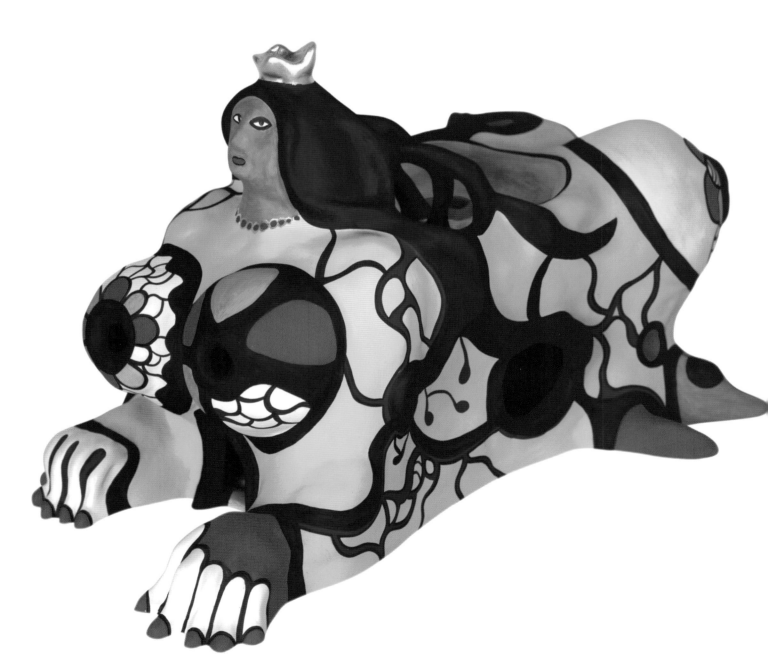

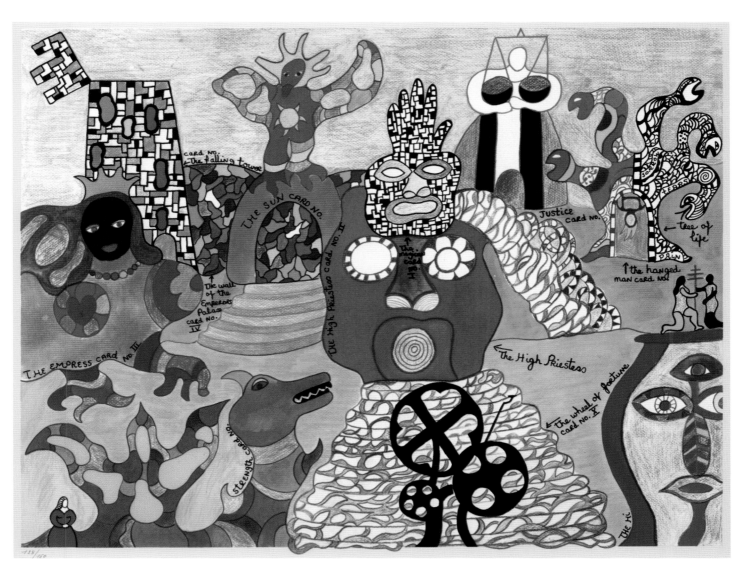

Tarot Garden, 1991
Lithograph, 60.3 x 80 cm

Sphinx/Sphinge, 1990
Polyester paint, 28 x 43 x 32 cm

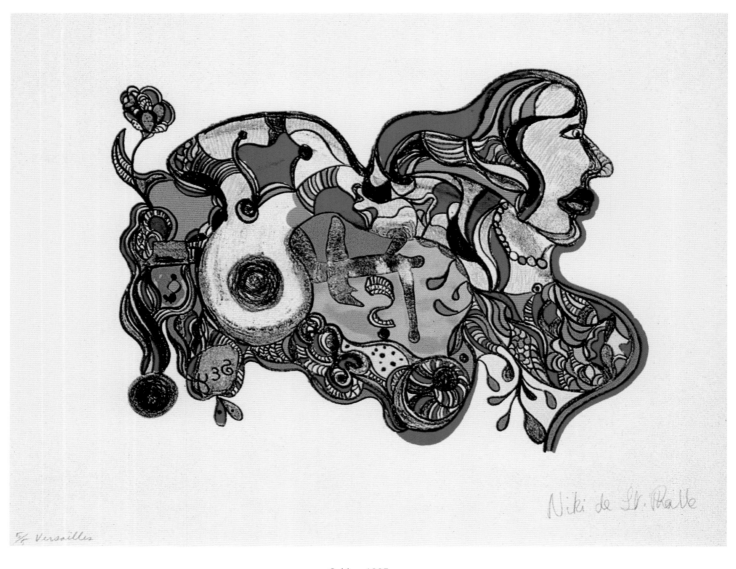

Sphinx, 1995
Lithograph, 36.4 x 47.2 cm

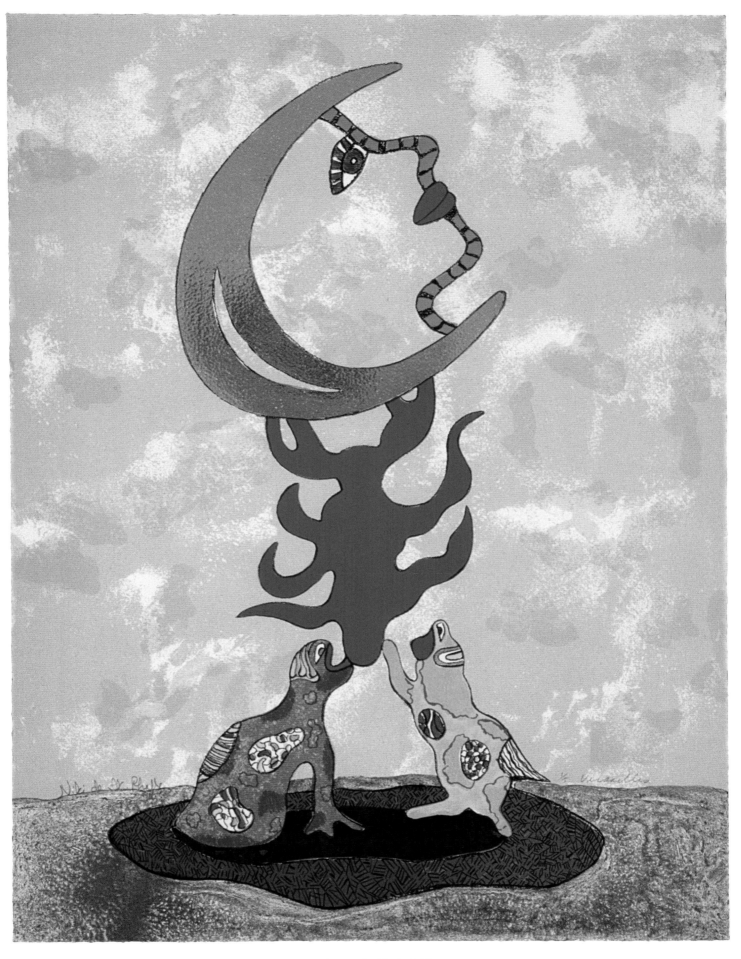

La Lune (*Moon Goddess*), 1997
Lithograph, collage, 75 x 58.8 cm

131

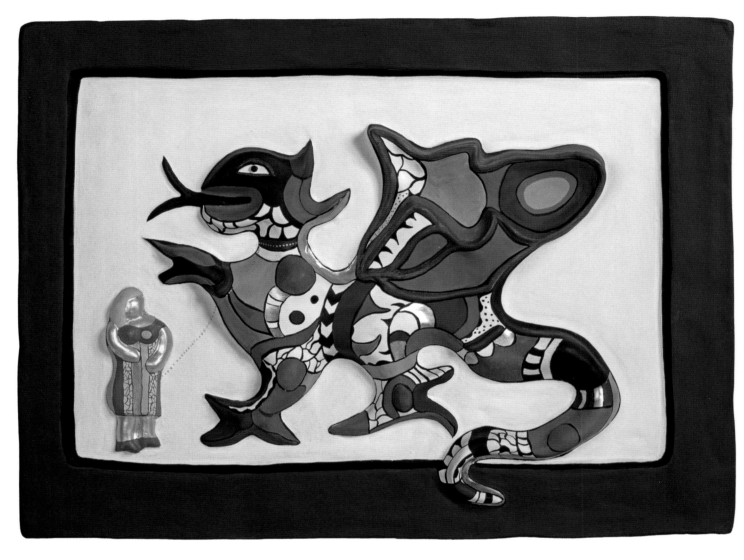

La force (*Strength*), 1985
Polyester paint, 36 x 50 cm

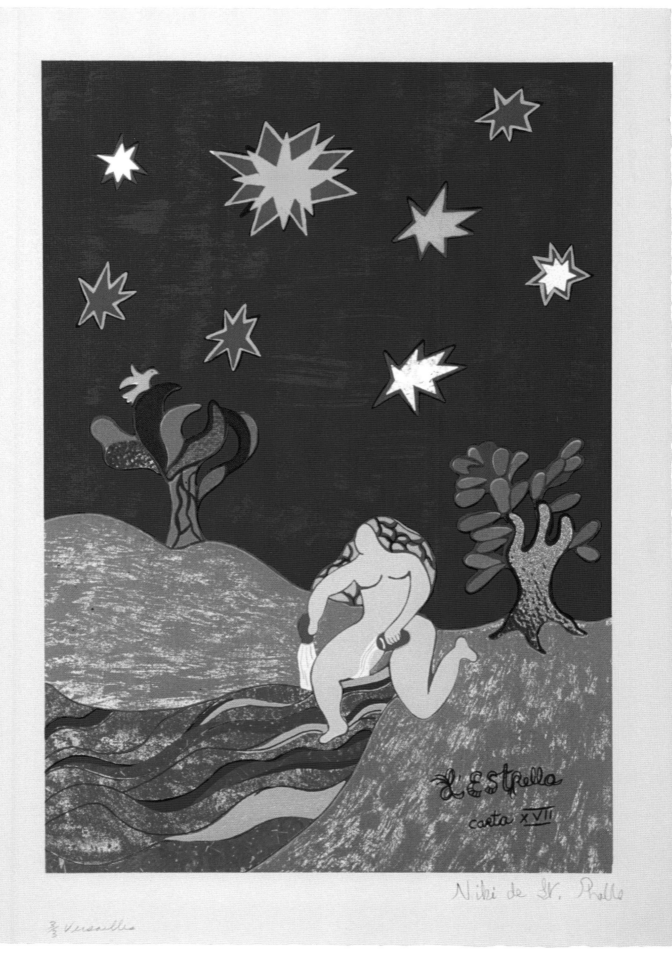

L'Estrella carta XVII (The Star)
(*The Star Card XVII [The Star]*), 1997
Lithograph, collage, 55.4 x 40.2 cm

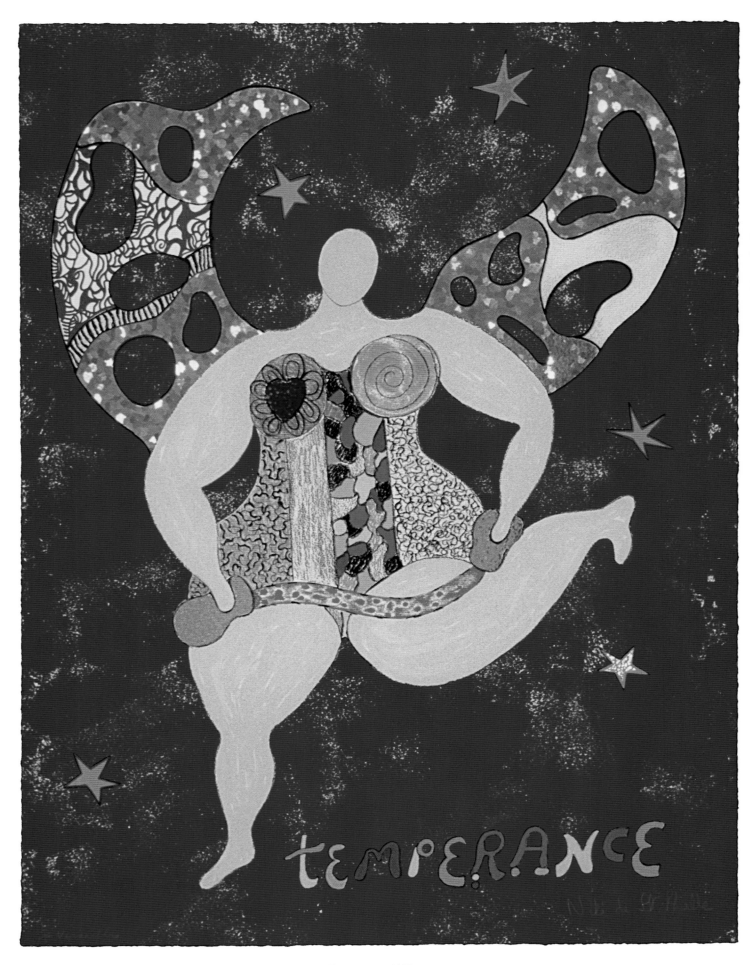

Temperance, 1997
Lithograph, collage, 74.9 x 56.5 cm

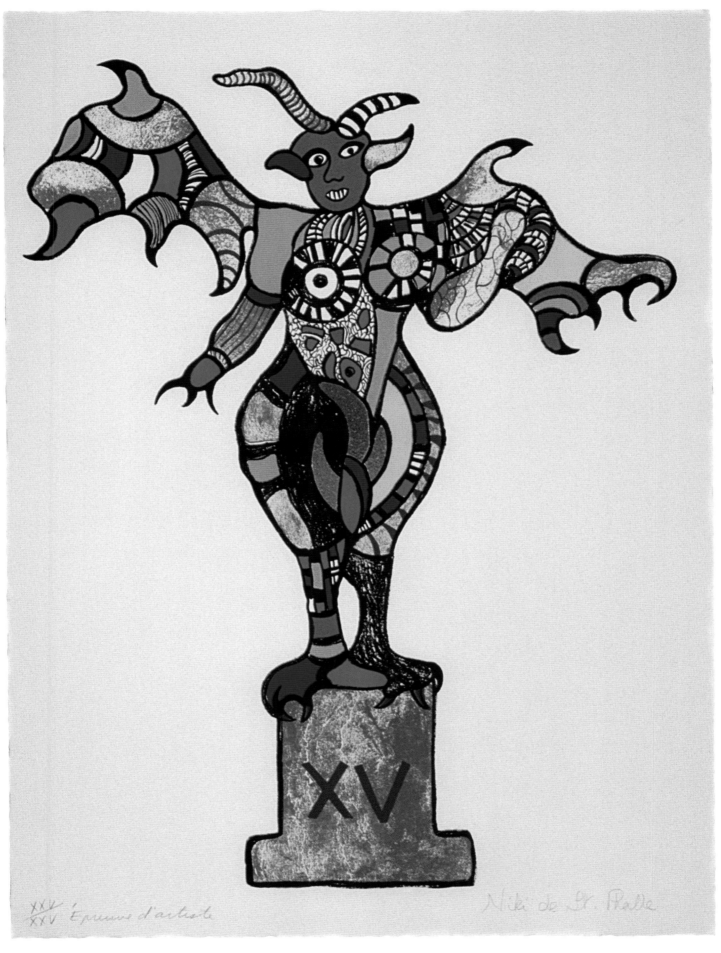

The Devil XV, 1997
Lithograph, collage, 75 x 56.2 cm

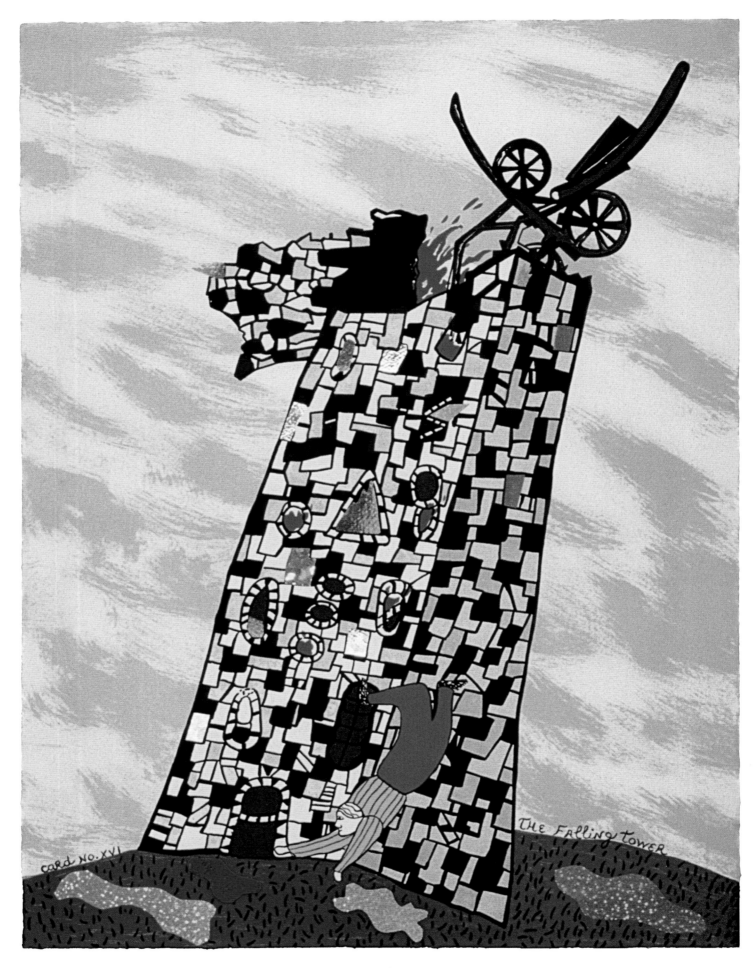

The Falling Tower, Card no. XVI, 1997
Lithograph, collage, 75 x 56.7 cm

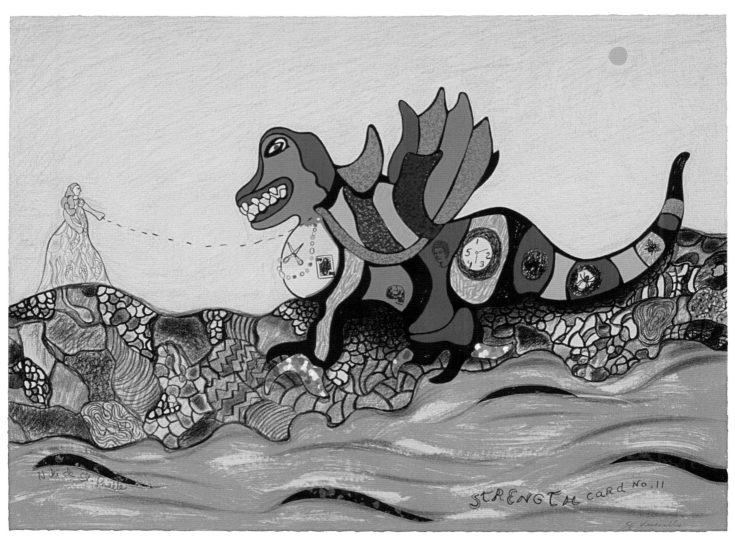

Strength, Card no. II, 1998
Lithograph, collage, 56.5 x 74.9 cm

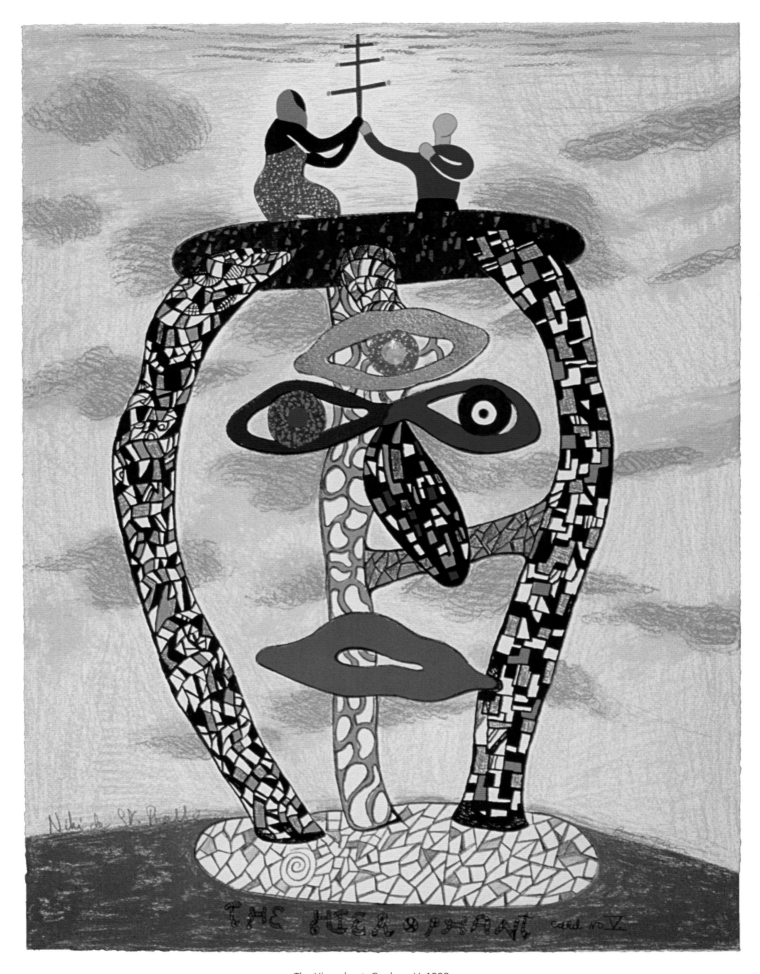

The Hierophant, Card no. V, 1998
Lithograph, collage, 75.2 x 56.2 cm

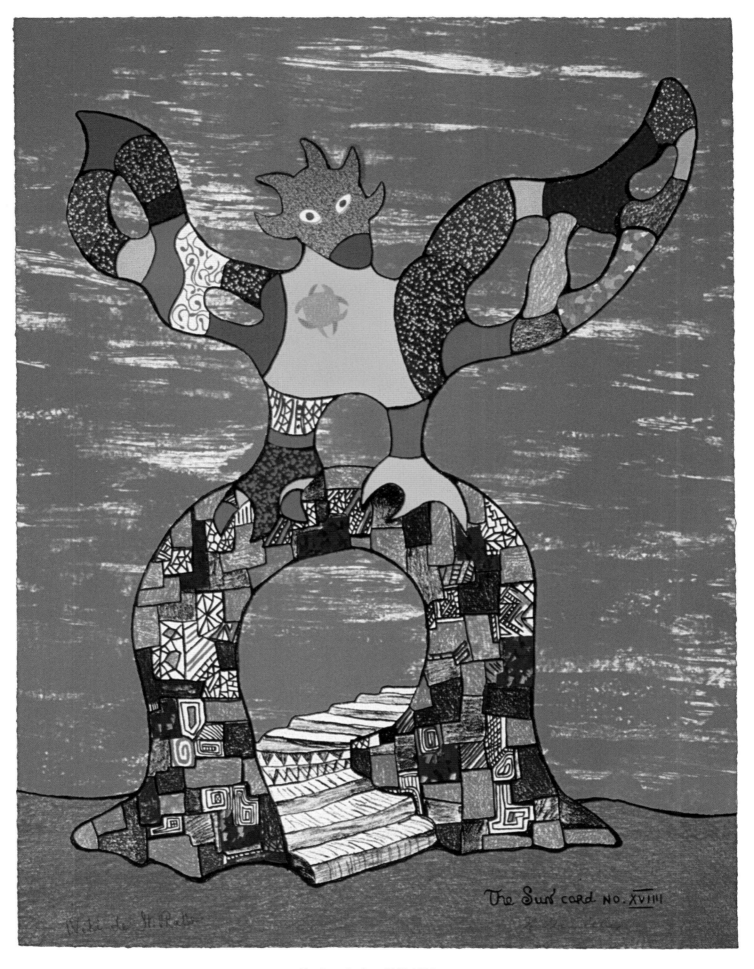

The Sun, Card no. XVIII, 1998
Lithograph, collage, 75 x 56.7 cm

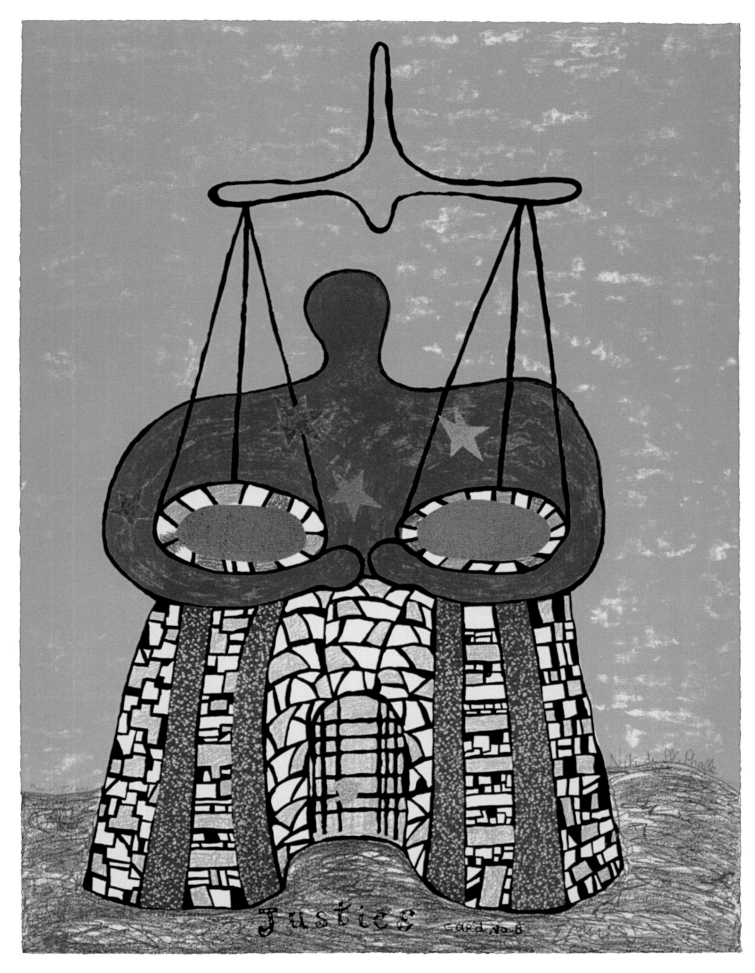

Justice, 1999
Lithograph, collage, 75 x 56.7 cm

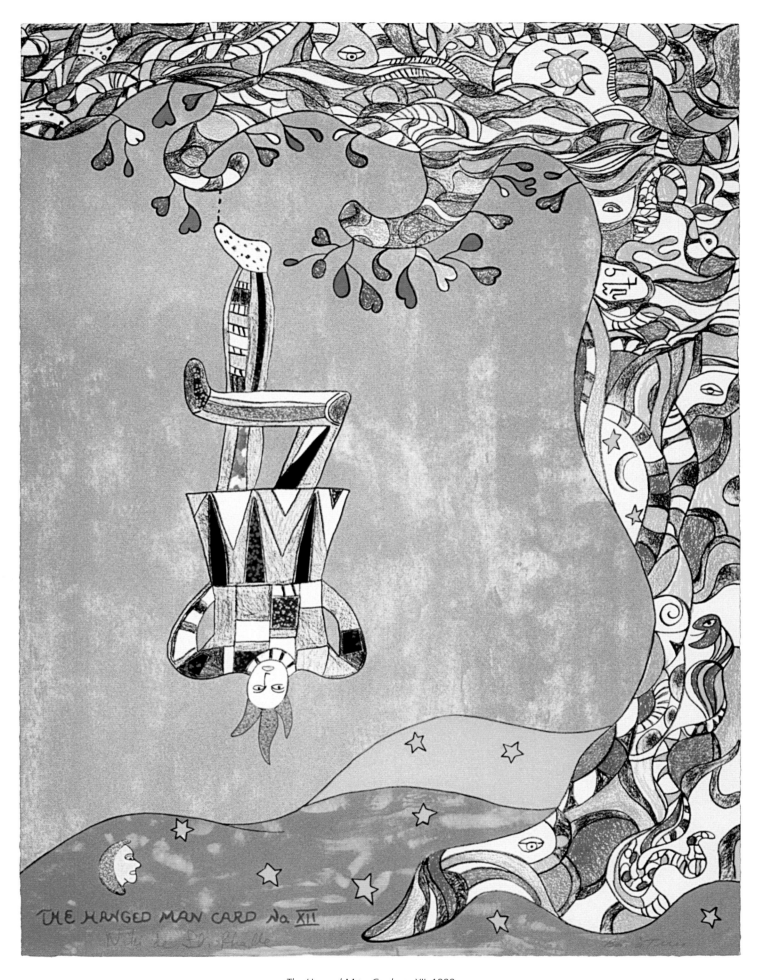

The Hanged Man, Card no. XII, 1999
Lithograph, collage, 75.5 x 56.6 cm

Spiritu

al Path

Could We Have Loved?, 1968
Silk screen print on Offset-Super-Bütten, 59 x 74 cm

My Love We Won't, 1968
Silk screen print on white Balkis, 61 x 49.3 cm

Sweet Sexy Clarice, 1968
Silk screen print on Offset-Super-Bütten, 59 x 74 cm

You Are My Love Forever and Ever and Ever, 1968
Silk screen print on Offset-Super-Bütten, 40 x 60 cm

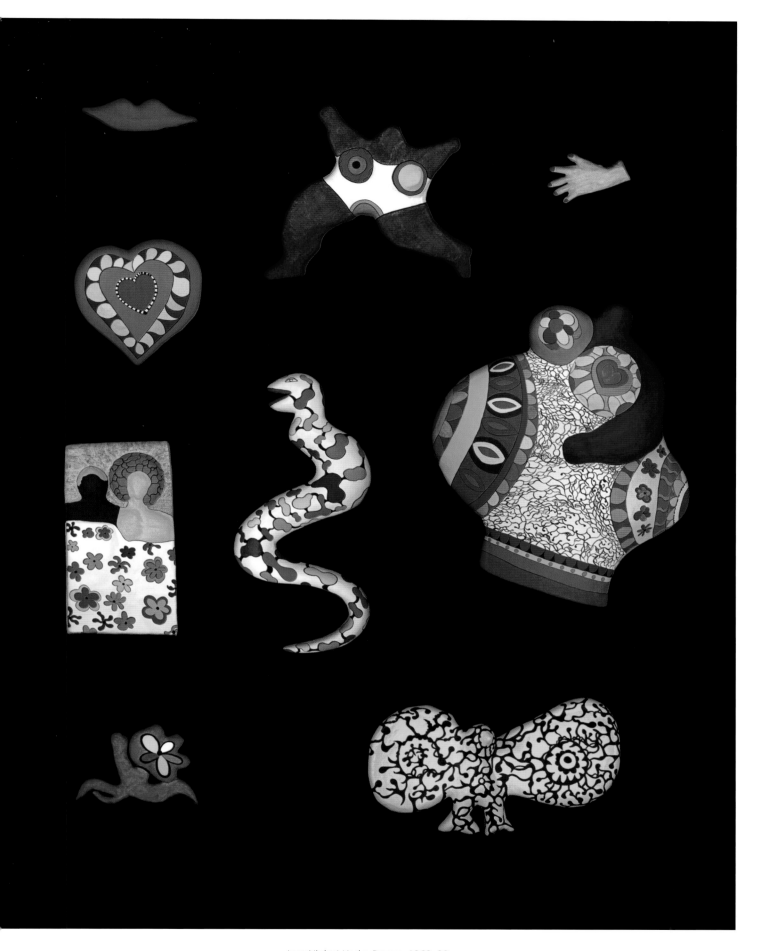

Last Night I Had a Dream, 1968–88
Multi-part polyester paint piece,
variable dimensions

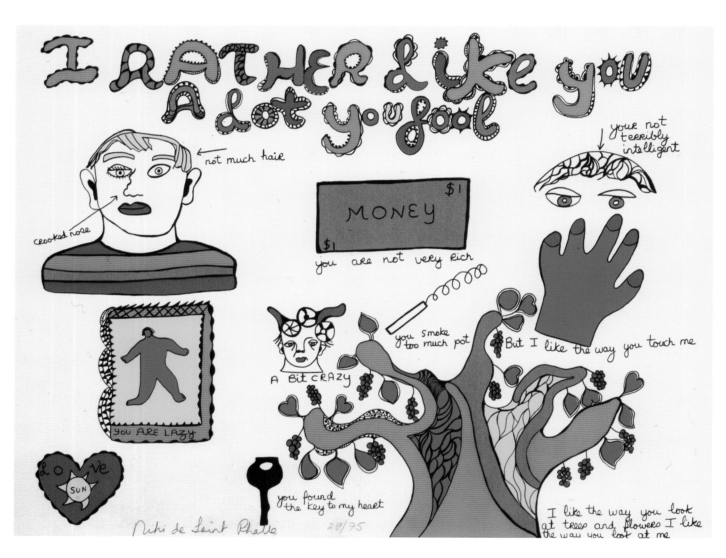

I Rather Like You a Lot You Fool, 1970
Silk screen print on white Balkis, 50 x 65.5 cm

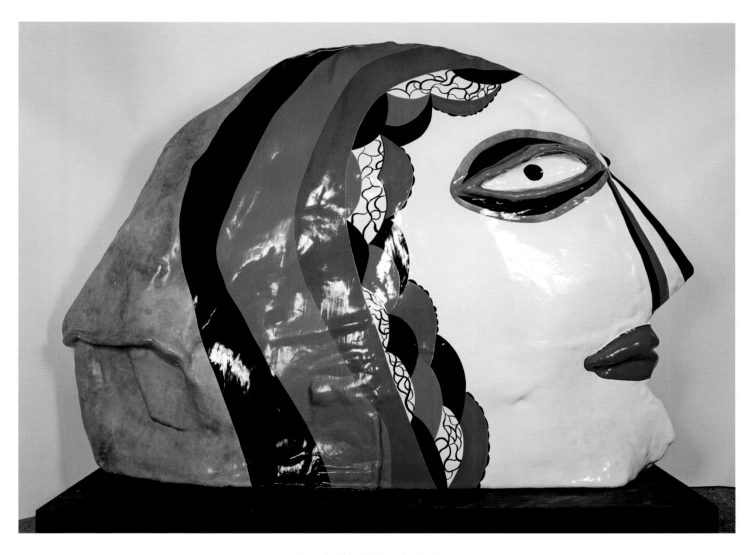

Grande Tête (*Big Head*), 1971
Polyester paint, 240 x 200 x 85 cm

"By making gay, joyous sculpt

the world is awful, but it is c

greatness." My work is about c

colors for dreams and emotions

purple. And it's about roundnd

My work gives me hope, enthus

is my REAL DIARY."

ee maybe I'm saying "look,

so great. So, let's enjoy its

or, the changing of

— red, blue, yellow, green,

s and the curves of nature.

sm, structure. My work

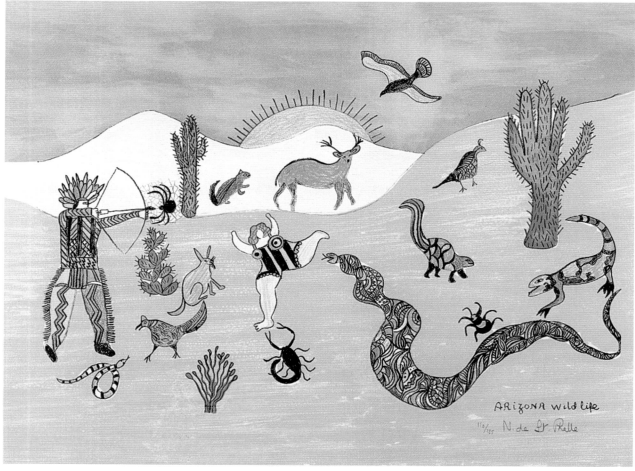

Dreaming Under a Cactus Tree, 1977
Lithograph, 50 x 65 cm

Arizona Wildlife, 1978
Lithograph, 50 x 65 cm

I Dreamt I Was in Arizona, 1978
Lithograph, 50 x 65.1 cm

Le chief indien (*Indian Chief*), 1978
Lithograph, 50 x 64 cm

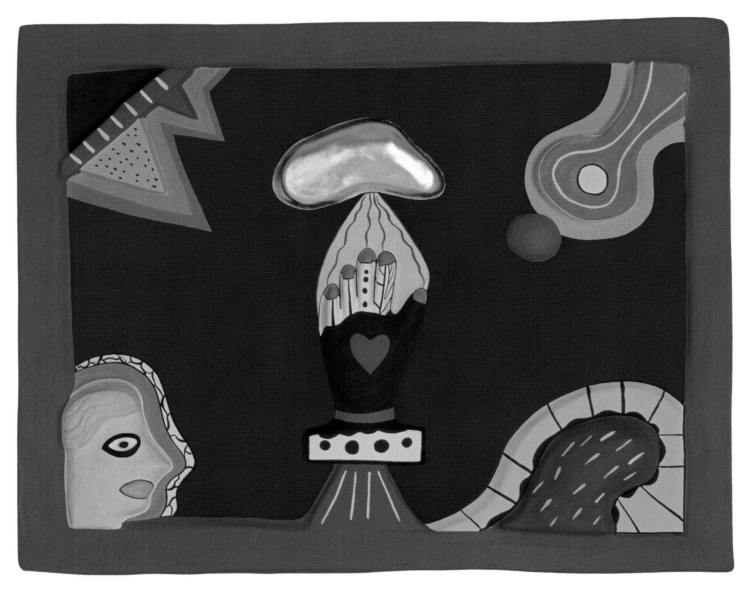

La main (*Hand*), 1984
Polyester paint, 33 x 41.5 x 4 cm

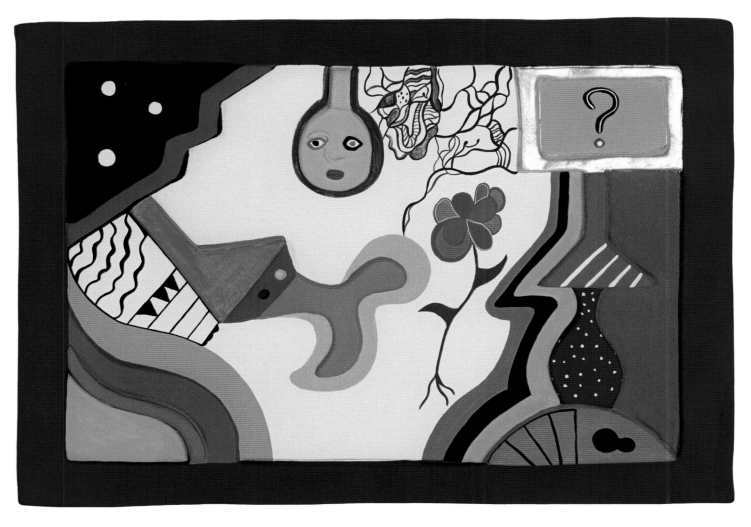

La question (*Question*), 1984
Polyester paint, 33 x 48.2 x 3 cm

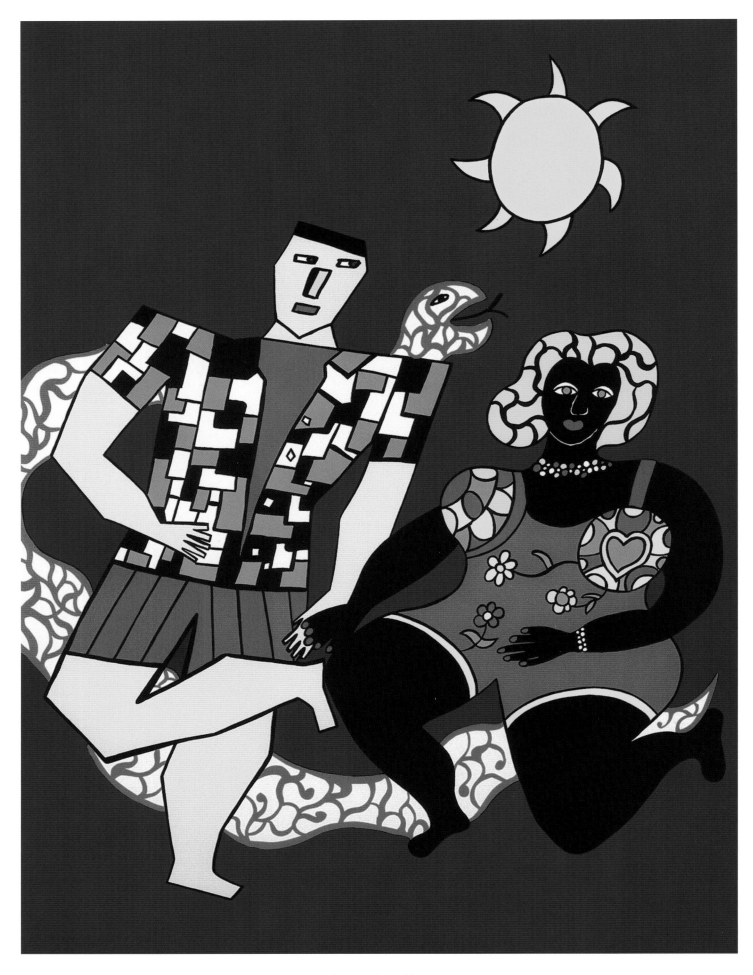

Les fiancées de Knokke II
(*The Fiancées of Knokke II*), 1997
Silk screen print, 79.7 x 60.4 cm

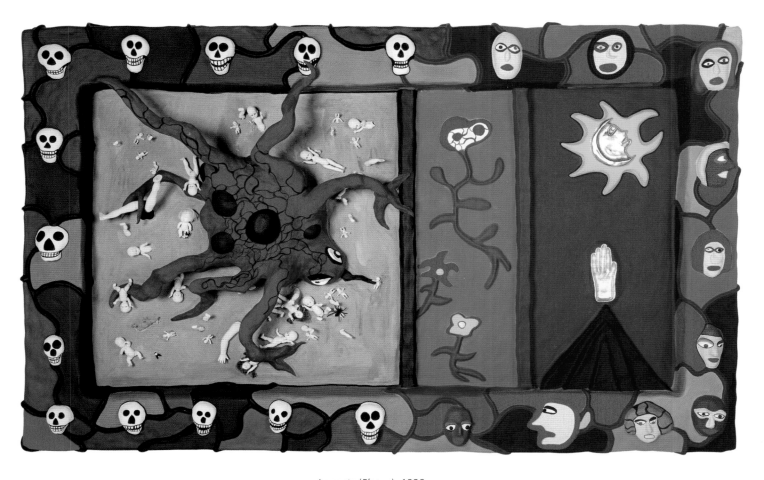

La peste (*Plague*), 1986
Polyester paint, (bright) plastic baby figurines,
113 x 185 x 30 cm

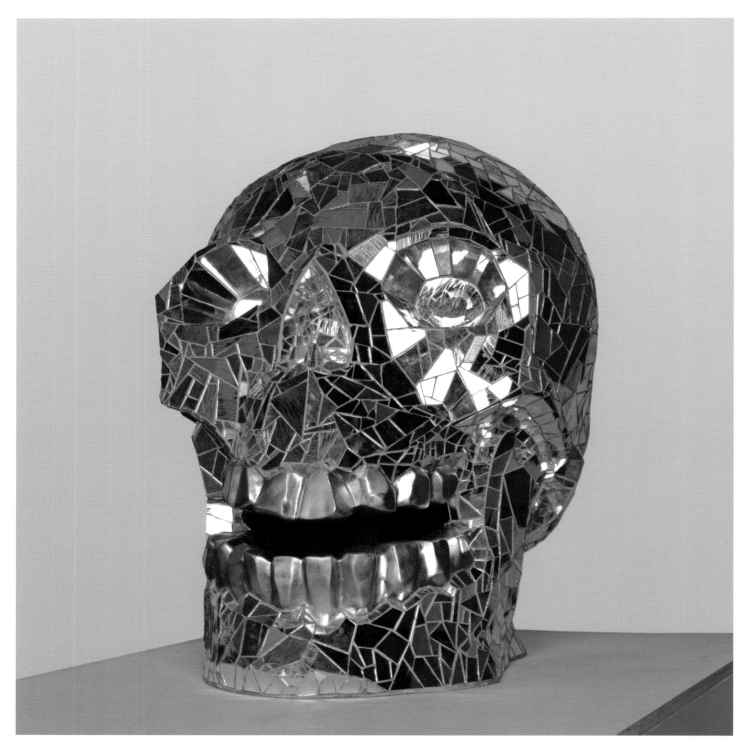

Tête de mort I (*Dead Head I*), 1988
Polyester, mirror, palladium leaf,
114.3 x 127 x 86.4 cm

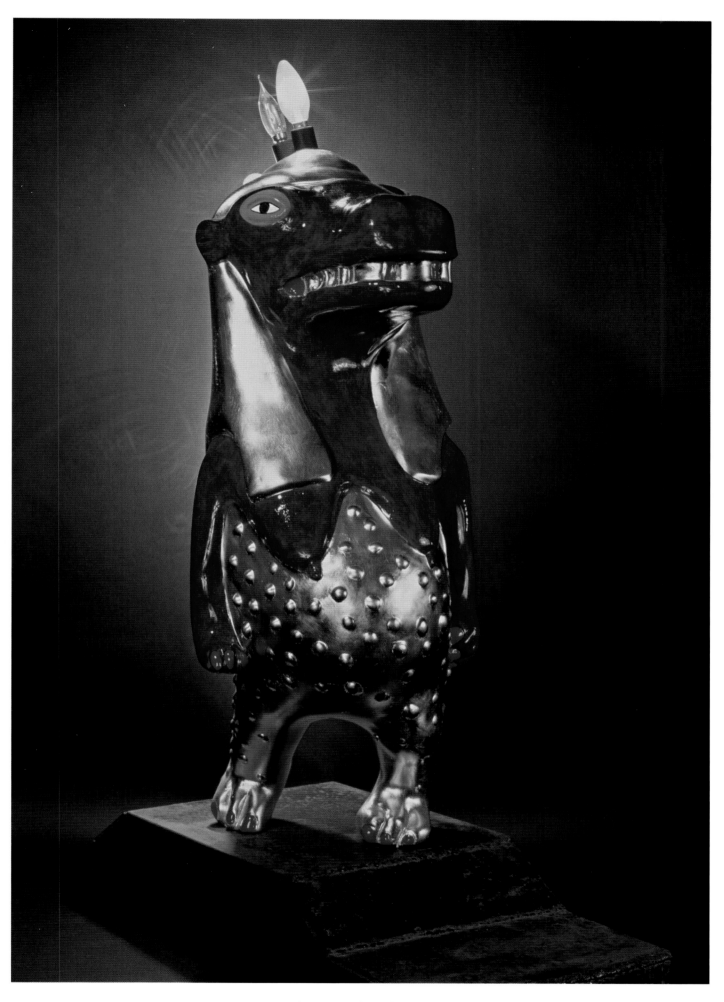

Thoëris-Hippo lampe (bleu) (B)
(*Thoëris-Hippo lamp [blue] [B]*), 1990
Polyester paint, bulbs on metal base,
90 x 31 x 37 cm

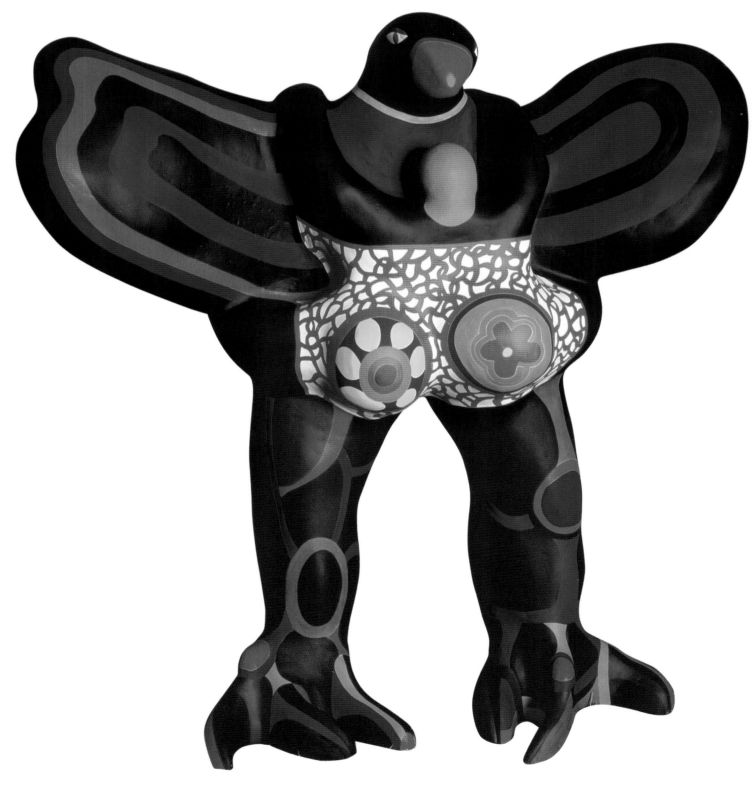

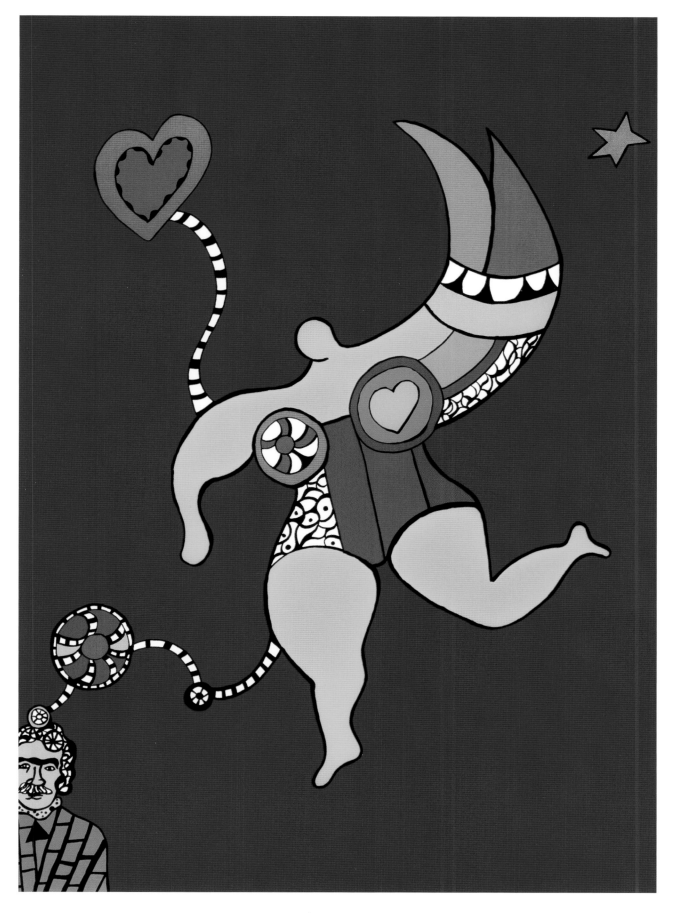

Jean in My Heart, 1992
Silk screen print, 100 x 70 cm

Oiseau amoureux (la nuit)
(*Bird in Love [the night]*), 1990
Polyester, polyurethane paint,
160 x 150 x 65 cm

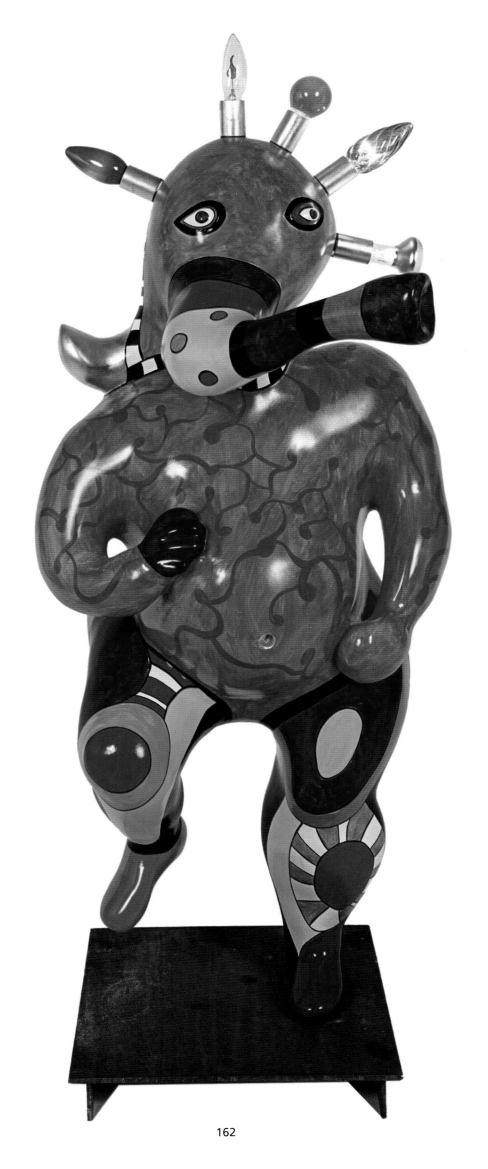

Californian Diary (Shamu! Killer Whale), 1993
Silk screen print, 121.9 x 79.4 cm

Ganesh (Série A) (Ganesh [Series A]), 1993
Polyester resin, resin paint, metal base,
light fixtures, 98 x 46 x 53 cm

163

Californian Diary (Christmas), 1993
Silk screen print, 80 x 120 cm

Californian Diary (Telephone), 1993
Silk screen print, 80 x 120 cm

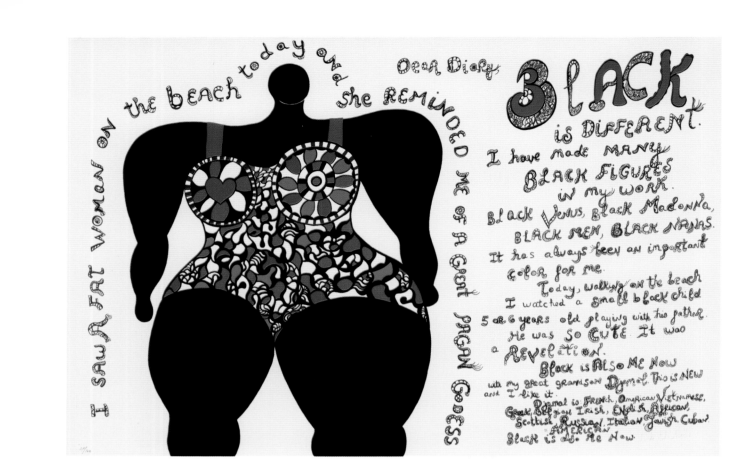

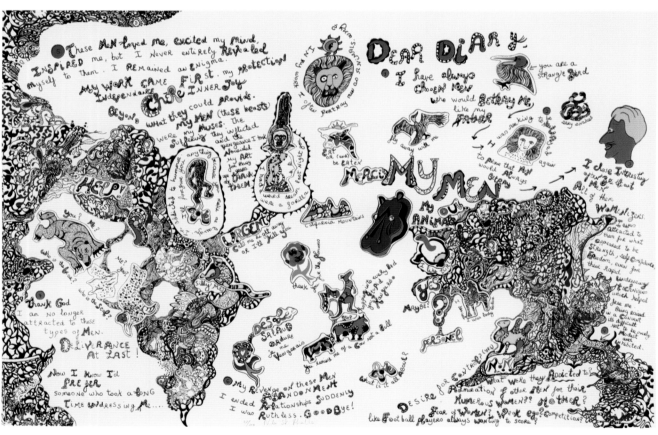

Californian Diary (Black is Different), 1994
Silk screen print, 80 x 120 cm

Californian Diary (My Men), 1994
Silk screen print, 80 x 120 cm

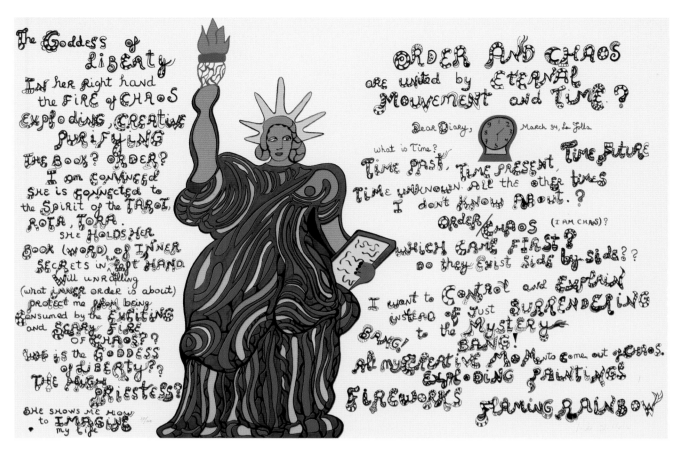

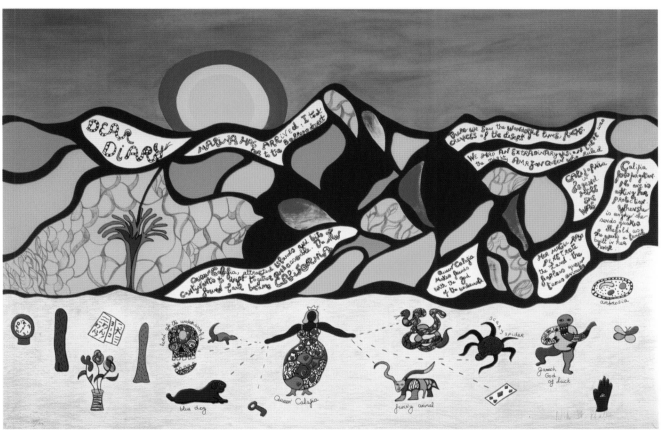

Californian Diary (Order and Chaos), 1994
Silk screen print, 80 x 120 cm

Californian Diary (Queen Califia), 1994
Silk screen print, 80 x 120 cm

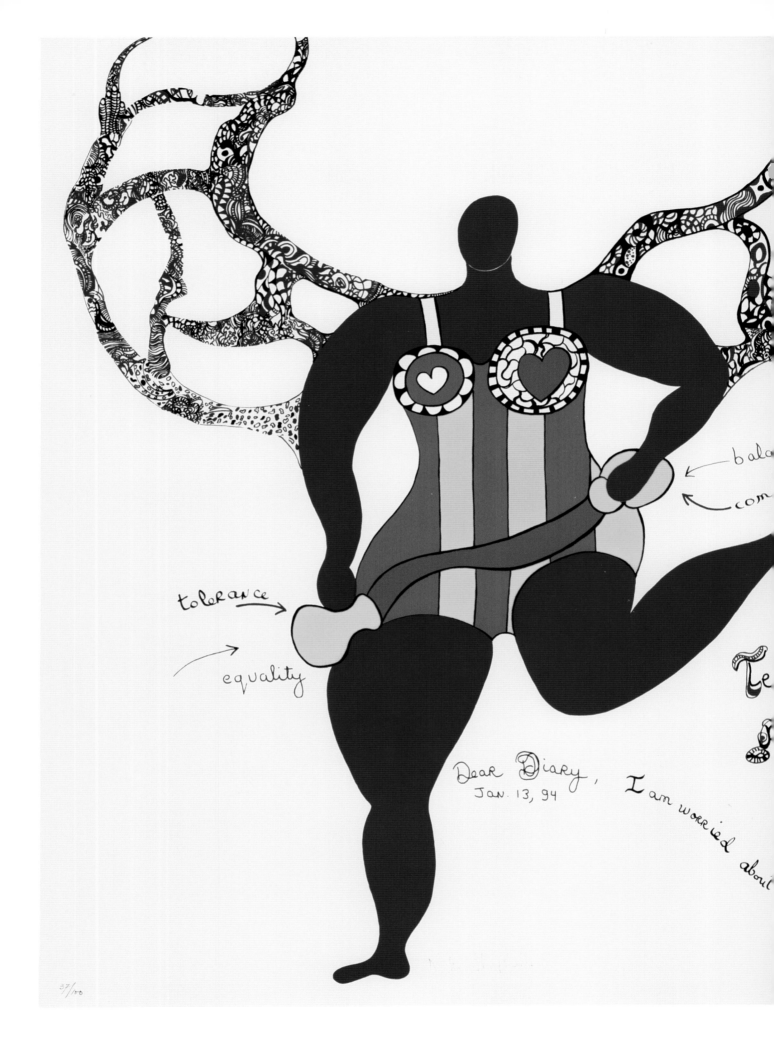

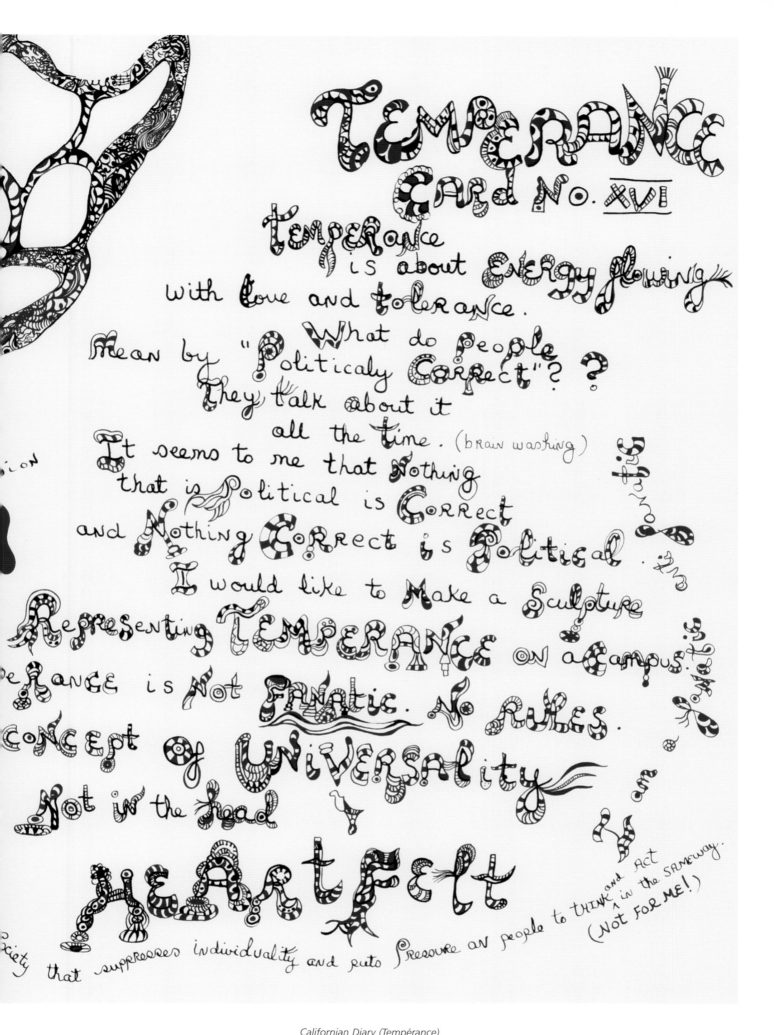

TEMPERANCE

CARD No. XVI

TEMPERANCE is about ENERGY flowing with love and tolerance.

What do people mean by "Politicaly Correct"? ?
They talk about it all the time. (brain washing)

It seems to me that Nothing that is Political is Correct and Nothing Correct is Political.

I would like to Make a Sculpture Representing TEMPERANCE on a campus.

TemPERANGE is Not FANATIC. No RULES. CONCEPT of UNIVERSALITY Not in the head HEARTFELT

...city that suppresses individuality and puts Pressure on people to THINK and ACT in the SAMEWAY. (NOT FOR ME!)

Californian Diary (Tempérance)
(*Californian Diary [Temperance]*), 1994
Silk screen print, 80 x 120 cm

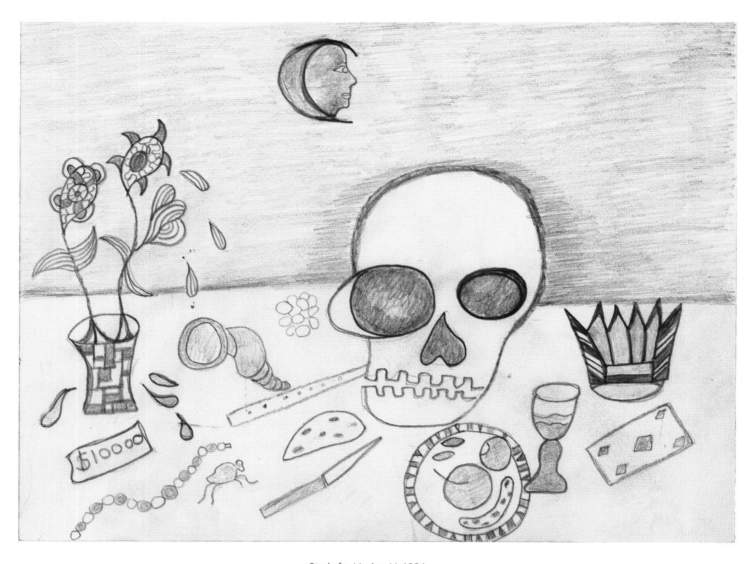

Study for Vanitas V, 1994
Pencil on paper, 229 x 305 mm

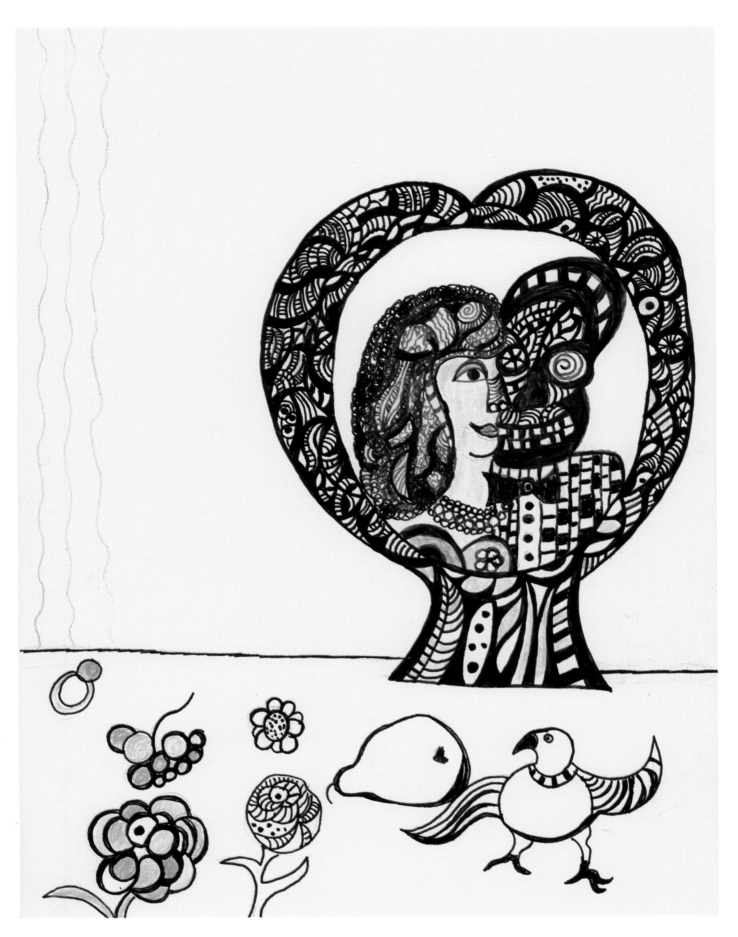

Study for Vanitas VI, 1994
Pencil, fine black liner, colored pencil on paper,
307 x 228 mm

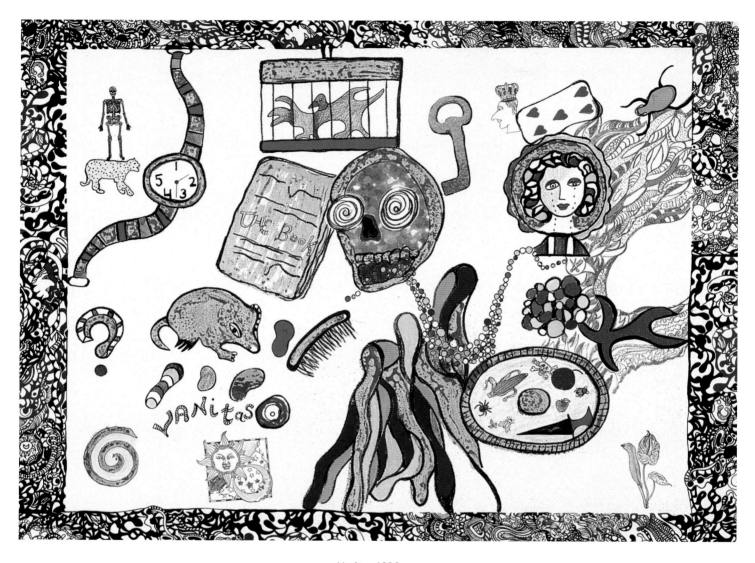

Vanitas, 1996
Lithograph, collage, 56.6 x 75.2 cm

Chandelier "Tete de mort"
(Inside skull rose) ("Dead Head" Candelabra
[Inside skull rose]), 1998
Polyester paint, multicolor glasses, electronic
components, mirrors, metal, 46 x 53 x 34 cm

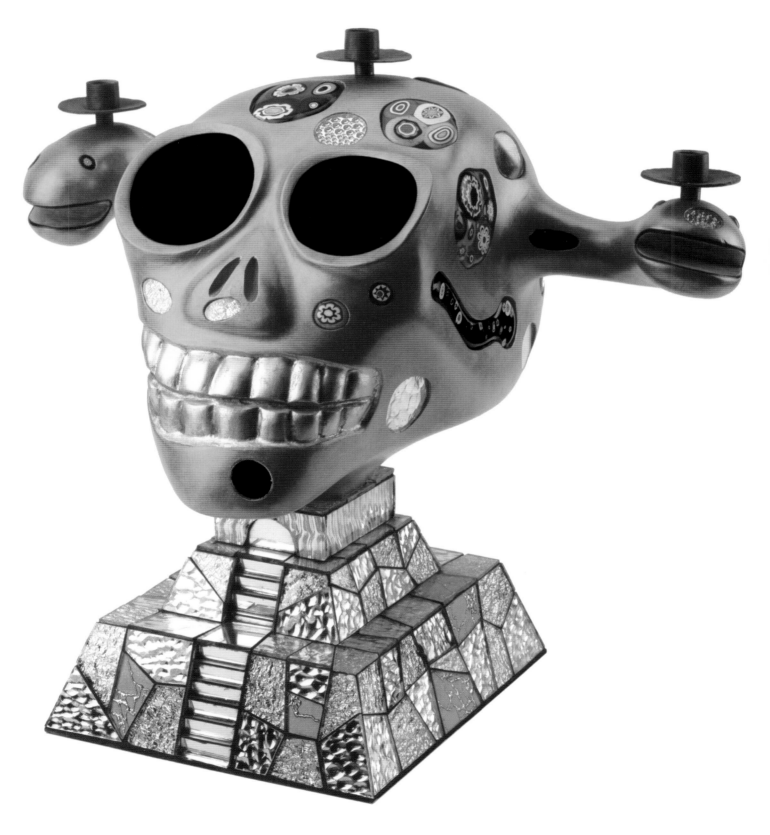

174

Fish Totem, 2000
Polyester paint, gold leaf, 94 x 38.1 x 35.6 cm

Snake Totem (Red), 2000
Polyester paint resin, mounted on square
steel base, 81.3 x 25.4 x 25.4 cm

Yelling Man Totem, 2000
Polyester paint resin, mounted on square
steel base, 89 x 35.6 x 35.5 cm

Step Totem, 2001
Polyester paint, gold leaf,
63.5 x 38.1 x 17.8 cm

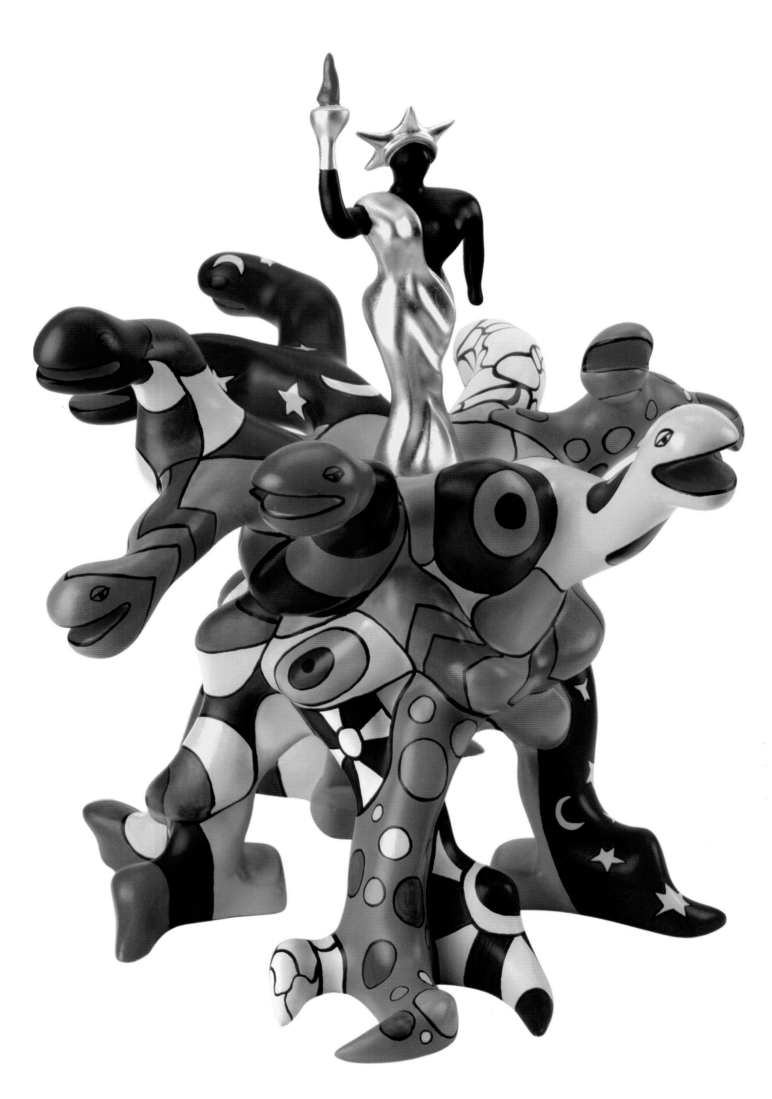

La mort n'existe pas, life is eternal
(*Death Does Not Exist, Life is Eternal*), 2001
Silk screen print, sticker, 61.6 x 48 cm

Tree of Liberty, 2000–01
Polyester paint, gold leaf, 48 x 50 x 54 cm

Biography

1930
Catherine Marie-Agnès Fal de Saint Phalle is born at Neuilly-sur-Seine on October 29. She is the second of five children born to Jeanne Jacqueline née Harper and André Marie Fal de Saint Phalle. Her father is one of seven brothers with a share in the family's banking house. When the stock exchange collapsed in 1930, he lost both the business and his fortune. Marie-Agnès is sent to her paternal grandparents in France where she spends the next three years in Nièvre.

1933
Marie-Agnès rejoins her parents in Greenwich, Connecticut. She often spends her summer holidays at the Château of Filerval, owned by her maternal grandfather and built by Le Nôtre.

1937
The family moves into an apartment on East 88th Street, New York. Marie-Agnès, now known as Niki, attends the Convent School of the Sacred Heart in East 91st Street.

1941
Niki de Saint Phalle is expelled from the Convent School. She moves to Princeton, New Jersey, to live with her grandparents, who left France because of the Second World War. She attends the local public school.

1942
Niki de Saint Phalle returns to her parents' home and attends Brearley School, New York. She reads Edgar Allan Poe, Shakespeare and Greek tragedy. She takes part in school performances and writes her first plays and poems, among which is *La Peste*.

1944
Niki de Saint Phalle paints the fig leaves on the school statues bright red. Her headmistress suggests Niki should either have psychiatric treatment or leave school. Her parents send her to a Convent School at Suffren, New York State.

1947
Niki de Saint Phalle graduates from Oldfield School, Maryland.

1948–49
She works as a model. Photographs of her appear in *Vogue*, *Harper's Bazaar* and on the cover of *Life Magazine*. At the age of 18, she elopes with Harry Mathews, 19, who had enrolled in the US Marines. On June 6, 1949, they marry in a registry office.

1950
In February, fulfilling their parents' wishes, Niki de Saint Phalle and Harry Mathews get married in the French Church, New York, and settle in Cambridge, Massachusetts. He studies music at Harvard University and Niki begins to produce her first oils and gouaches.

1951
In April, birth of their daughter, Laura, in Boston.

1952
Niki, Harry and Laura Mathews leave Boston and move into an apartment in the Rue Jean

Dolent in Paris. Harry Mathews carries on with his music studies in the hope of becoming a conductor. Niki studies drama. They both take charge of their daughter's education. The family spends the summer months in the South of France, Spain and Italy, where they visit museums and cathedrals. Niki is impressed by the idea that a cathedral is the result of a "collective ideal"; this thought will later have an important impact on her own work.

1953
Niki de Saint Phalle suffers a severe nervous breakdown and is treated as an in-patient in Nice. Since painting helps her to overcome this crisis in her life, she decides to give up acting and become a painter. At the same time, Harry Mathews abandons his music studies and writes his first novel.

1954
In March, Niki and Harry Mathews buy their first car in Nice. They drive back to Paris, where they share a house with Anthony Bonner, an American jazz musician and composer. Niki Mathews is introduced to the American painter Hugh Weiss, who remains her mentor for five years and who encourages her to retain her autodidactic style. In September, Niki, Harry and Laura Mathews move to Deyá on the island of Mallorca.

1955
Birth of their son Philip on May 1. Niki visits Madrid and Barcelona, where she discovers the work of Gaudí. These visits and particularly the Park Güell, change her life, and give her the idea of creating a garden of sculpture herself one day.

1956–58
The Mathews family spends most of their time in the French Alps at Lans-en-Vercors. Niki produces a series of oil paintings, which she exhibits for the first time in St. Gallen in April 1956.
In August the family returns to Paris and moves into a small apartment in the Rue Alfred Durand-Claye. Harry and Niki often visit the Louvre and other museums. Niki discovers the works of Paul Klee, Henri Matisse, Pablo Picasso and the Douanier Rousseau. With Harry Mathews she meets many contemporary writers, including John Ashbery and Kenneth Koch.
In 1956, Niki also meets Jean Tinguely and his wife Eva Aeppli. Niki visits Joseph Ferdinand Cheval's Palais Idéal at Hauterives. For her first sculpture, Niki asks Jean Tinguely to prepare an iron structure, which she covers with plaster.

1959
Niki visits the Musée d'Art Moderne de la Ville de Paris and sees works by the American artists Jasper Johns, Willem de Kooning, Jackson Pollock and Robert Rauschenberg.

1960
Niki and Harry Mathews separate; Harry moves to the Rue de Varennes with their children, while Niki remains in the Rue Alfred Durand-Claye. She continues her artistic experiments; producing assemblages in plaster and target pictures. At the end of the year, she and Jean

Tinguely move into the Impasse Ronsin, where they share the same studio. Jean Tinguely introduces her to Pontus Hulten, the director of the Moderna Museet in Stockholm who will organize many important exhibitions at that time and buy some of her works for the Moderna Museet.

1961

During February a group exhibition is held at the Musée d'Art Moderne de la Ville de Paris under the title *Comparaison: Peinture – Sculpture*. Niki exhibits a target montage titled *Portrait of My Lover*.

On February 12 she organizes the first of more than twelve "shootings" which are held in 1961, 1962 and 1963. These events involve assemblages incorporating containers of paint which, concealed beneath the plaster, spatter their contents over the image when shot with a pistol. The resultant pictures are known as "shooting paintings". Among spectators at the first event are members of the Nouveaux Réalistes. Enthused, Pierre Restany invites Niki to join the group, which already includes Arman, César, Christo, Gérard Deschamps, François Dufrêne, Raymond Hains, Yves Klein, Martial Raysse, Mimmo Rotella, Daniel Spoerri, Jean Tinguely and Jacques Villeglé.

In March, Niki de Saint Phalle takes part in an exhibition, *Bewogen Beweging*, organized by Pontus Hulten at the Stedelijk Museum in Amsterdam. This exhibition is later shown in the Moderna Museet in Stockholm and the Louisiana Museum in Humlebaek, Denmark.

On June 20, Jasper Johns, Robert Rauschenberg, Niki de Saint Phalle and Jean Tinguely take part in one of John Cage's concerts, a performance of *Variations II*, in the American Embassy in Paris. While David Tudor plays music by John Cage on the piano, other works of art are created on stage.

Pierre Restany organizes at the Galerie J, which is run by his wife Jeannine Goldschmidt, Niki's first solo exhibition under the title *Tir à volonté*, from June 30 to July 12. Leo Castelli, Robert Rauschenberg, Jasper Johns and all the Nouveaux Réalistes attend the launch. Rauschenberg buys a "shooting painting".

Pierre Restany organizes a Festival of Nouveaux Réalistes at the Galerie Muratore in Nice. For the official opening on the evening of July 13, Niki de Saint Phalle arranges a "shooting" at the Abbaye Roseland in which all the Nouveaux Réalistes take part.

Marcel Duchamp introduces Niki de Saint Phalle and Jean Tinguely to Salvador Dalí. During a trip to Spain in August, both artists are invited to take part in celebrations in honor of Dalí. They create a life-size bull made of plaster and paper, which explodes in the Arena at Figueras during a firework display.

In October Niki takes part in *The Art of Assemblage* exhibition at The Museum of Modern Art in New York. The exhibition subsequently travels to the Dallas Museum for Contemporary Art and the San Francisco Museum of Art.

Between June and September more than fifty international magazines and journals carry reports on Niki de Saint Phalle's work.

In the fall, Larry Rivers and his wife Clarice settle in one of the studios in the Impasse Ronsin; they and Niki soon strike up a friendship.

1962

In February Niki de Saint Phalle and Jean Tinguely travel to California and visit Simon Rodilla's Watts Tower near Los Angeles. With the help of Niki de Saint Phalle he organizes a "happening", *Study for an End of the World Number 2*, in the Nevada Desert. Niki stages her first two "shootings" in the United States: the first is held on March 4 at Virginia Dwan's beach house at Malibu, the second assisted by Ed Kienholz in the hills overlooking Malibu. Niki de Saint Phalle and Jean Tinguely travel to Mexico.

On May 4, Niki de Saint Phalle, Jean Tinguely and many other artists take part in Kenneth Koch's play, *The Construction of Boston*, directed by Merce Cunningham. On stage at the Maidman Playhouse, New York, is her "shooting sculpture" *Vénus de Milo*.

Following her return to Europe she exhibits ten works at a solo exhibition at Paris's Galerie Rive Droite. Among the visitors is Alexander Iolas, who invites Niki to exhibit in New York the following October. He supports her financially for many years and organizes numerous exhibitions. It is Iolas who introduces her to the Surrealist painters, Victor Brauner, Max Ernst and René Magritte.

Yves Klein dies suddenly on June 6.

From August 30 to September 30, Niki takes part in *Dylaby* (Dynamic Labyrinth), a large-scale installation at the Stedelijk Museum in Amsterdam, in which Robert Rauschenberg, Martial Raysse, Daniel Spoerri, Jean Tinguely and Per Olof Ultvedt are also involved.

From October 15 to November 3, Niki opens her first solo exhibition in New York at the Alexander Iolas Gallery. In addition to ten other works, she exhibits her *Homage to Le Facteur Cheval*, a shooting gallery in which members of the public are invited to fire at a construction.

1963

In May, Virginia Dwan organizes a shooting event in Los Angeles at which Niki de Saint Phalle shoots at her monumental sculpture *King Kong*. This work is bought by the Moderna Museet in Stockholm. Her taste for horror films is a source of inspiration for her. Niki de Saint Phalle and Jean Tinguely buy a former Inn, the Auberge du Cheval Blanc, at Soisy-sur-Ecole near Essonne, in France. Niki confronts the various roles of women in society, producing a series of sculptures of women in childbirth, devouring mothers, witches and whores.

1964

Niki de Saint Phalle spends the summer at Lutry, near Lausanne, working on large papier-mâché and wool heads, brides and her *St George and the Dragon*.

In September she has her first solo exhibition at London's Hanover Gallery.

In October she visits New York where she lives and works at the Chelsea Hotel, making a series of paper collages of Nanas, hearts and dragons.

1965

Inspired by Clarice Rivers' pregnancy, in April Niki de Saint Phalle creates her first Nanas, which are made of papier-mâché and wool.

In August, Monique Jacot writes a 12 page article on Niki in the Swiss art review *DU*.

In September, Niki shows her Nanas during her solo exhibition at the Galerie Alexandre Iolas in Paris. During the show the Artists Club of New York organizes a sort of tombola where works by leading artists are left in lockers at Penn Station. Keys cost $10 each. On that occasion, Iolas publishes her first artist's book, which includes a handwritten text illustrated with her drawings of Nanas.

At Iolas' suggestion, Niki begins to work on many promotional projects (invitations, posters, books, writings). She also makes her first series of silkscreen prints.

1966

In collaboration with Martial Raysse and Jean Tinguely, Niki de Saint Phalle designs the scenery and costumes for Roland Petit's ballet, *Éloge de la folie*, performed in March at the Théâtre des Champs-Elysées in Paris.

In June, Niki, Tinguely and Per Olof Ultvedt are invited by Pontus Hulten to install a sculpture in the Moderna Museet in Stockholm. They decide to create a monumental reclining Nana, 28 meters long, 9 meters wide and 6 meters high. It is called *Hon* (the Swedish pronoun meaning "she").

While working in Stockholm, Niki and Tinguely meet the young Swiss artist, Rico Weber. He works on *Hon* with them and remains their assistant and colleague for many years.

In October, Niki designs the sets and costumes for Aristophanes' *Lysistrata* in a production by Rainer von Diez at the Staatstheater in Kassel.

1967

Niki de Saint Phalle and Jean Tinguely work on *Le Paradis Fantastique*, a commission from the French government for the French Pavilion at Expo'67 in Montreal. The commission consists of nine painted sculptures by Niki and six black kinetic machines by Tinguely.

Le Paradis Fantastique is subsequently shown at the Albright-Knox Art Gallery in Buffalo and, for a year, in Central Park, New York. It is now on permanent exhibition in Stockholm, close to the Moderna Museet.

In August, Niki de Saint Phalle's first museum show is held at the Stedelijk Museum, Amsterdam, under the title *Nana Power*. For this exhibition she creates her first Nana Dream House and her first Nana Fountain and plans her first Nana Town.

The new exhibits are made of polyester, a material with which she has only recently started to work.

1968

In June, Niki de Saint Phalle's first play, *ICH* (All about Me), is performed at the Staatstheater in Kassel. Her co-author is the director, Rainer von Diez. She designs the sets, costumes and the bill.

In October, Niki exhibits her eighteen-part wall relief, *Last Night I Had a Dream*, at the Galerie Alexandre Iolas in Paris. She designs inflatable Nanas, which are marketed in New York. Towards the end of the year Niki suffers serious breathing difficulties caused by inhaling polyester fumes and dust. She visits Morocco.

1969

Following her return from a visit to India, Niki de Saint Phalle begins work on her first architectural project: three houses in the South

of France for Rainer von Diez, which were completed in 1971.

The Whitney Museum of American Art in New York acquires the sculpture *Black Venus* and exhibits it at its April exhibition, *Contemporary American Sculpture, Selection 2*.

Niki de Saint Phalle begins work on *La tête (Le Cyclop)*, a collaborative project in Milly-la-Forêt, France, initiated by Jean Tinguely and involving a large number of artists.

1970

On November 29, a festival is organized by Pierre Restany and Guido Le Noci in Milan to mark the tenth anniversary of the founding of the Nouveaux Réalistes. At the opening ceremony, Niki de Saint Phalle shoots at an altar assemblage.

A series of seventeen serigraphs is published in Paris under the title Nana Power.

Niki visits Egypt for the first time with Jean Tinguely.

1971

On July 13, Niki de Saint Phalle and Jean Tinguely are married in Soisy. They visit Morocco. Her granddaughter Bloum is born on the Island of Bali to Niki's daughter, Laura, and Laurent Condominas.

Niki designs her first jewelry. At the end of the year she begins work on *Golem*, an architectural project for children in Jerusalem's Rabinovitch Park, completed in 1972.

1972

From this year on Niki de Saint Phalle works with Robert Haligon, Fabricant de Plastiques d'Art, and later with his son Gérard, to produce her large-scale sculptures and editions. In July she rents the Château-de-Mons near Grasse in the South of France, where she begins shooting the first version of *Daddy*, written and produced in association with Peter Whitehead, and shown at London's Hammer Cinema the following November.

She also visits Greece.

1973

In January, Niki de Saint Phalle works on a revised version of *Daddy* in Soisy and New York, again with Mia Martin, Clarice Rivers and Rainer von Diez. The world première of the revised version is shown in April as part of the 11th New York Film Festival at the Lincoln Center. Niki designs the cover of the program. She designs a swimming pool for Georges Plouvier in Saint-Tropez.

In the Belgian town of Knokke-le-Zoute she builds the *Dragon*, a fully equipped playhouse for the children of Fabienne and Roger Nellens.

1974

Niki de Saint Phalle installs three gigantic Nanas in Hanover, which the city names Caroline, Charlotte and Sophie, to honor the city's most recognized women in history.

In Paris the Galerie Alexandre Iolas shows an exhibition of her architectural projects.

She suffers an abscess on her lung, caused by years of working with polyester. After a period in hospital she visits Arizona and St. Moritz to convalesce. It is here that she meets again Marella Agnelli, a friend whom she met in the 1950s in New York. Niki tells her of her dream of making a sculpture garden and Marella's

brothers, Carlo and Nicola Caracciolo, offer her land in Tuscany on which to realize her dream.

1975

Niki de Saint Phalle writes the screenplay for the film, *Un rêve plus long que la nuit*. Many of her artist friends are involved in shooting the film. She designs several pieces of furniture for the sets.

1976

Niki spends the entire year in the Swiss mountains planning her sculpture park.

1977

Together with Constantin Mulgrave, Niki de Saint Phalle designs the sets for the film, *The Traveling Companion*, which is based on a fairy story by Hans Christian Andersen, yet the film is never finalized. She visits Mexico and New Mexico. Ricardo Menon becomes her assistant. He will work with her for the next ten years.

1978

Niki de Saint Phalle begins laying out her Tarot Garden on the estate of Carlo and Nicola Caracciolo at Garavicchio in Tuscany. Inspired by the Tarot cards, Niki begins a series of 22 monumental sculptures.

1979

Niki de Saint Phalle spends most of her time in Tuscany laying the foundations for her Tarot Garden. In March she holds her first exhibition in Japan at Tokyo's Watari Gallery. Gimpel & Weitzenhoffer of New York holds an exhibition of the models and photographs for her architectural projects. The exhibition, *Monumental Projects*, tours the U.S.A.

She invents new sculptures, which she calls *Skinnies*.

1980

In April, Niki begins work on the first sculptures for her Tarot Garden, *The Magician* and *The High Priestess*. In Ulm, her sculpture *Le Poète et sa Muse*, is unveiled on the university campus. The installation coincides with an exhibition of her graphic work, which lasts from May until July.

From July to September the Centre Georges Pompidou in Paris devotes an important retrospective exhibition to her, which subsequently travels to Austria, Germany and Sweden.

Yoko Masuda organizes the first exhibition at the Space Niki in Tokyo.

Niki makes her first polyester snake chairs, vases and lamps.

1981

Niki rents a small house close to the Tarot Garden for which she employs local workers. Jean Tinguely and his All Star Swiss Team of Sepp Imhof and Rico Weber take on the task of welding the tarot sculptures. In spring she paints the exterior of a new twin-engine airplane, the Piper Aerostar 602 P, for the Peter Stuyvesant Foundation in Amsterdam. In June, the plane arrives second in the first Paris-New York-Paris transatlantic air race.

1982

An American company, Jacqueline Cochran, New York, invites Niki de Saint Phalle to create

a new perfume. She uses the proceeds to finance her Tarot Garden.

Tinguely and Niki collaborate on a sculpture-fountain of 15 elements for the Place Igor Stravinsky in front of the Centre Georges Pompidou, Paris.

They are assisted by Pierre Marie Lejeune who continues to assist Niki and Jean for many years.

The Galleries of Gimpel & Weitzenhoffer in New York and Gimpel Fils, London, show Niki's Skinnies.

Work on the Tarot Garden progresses. Substituting Jean Tinguely, the Dutch artist Doc van Winsen works on the steel construction of the sculptures. By the end of the year they begin applying cement.

Niki suffers her first attack of rheumatoid arthritis.

1983

The Stuart Foundation commissions a sculpture, *Sun God*, for the campus of the University of California at San Diego.

Niki de Saint Phalle moves into *The Empress* in the Tarot Garden and will use that building, designed in the shape of a sphinx, as a studio and home for the next seven years.

She decides to use ceramics in addition to mirrors and glass for the sculptures. Ricardo Menon discovers Venera Finocchiaro, a ceramics teacher in Rome, who produces all their ceramics from now on.

1984

Niki works full-time on her Tarot Garden.

1985

The buildings *The Magician, The Tower, The Empress* and *The High Priestess* are completed. Jean Tinguely constructs a machine for *The Tower of Babel*.

1986

Niki de Saint Phalle spends most of the year at Garavicchio, where more sculptures are installed in her Tarot Garden.

Together with Professor Silvio Barandun she writes and illustrates a book, *AIDS: You Can't Catch It Holding Hands*, published in English and later translated into five other languages.

Ricardo Menon returns to Paris to attend drama school. He introduces Niki de Saint Phalle to Marcelo Zitelli, who becomes her assistant.

1987

In March, the Kunsthalle der Hypo-Kulturstiftung in Munich holds a major exhibition of Niki de Saint Phalle's work, *Niki de Saint Phalle - Bilder - Figuren - Phantastische Gärten*.

Her first retrospective in America is held at the Nassau County Museum of Fine Art in Roslyn, Long Island, under the title *Fantastic Visions: Works by Niki de Saint Phalle*.

1988

Niki de Saint Phalle and Jean Tinguely receive a commission from President Mitterrand to design a fountain for Château Chinon, where he had been mayor for many years. Mitterrand unveils the fountain, in front of the town hall, on March 10.

Helen Schneider commissions another fountain

for the Schneider Children's Hospital in Long Island. Niki de Saint Phalle designs a snake tree 5.50 meters in height.
She also designs a gigantic kite *L'Oiseau amoureux*, for a world-wide traveling exhibition devoted to kites and organized by the Goethe Institute, Japan.

1989
Niki has a twin exhibition at the JGM Galerie and the Galerie de France in Paris under the title *Oeuvres des années 80*, where she shows works created in collaboration with Jean Tinguely.
She works in bronze for the first time and designs a series of Egyptian gods.
Ricardo Menon dies of AIDS.
Together with her son Philip Mathews, she produces a cartoon film that is based on her book, *AIDS: You Can't Catch It Holding Hands*.

1990
In June, Niki de Saint Phalle exhibits works from the 1960s at both the Galerie de France and the JGM Galerie in Paris. The exhibitions are titled *Tirs... et autres révoltes 1961-1964*.
In November she presents her film about Aids at the Musée des Arts Décoratifs in Paris.
To coincide with the presentation, the museum mounts an exhibition of drawings for the film and for the revised version of the book *Sida: tu ne l'attraperas pas...* is published by the Agence Française de Lutte contre le SIDA and distributed to schoolchildren throughout France.

1991
Niki makes a maquette for *Le Temple Idéal*, a place for worship for all religions. This architecture was originally conceived in the early 1970s as a hopeful alternative to the religious intolerance she observed while working in Jerusalem. She receives commission from the City of Nîmes, France, to build this architectural sculpture. Because of politics, the project is never realized.
In June, an exhibition is held at the Gimpel Fils Gallery, London, under the title *Gods*.
Jean Tinguely dies in Bern, Switzerland, in August 1991. In his honor, she makes her first kinetic sculptures, the *Meta-Tinguelys*.

1992–93
A major retrospective is organized by the Kunst- und Ausstellungshalle in Bonn, Germany, which later travels – slightly modified for each new exhibition – to the McLellan Galleries, Glasgow; the Musée d'Art Moderne de la Ville de Paris; and the Musée d'Art et d'Histoire, Fribourg, Switzerland.
She conceives a series of kinetic reliefs or paintings in movement called the *Tableaux Eclatés*. A large-scale outdoor fountain, *Lebensretter*, is installed in Duisburg, Germany. She makes a sculpture called *The Footballers* for the Musée Olympique in Lausanne.

1994
Niki de Saint Phalle moves to San Diego, California, where she lives for the next eight years. She contracts with Lech Juretko to organize a studio for the cutting of mirrors, glass and stones, which she increasingly uses in her sculptures in place of paint.
She creates a series of silkscreens, *California*

Diary, published by Ebi Kornfeld, as well as 26 lithographs created with George Page and Jacob Samuel, who both used to work with Sam Francis. In October, the Niki Museum opens in Nasu, Japan, devoted to the life and work of Niki de Saint Phalle.
She embarks on collaboration with Swiss architect Mario Botta for a major sculpture/architecture project, *Noah's Ark*, commissioned by the Jerusalem Foundation for The Tisch Family Zoological Gardens in Jerusalem, Israel.
She designs the postage stamp *Stop AIDS/Stop SIDA* for Switzerland where she is awarded Le Prix Caran d'Ache.

1995
Peter Schamoni completes a documentary film about Niki, *Who is the Monster? You or Me?*
The French cultural agency, Asociacion Francesca de Accion Artistica, organizes a traveling exhibition of Niki's works to major museums in Mexico, Venezuela, Brazil and Chile.

1996
This year Niki begins construction at a private residence in San Diego of the *Gila Monster*, a children's playhouse in the form of a dragon 4 meters high and 9.50 meters long. It is covered in a mosaic of mirrors, stones, ceramics and glass.
The Jean Tinguely Museum designed by Mario Botta opens in Basel. Niki donates 55 major sculptures and over a hundred graphic works by Jean, making up the bulk of the collection.

1997
Niki de Saint Phalle receives a commission from the Swiss Railways (CFF) for *L'Ange Protecteur*, a 33 feet high sculpture, which is unveiled in November in Zurich railway station.
Mario Botta constructs a wall and an entrance for the Tarot Garden.
Niki designs snake chairs in wood with mosaic inlay, which are made by Del Cover and Dave Carr.

1998
The Tarot Garden is officially opened on May 15, 1998.
Niki finishes the last of twenty-two animal sculptures for *Noah's Ark* as well as the *Black Heroes* series, a homage to prominent African-Americans, including Miles Davis, Louis Armstrong and Josephine Baker.
The largest American retrospective to date of Niki de Saint Phalle's work is curated by her close friend Martha Longenecker, the director of The Mingei International Museum in San Diego.

1999–2000
Niki begins a search for land on which to build a sculpture garden in San Diego County. In October 2000, the City of Escondido accepts her offer to create a garden in the Sankey Arboretum in Kit Carson Park. She starts design work and plans for *Queen Califia's Magical Circle*. She draws much of its imagery from her interpretations of early California history, myth, and legend, Native Americans and Mesoamerican culture and the study of indigenous plant and wildlife.
She is awarded the 12th Praemium Imperial

Prize (Sculpture Category) sponsored by the Japan Art Association, which is considered to be the equivalent to the Nobel Prize in the art world. Among the other prize winners in 2000 are American composer Stephen Sondheim, painter Ellsworth Kelly, the German composer Hans Werner Henze, and the British architect Richard Rogers.
Niki starts to exhibit at the Tasende Gallery, San Diego.
In November 2000, the Sprengel Museum in Hanover, Germany, unveils a portion of the more than 300 works she has donated and publishes a major catalogue about the gift.
Niki makes a new series of vases.

2001
Niki accepts a commission to redesign and ornament three rooms in the historic seventeenth-century Grotto built in Hanover's Royal Herrenhausen Garden. Originally decorated with shells, crystals and minerals, which were removed in the eighteenth century, the building was used as a store for many years.
Niki donates major gifts of works to the City of Nice for its Musée d'Art Moderne et d'Art Contemporain, and to the Musée d'Art Décoratifs in Paris.
She designs and builds a 12-meter-tall sculpture *Coming Together* for the Port of San Diego. The sculpture is in the shape of a face, half female and half male, adorned with mosaic and stones, and it is inaugurated in October.
Niki finishes writing the second volume of her autobiography *Harry & Me. The Family Years*.

2002
Niki de Saint Phalle dies on May 21 at the age of 71 in La Jolla, California.
Her granddaughter Bloum Cardenas, assistant/collaborator Marcelo Zitelli, technical advisor Lech Juretko, and other members of her international staff oversee final work on the Escondido and Hanover projects to ensure they meet her specifications. The exhibition, *From Niki Matthews to Niki De Saint Phalle*, opens at the Sprengel Museum in Hanover.

2003
The Grotto opens in March with mosaic decorations of glass, mirrors, and pebbles, as well as a host of painted and sculpted figures.
A summer exhibition of monumental sculptures is held in the Palais-Royal Gardens in Paris.
Queen Califia's Magical Circle is dedicated and opens to the public on October 26. This is her first American garden and the last major project realized by the artist.
The Niki Charitable Art Foundation, a non-profit organization, is established.

Bibliography

1961

• *Comparaisons: Peinture Sculpture*, exhibition catalogue, M.A.M.V.P., Paris, France.
• *Bewogen Beweging*, exhibition catalogue, Stedelijk Museum, Amsterdam, Netherlands.
• *Rörelse i konsten*, exhibition catalogue, Moderna Museet, Stockholm, Sweden.
• *Nouveaux Réalistes*, exhibition catalogue, Galerie Samlaren, Stockholm, Sweden.
• *The Art of Assemblage*, exhibition catalogue, The Museum of Modern Art, New York, USA.

1962

• *Niki de Saint Phalle*, exhibition catalogue, Galerie Rive Droite, Paris, France.
• *Comparaisons: Peinture Sculpture*, exhibition catalogue, M.A.M.V.P., Paris, France.
• *Donner à voir n° 1*, exhibition catalogue, Galerie Creuze, Paris, France.
• *DYLABY – dynamisch labyrint*, exhibition catalogue, Stedelijk Museum, Amsterdam, Netherlands.
• *Niki de Saint Phalle*, exhibition catalogue, Alexander Iolas Gallery, New York, USA.

1963

• *Les Nouveaux Réalistes*, exhibition catalogue, Neue Galerie im Künstlerhaus, Munich, Germany.
• *XXe Salon de Mai*, exhibition catalogue, M.A.M.V.P., Paris, France.
• *Troisième biennale de Paris*, exhibition catalogue, M.A.M.V.P., Paris, France.

1964

• *Cinquante ans de collage*, exhibition catalogue, Musée d'Art et d'Industrie, St-Etienne, France.
• *10 ans d'art actuel – Salon Comparaisons*, exhibition catalogue, M.A.M.V.P., Paris, France.
• *XXe Salon de Mai*, exhibition catalogue, Musée d'Art Moderne de la Ville de Paris, Paris, France.
• *Mythologies quotidiennes*, exhibition catalogue, M.A.M.V.P., Paris, France.
• *Perspektiven*, exhibition catalogue, Galerie Handschin, Basel, Switzerland.
• *Constant Companions*, exhibition catalogue, Art Department, University of St. Thomas, Houston, Texas, USA.

1965

• *Pop Art, Nouveau Réalisme, etc*, exhibition catalogue, Palais des Beaux-Arts, Brussels, Belgium.
• *Le Merveilleux Moderne*, exhibition catalogue, Lunds Konsthall, Lund, Sweden.
• *XXIe Salon de Mai*, exhibition catalogue, Musée d'Art Moderne de la Ville de Paris, France.
• *Moderna Museet besöker Landskrona*, exhibition catalogue, Konsthalle, Landskrona, Sweden.
• *Det Underbara Moderna, Det Underbara Idag*, exhibition catalogue, AB Skanska Centraltryckeriet, Lund Konsthall, Sweden.
• *La figuration narrative dans l'art contémporain*, exhibition catalogue, Galerie Creuze, Paris, France.
• *Niki de Saint Phalle*, exhibition catalogue, Delpire, Paris, France.

1966

• *VIIe Salon Grands et Jeunes d'Aujourd'hui*, exhibition catalogue, M.A.M.V.P., Paris, France.
• *Weiss auf Weiss*, exhibition catalogue, Kunsthalle, Bern, Switzerland.
• *Hon-en katedral*, exhibition catalogue, Moderna Museet, Stockholm, Sweden.
• *Niki Nanas*, exhibition catalogue, Iolas Gallery, New York, USA.

1967

• *Les Nanas au pouvoir*, exhibition catalogue, Stedelijk Museum, Amsterdam, Netherlands.
• *Alcoa Collection of Contemporary Art*, exhibition catalogue, Carnegie Institute, Pittsburgh, Penn., USA.
• *La fureur poétique*, exhibition catalogue, Musée d'Art Moderne de la Ville de Paris, France.
• *Französiche Malerei der Gegenwart*, exhibition catalogue, Kunsthaus Hamburg, Germany.
• *Table d'orientation…*, exhibition catalogue, Galerie Henri Creuzevault, Paris, France.

1968

• *Niki de Saint Phalle: Werke 1962–1968*, exhibition catalogue, Kunstverein, Düsseldorf, Germany.
• *Dada, Surrealism, and Their Heritage*, exhibition catalogue, MoMA, New York, USA.
• *The Obsessive Image 1960–1968*, exhibition catalogue, I.C.A., London, UK.
• *Le décor quotidien de la vie en 1968*, exhibition catalogue, Musée Galliera, Paris, France.
• *L'Art Vivant 1965–1968*, exhibition catalogue, Fondation Maeght, Saint-Paul-de-Vence, France.
• *Sammlung Hahn*, exhibition catalogue, Wallraff-Richartz Museum, Köln, Germany.
• Catalogue of Museum of Contemporary Art, Chicago, USA.
• *Destruction Art: Destroy to Create*, exhibition catalogue, Contemporary Wing, New York, USA.
• *Niki de Saint Phalle*, exhibition catalogue, Sergio Tosi under license to Alexandre Iolas, Milan, Italy.
• *Niki de Saint Phalle*, exhibition catalogue, Gimpel & Hanover Galerie (in collaboration with Galerie Iolas), Zürich, Switzerland.

1969

• *Niki de Saint Phalle: Werke 1962–1968*, exhibition catalogue, Kunstverein, Hanover, Germany.
• Catalogue Museum of Contempory Art, Chicago, USA.
• *Figuren Gestalten Personen…*, exhibition catalogue, Frankfurter Kunstverein, Frankfurt, Germany.
• *Socha piestanskych Parkov '69*, exhibition catalogue, Piestany, Czechoslovakia.

1970

• *Sammulung Etzold*, exhibition catalogue, Kölnischer Kunstverein, Cologne, Germany.
• *Open Air Sculpture II*, exhibition catalogue, Gimpel Fils, London, UK.
• *Pop Art: Nieuwe Figuratie/Nouveau Realistie*, exhibition catalogue, Casino Knokke, Belgium.
• *3 tendances de l'art contemporain en France*, exhibition catalogue, Musée, Mons, Belgium.
• *Nouveau Réalisme 1960–1970*, exhibition catalogue, Galerie Mathias Fels, Paris, France.
• *3 -> 00: New multiple art*, exhibition catalogue, Arts Council of Great Britain, London, UK.
• *10th Anniversary of the Nouveaux Réalistes*, exhibition catalogue, Rotonda della Besana, Milan, Italy.
• Saint Phalle, Niki de. *Please, Give Me a Few Minutes of Your Eternity*, Galerie Alexandre Iolas, France.

1971

• *Multiplication*, exhibition catalogue, Södertälje Konsthall, Södertälje, Sweden.
• *ROSC '71: the poetry of vision*, exhibition catalogue, Royal Dublin Society, Dublin, Ireland.
• *Machines de Tinguely*, exhibition catalogue,

Centre National d'Art Contemporain, Paris, France.
• Saint Phalle, Niki de. *My Love*, Moderna Museet, Stockholm, Sweden.

1972
• *Niki avant les Nanas*, exhibition catalogue, Galerie Bonnier, Geneva, Switzerland.
• *Etudes et Epures*, exhibition catalogue, Galerie Henri Creuzevault, Paris, France.
• *72/72, 12 ans d'art contemporain en France*, exhibition catalogue, Grand Palais, Paris, France.
• *100 acquisitions récentes 1969–1972*, exhibition catalogue, Musée Cantini, Marseille, France.
• Saint Phalle, Niki de. *The Devouring Mothers*, Gimpel Fils Gallery, London, UK.

1973
• *Jahresgaben 1973*, exhibition catalogue, Kunstverein Hannover, Hanover, Germany.
• *Jewelry as sculpture as jewelry*, exhibition catalogue, Institute of Contemporary Art, Boston, USA.

1974
• *Réalisations et projets d'architecture*, exhibition catalogue, Galerie Alexandre Iolas, Paris, France.

1975
• *Niki de Saint Phalle*, exhibition catalogue, Arles, France.

1976
• *Niki de St Phalle*, exhibition catalogue, Museum Boymans-van Beuningen, Rotterdam, Netherlands.
• *Niki de St Phalle sculpturer*, exhibition catalogue, Nordjyllands Kunstmuseum, Aalborg, Denmark.
• *Les Nouveaux Réalistes*, exhibition catalogue, Galerie Beaubourg, Paris, France.
• *Katalogen*, exhibition catalogue, Moderna Museet, Stockholm, Sweden.

1977
• *3 villes, 3 collections*, exhibition catalogue, Musée Cantini, Marseille, France.
• *De Fiets*, exhibition catalogue, Museum Boyman-van Beuningen, Rotterdam, Netherlands.
• *Biennale de Paris – une anthologie 1959–1967*, exhibition catalogue, F.N.A.P.G., Paris, France.
• *Paris-New York: un album*, exhibition catalogue, Centre Georges Pompidou, Paris, France.
• *Véloscopie*, Casino Knokke, Knokke-le-Zoute, Belgium.

1978
• *Nouveaux Réalistes*, exhibition catalogue, Zoumboulakis Galleries, Athens, Greece.
• *Biennale de Paris '59–'73*, exhibition catalogue, The Seibu Museum of Art, Tokyo, Japan.
• Catalogue Abbaye de Beaulieu-en-Rouergue, Centre d'Art Contemporain, France.
• *Hammer Austellung*, exhibition catalogue, Hammerstraße 158, Basel, Switzerland.
• *Henri Matisse…*, exhibition catalogue, Museum van Hedendaagse Kunst, Gand, Belgium.
• *The Museum of Drawers*, exhibition catalogue, Kunsthaus Zürich, Switzerland.
• *Art: -*, exhibition catalogue, Museum des Geldes, Düsseldorf, Germany.

1979
• *Niki de Saint Phalle*, exhibition catalogue, Galerie Watari, Tokyo, Japan.
• *Biennale de Paris '59–'73*, exhibition catalogue, Seibu Museum of Art, Tokyo, Japan.
• *In Names des Volkes*, exhibition catalogue,

Museum der Stadt, Duisburg, Germany.
• *Musée des sacrifices Musée de l'argent*, exhibition catalogue, CGP, Paris, France.
• *Kunst der letzten 30 Jahre*, exhibition catalogue, Museum Moderner Kunst, Vienna, Austria.
• *Sammlung Hahn*, exhibition catalogue, Museum Moderner Kunst, Vienna, Austria.

1980
• *Niki de St Phalle: Das graphische Werk 1968–1980*, exhibition catalogue, Ulmer Museum, Ulm, Germany.
• *Exposition rétrospective*, exhibition catalogue, M.N.A.M./C.G.P., Paris, France.
• *Retrospektive 1954–1980*, exhibition catalogue, Wilhelm-Lehmbruck Museum, Duisburg, Germany.
• *Skulptur im 20. Jahrhundert*, exhibition catalogue, Wenkenpark, Basel, Switzerland.
• *Lothar Wolleh*, exhibition catalogue, Kunstverein, Düsseldorf, Germany.
• *Bestand II*, exhibition catalogue, Städtisches Museum Abteiberg, Mönchengladbach, Germany.
• *Niki de Saint Phalle*, exhibition catalogue, Centre Georges Pompidou, Paris, France.

1981
• *Niki de Saint Phalle in DADDY*, exhibition catalogue, Space Niki, Tokyo, Japan.
• *Niki de Saint Phalle*, exhibition catalogue, Moderna Museet, Stockholm, Sweden.
• *Avant-Garde in Europe 1955–1970*, exhibition catalogue, Gallery of Modern Art, Edinburgh, UK.
• *100 œuvres nouvelles 1977-1981. Musée National d'art Moderne*, exhibition catalogue, Centre Georges Pompidou, Paris, France.

1982
• *My Skinnies*, exhibition catalogue, Gimpel & Weitzenhoffer Gallery/Gimpel Fils, New York/London.
• *Rosenthal: Hundert Jahre Porzellan*, exhibition catalogue, Kestner-Museum, Hanover, Germany.
• *Heiter bis aggressiv*, exhibition catalogue, Museum Bellerive, Zürich, Switzerland.
• *Les Nouveaux Réalistes*, exhibition catalogue, Galerie des Ponchettes, Nice, France.
• *Sammlungen Hans und Walter Bechtler*, Kunsthaus, Zürich, Switzerland.

1983
• *Salon d'automne : Lyon 83*, exhibition catalogue, Lyon, France.
• *Moderna Museet 1958–1983*, exhibition catalogue, Moderna Museet, Stockholm, Sweden.
• Boulez, Pierre et al.. *Jean Tinguely, Niki de Saint Phalle. Strawinsky-Brunnen Paris*, Benteli Verlag, Bern, Switzerland.

1984
• *La part des femmes dans l'art contemporain*, exhibition catalogue, Vitry-sur-Seine, France.
• *Skulptur im 20. Jahrhundert*, exhibition catalogue, Basel, Switzerland.
• Catalogue Hirshhorn Museum and Sculpture Garden, Washington, D.C., USA.
• *Zufall*, exhibition catalogue, Wilhelm Hack Museum, Ludwigshafen, Germany.

1985
• *Niki de Saint Phalle 1962–1980*, exhibition catalogue, Galerie Littmann, Basel, Switzerland.
• *Niki de Saint Phalle*, exhibition catalogue, Casino Knokke, Knokke-le-Zoute, Belgium.
• *Permanent Collection…*, exhibition catalogue, Museum of Contemporary Art, Chicago, USA.

• *Mr. and Mrs. Joseph R. Shapiro Collection*, exhibition catalogue, Art Institute of Chicago, USA.
• *Femmes… Portraits et Nus*, exhibition catalogue, Cannes, France.
• *1ère approche pour un parc*, exhibition catalogue, Fondation Cartier, Jouy-en-Josas, France.
• *The Hakone Open-Air Museum*, Japan.
• *Tarot Cards in Sculpture*, exhibition catalogue, Giuseppe Ponsio, Milan, Italy.

1986
• *Space Niki Collection*, exhibition catalogue, Space Niki, Tokyo, Japan.
• *5 vases par Niki de St Phalle*, exhibition catalogue, Galerie Colette Creuzevault, Paris, France.
• *Architectures fantastiques*, exhibition catalogue, Halle Saint-Pierre, Paris, France.
• *1960 : Les Nouveaux Réalistes*, exhibition catalogue, MAMVP, Paris, France.
• *Biennale di Venezia - Arte e Scienza: Colore*, exhibition catalogue, Venice Biennale, Italy.
• *1960: Les Nouveaux Réalistes*, exhibition catalogue, Kunsthalle, Mannheim, Germany.
• *Portrait of Niki de Saint Phalle*, exhibition catalogue, Parco Co., Ltd., Tokyo, Japan.
• Saint Phalle, Niki de. *AIDS: You Can't Catch It Holding Hands/ AIDS: Vom Händchenhalten kriegt man's nicht*, C.J. Bucher GmbH, Munich, Germany.
• Saint Phalle, Niki de. *AIDS: You Can't Catch It Holding Hands*, Toppan Printing Co., Japan.

1987
• *Niki de St Phalle*, exhibition catalogue, Kunsthalle der Hypo-Kulturstiftung, Munich, Germany.
• *Niki de Saint Phalle : Œuvres récentes*, exhibition catalogue, Galerie Bonnier, Geneva, Switzerland.
• *Fantastic Vision*, exhibition catalogue, Nassau County Museum of Fine Art, Roslyn, New York, USA.
• *Sacred Spaces*, exhibition catalogue, Everson Museum of Art, Syracuse, New York, USA.
• *The World though 'Naives' Eyes*, exhibition catalogue, Urban Gallery, New York, USA.
• *Hommage au Président Georges Pompidou*, exhibition catalogue, Artcurial, Paris, France.
• *Katalog der Sammlung*, exhibition catalogue, Kunstmuseum, St. Gallen, Switzerland.
• *Matti Koivurinnan Taidemuseo*, exhibition catalogue, Åbo, Finland.
• *Niki de Saint Phalle. Bilder-Figuren-Phantastische Gärten*, exhibition catalogue, Prestel-Verlag, Munich, Germany.
• Saint Phalle, Niki de. *L'AIDS: è facile da evitare*, Franco Muzzio & C. Editore spa, Italy.

1988
• *Nouveaux Réalistes: Works from 1957 to 1963*, Zabriskie Gallery, New York, USA.
• *Sculpture du vingtième siècle*, exhibition catalogue, JGM.Galerie, Paris, France.
• *XLIII Esposizione Internazionale d'Arte la Biennale*, exhibition catalogue, Venice, Italy.
• *Golem! Danger, Deliverance and Art*, exhibition catalogue, The Jewish Museum, New York, USA.
• *The Wounded Animals*, exhibition catalogue, Giuseppe Ponsio, Milan, Italy.
• *Bilder für den Himmel, Kunstdrachen*, exhibition catalogue, Goethe-Institut, Osaka, Japan.
• *Jean Tinguely*, exhibition catalogue, Centre Georges Pompidou, Paris, France.
• *The Tate Gallery 1984–86*, exhibition catalogue, London, UK.

• "Beständekatalog Kunst der Gegenwart, exhibition catalogue, Wolfgang Heinen, Mönchengladbach, Germany.

1989
• Œuvres des Années 80, exhibition catalogue, Galerie de France, JGM.Galerie, Paris, France.
• Niki de Saint Phalle, exhibition catalogue, Palais Bénédictine, Fécamp, France.
• Salon de Mars, exhibition catalogue, Paris, France.
• L'art de vivre…, exhibition catalogue, Cooper Hewitt Museum, New York, USA.
• Corps-Figures, exhibition catalogue, Artcurial, Paris, France.
• Americans abroad, exhibition catalogue, Smith Galleries, Covent Garden, UK.
• Sculpture Reliefs & Drawings, exhibition catalogue, Gimpel Fils, London, UK.
• Dimension : Petit, exhibition catalogue, Musée Cantonal des Beaux-Arts, Lausanne, Switzerland.
• Peinture, cinéma, peinture, exhibition catalogue, La Vieille Charité, Marseille, France.
• Fers : de Gonzalez à Tony Cragg, exhibition catalogue, JGM.Galerie, Paris, France.
• The Evidence of Magic, exhibition catalogue, Galerie de Seoul, South Korea.
• Kunstdrachen. Bilder für den Himmel, exhibition catalogue, Goethe-Institute Osaka/Prestel Verlag, Germany.
• Saint Phalle, Niki de, and Laurent Condominas. Meany Meany and the Stolen Toys.

1990
• Niki de Saint Phalle, exhibition catalogue, Galerie Wolfgang Ketterer, Munich, Germany.
• Tirs… et autres révoltes 1961–1964, exhibition catalogue, JGM.Galerie, Paris, France.
• Art in Europe and America, exhibition catalogue, Wexner Center for the Visual Arts, Columbus, Ohio, USA.
• Looking at Contemporary Art, exhibition catalogue, Wexner Center for the Visual Arts, Columbus, Ohio, USA.
• Europaïsche Skulptur, exhibition catalogue, Wilhem-Lehmbruck Museum, Duisburg, Germany.
• Festival Landmarks '90, exhibition catalogue, Gateshead, UK.
• Form, Action, Expression of Human Body…, exhibition catalogue, Fukushima Art Museum, Japan.
• Années 60 : l'objet-sculpture, exhibition catalogue, Paris, France.
• Le Territoire de l'Art, exhibition catalogue, Musée Russe, Leningrad, USSR.
• L'art en France 1945–1990, exhibition catalogue, Musée Temporaire, Fréjus, France.
• Vénus, exhibition catalogue, Moulins Albigeois, Albi, France.
• Au rendez-vous des amis, exhibition catalogue, Galerie Enrico Navarra, Paris, France.
• Virginia Dwan et les Nouveaux Réalistes, exhibition catalogue, Galerie Montaigne, Paris, France.
• 12th International Biennale of Drawings, exhibition catalogue, Museum of Modern Art, Rijeka, Croatia.
• L'art en France 1945-1990, exhibition catalogue, Fondation Daniel Templon, Paris, France.
• Daniel Spoerri, exhibition catalogue, Centre Georges Pompidou, Paris, France.
• Saint Phalle, Niki de. Le sida : Tu ne l'attraperas pas…, Agence française de lutte contre le sida, France.

1991
• Gods, exhibition catalogue, Gimpel Fils Ltd., London, UK.
• Œuvres récentes, exhibition catalogue, Guy Pieters Gallery, Knokke-le-Zoute, Belgium.
• Une touche suisse, exhibition catalogue, Galerie Bonnier, Geneva, Switzerland.
• La sculpture et son dessin, exhibition catalogue, JGM Galerie, Paris, France.
• Pierre Restany : le cœur et la raison, exhibition catalogue, Musée des Jacobins, Morlaix, France.
• The Pop Art Show, exhibition catalogue, The Royal Academy of Arts, London, UK.
• Les Nouveaux Réalistes, exhibition catalogue, Galerie Rigassi, Bern, Switzerland.
• Bezzola, Leonardo and Niki de Saint Phalle, The Birth of a Monster, Zürich, Switzerland.

1992
• Niki de Saint Phalle, exhibition catalogue, Kunst- und Ausstellungshalle, Bonn, Germany.
• Artists pour Amnesty International, exhibition catalogue, Paris, France.
• La France en guerre d'Algérie, exhibition catalogue, Musée d'histoire contémporaine, Nanterre, France.
• Territorium Artis, exhibition catalogue, Kunst- und Ausstellungshalle, Bonn, Germany.
• Dolls and emotion today, exhibition catalogue, Kanagawa Prefectural Gallery, Yokohama, Japan.
• Images of Man, exhibition catalogue, Isetan Art Museum, Tokyo, Japan.
• Parallel Visions, exhibition catalogue, Los Angeles County Museum, Los Angeles, USA.
• L'Art actif/Art works : Collection Fond. Peter Stuyvesant, exhibition catalogue, Paris, France.
• Pour un musée d'art moderne et contémporaine, exhibition catalogue, Musée d'Art et d'Histoire, Geneva, Switzerland.
• Art Kites. Pictures for the Sky, exhibition catalogue, Goethe-Institute Osaka/ Prestel Verlag, USA & Canada.

1993
• L'invitation au musée, exhibition catalogue, Musée d'Art Moderne de la Ville de Paris, France.
• L'ivresse du réel, exhibition catalogue, Carré d'Art, Nîmes, France.
• Atelier de France, exhibition catalogue, Ludwig Museum, Koblenz, Germany.
• Drawings the Line Against AIDS, exhibition catalogue, Peggy Guggenheim Coll., Venice, Italy.
• Devant, le futur, The Future Lies Ahead. Volume I, Ye young corp., Seoul, South Korea.
• Devant, le futur, exhibition catalogue, Taedok Science Town, Taejon, South Korea.
• Niki de Saint Phalle. Aventure Suisse, exhibition catalogue, Musée d'Art et d'Histoire, Fribourg, Switzerland.
• Niki de Saint Phalle. Tableaux Éclatés, exhibition catalogue, La Différence, Paris, France.
• Paris Post War, exhibition catalogue, Tate Gallery, London, UK.
• Tableaux éclatés, exhibition catalogue, La Différence, Paris, France.
• Contemporary Great Masters 16: Niki de Saint Phalle, Kodansha Ltd., Tokyo, Japan.
• Saint Phalle, Niki de, and Laurent Condominas. Méchant Méchant, La Différence, Paris France.

1994
• Tableaux éclatés + sculptures, exhibition catalogue, Maxwell Davidson/J. Goodman, New York, USA.

• La collection Pompidou, exhibition catalogue, Maison des Arts, Carjarc, France.
• Neo-Dada, exhibition catalogue, American Federation of Arts, New York, USA.
• Portraits de femmes, exhibition catalogue, Galerie Beaubourg, Vence, France.
• L'Art du portrait…, exhibition catalogue, Shoto Museum of Art, Tokyo, Japan.
• New Art in An Old City, exhibition catalogue, The Virlane Foundation, New Orleans, USA.
• Contemporary Great Masters 16. Niki de Saint Phalle, exhibition catalogue, Kodansha, Ltd., Tokyo, Japan.
• Tableaux Éclatés, exhibition catalogue, La Différence, Paris, France.
• Saint Phalle, Niki de. Mon Secret, La Différence, Paris, France.

1995
• Niki de Saint Phalle, exhibition catalogue, throughout the city, Luxembourg.
• Unser Jahrhundert, exhibition catalogue, Museum Ludwig, Cologne, Germany.
• Niki de Saint Phalle, exhibition catalogue, Museo Rufino Tamayo, Mexico.
• Niki de Saint Phalle, exhibition catalogue, Verlag Gerd Hatje, Ostfildern/Ruit, Germany.
• Niki de Saint Phalle. Dear Diary, exhibition catalogue, Galerie Kornfeld, Bern, Switzerland.
• Féminin-Masculin, le Sexe de l'Art, exhibition catalogue, CGP, Paris, France.
• Passions privés, exhibition catalogue, Musée d'Art Moderne de la Ville de Paris, Paris, France.
• La Clairière & Art Collection, exhibition catalogue, Jamont, Brussels, Belgium.
• New Art in an Old City II, exhibition catalogue, The Virlane Foundation, New Orleans, USA.
• Niki de Saint Phalle. Un Univers à découvrir, exhibition catalogue, Banque Génerale du Luxembourg, Luxembourg.
• Môtiers 95 – Art en plein air, exhibition catalogue, Acatos Editions, Lausanne, Paris, France.

1996
• Niki & Tinguely, exhibition catalogue, Musée Kawamura, Sakura, Japan.
• Niki de Saint Phalle, exhibition catalogue, Museo de Arte Contemporàneo, Caracas, Venezuela.
• Museum Jean Tinguely, Basel – La Collection, exhibition catalogue, Basel, Switzerland.
• Exposition inaugurale, exhibition catalogue, Museum Jean Tinguely, Basel, Switzerland.
• Niki de Saint Phalle, exhibition catalogue, Museo de Arte Moderno, Bogotá, Columbia.
• Kunst im Anschlag, exhibition catalogue, Walter König, Cologne, Germany.
• La Dimension du corps 1920–1980, exhibition catalogue, Tokyo/Kyoto, Japan.
• Chimériques polymères, exhibition catalogue, MAMAC, Nice, France.
• Pop Art, exhibition catalogue, Museum Boymans-Van-Boyningen, Rotterdam, Netherlands.

1997
• Niki de Saint Phalle, exhibition catalogue, Pinacoteca do Estado, São Paulo, Brazil.
• Niki de Saint Phalle, exhibition catalogue, Sala de Exposiciones Edificio, Santiago, Chile.
• Luxembourg Ville de la Sculpture, exhibition catalogue, Ville du Luxembourg.
• I Tarocchi di Niki de Saint Phalle, exhibition catalogue, Charta, Milan, Italy.
• Niki de Saint Phalle – Dear Diary, exhibition catalogue, Kunstverein, Wolfsburg, Germany.

• *Art/Fashion*, exhibition catalogue, Skira, Milan, Italy.
• *Die neuen Abenteuer der Objekte*, exhibition catalogue, Museum Ludwig, Cologne, Germany.
• *Produkt: Kunst!* , exhibition catalogue, Neues Museum Weserburg, Bremen, Germany.
• *Scene of the Crime*, exhibition catalogue, MIT Press, Cambridge, Mass., USA.
• *Nouveaux Réalistes Anni '60*, exhibition catalogue, Fonte d'Abisso Arte, Milan, Italy.
• *ZERO und Paris 1960. Und Heute*, Villa Merkel, Esslingen, Germany.
• *De Klein à Warhol*, exhibition catalogue, M.A.M.A.C., Nice, France.
• *Niki de Saint Phalle*, exhibition catalogue, Niki Museum, Nasu, Japan.
• Mazzanti Anna. *Niki de Saint Phalle. Il Giardino dei Tarocchi*, Charta, Milan, Italy.
• Saint Phalle, Niki de. *Le Jardin des Tarots*, Benteli Verlags AG, Bern, Switzerland.

1998
• *Hey Teto – Collection Ahrenberg*, exhibition catalogue, Belgium.
• *Niki de Saint Phalle. Insider/Outsider World Inspired Art*, exhibition catalogue, Mingei Museum, San Diego, Cal., USA.
• *Out of Actions*, exhibition catalogue, The Museum of Contemporary Art, Los Angeles, USA.
• *Monumental Sculpture in the Elements*, exhibition catalogue, Museum of Fine Arts, Kaohsiung, Taiwan.
• *Skulptur – Figur – Weiblich*, exhibition catalogue, Landesgalerie Oberösterreich, Linz, Austria.
• *Glancing at the Century*, exhibition catalogue, Basil & Elise Goulandris Found., Andros, Greece.
• *Niki de Saint Phalle. Aventure Suisse*, exhibition catalogue, Musée d'Art et d'Histoire, Fribourg, Switzerland.
• *L'Art pour la vie. Œuvres du XXe siècle au profit de la Fondation Claude Pompidou*, exhibition catalogue, Fondation Claude Pompidou, France.
• *Aventure Suisse*, exhibition catalogue, Benteli Verlag, Bern, Switzerland.

1999
• *Niki de Saint Phalle – Liebe, Protest, Phantasie*, exhibition catalogue, Ulmer Museum, Ulm, Germany.
• *Traces*, exhibition catalogue, JGM.Galerie, Paris, France.
• Saint Phalle, Niki de. *Der Tarot Garden*, Benteli Verlags AG, Bern, Switzerland.
• Saint Phalle, Niki de. *The Tarot Garden / Il Giardino dei Tarocchi*, Editions Acatos, Lausanne, Switzerland.
• Saint Phalle, Niki de. *Traces. An Autobiography Remembering 1930–1949*, Editions Acatos, Lausanne, Switzerland.

2000
• *Den Haag Sculptuur 2000/ The Hague Sculpture 2000/ De Mens In Beweging*, The Hague, Netherlands.

2001
• *La Fête-Die Schenkung Niki de Saint Phalle. Werke aus den Jahren 1952–2001*, Sprengel Museum Hannover / Hatje Cantz Verlag, Hanover, Germany.
• *Niki de Saint Phalle*, exhibition catalogue, Museum Jean Tinguely Basel, Basel, Switzerland.
• *Niki de Saint Phalle, Neue Graphik der Jahre 1997 bis 2000*, exhibition catalogue, Galerie Kornfeld, Bern, Switzerland.

• *Praemium Imperiale*, exhibition catalogue, The Japan Art Association, Japan.
• Becker, Monika. *Starke Weiblichkeit entfesseln*. Niki de Saint Phalle, Econ Ullstein List, Verlag GmbH., Munich, Germany.

2002
• *Von Niki Mathews zu Niki de Saint Phalle*, exhibition catalogue, Sprengel Museum Hannover, Hanover, Germany.
• *La Donation*, exhibition catalogue, Georges Naef, MAMAC Nice, France.
• *Catalogue Raisonné. 1949–2000. Volume I*, Acatos Editions, Lausanne, Switzerland.
• *Monographie. Monograph*, Acatos Editions, Lausanne, Switzerland.
• *Jean Tinguely & Cie. Collaborations artistiques*, exhibition catalogue, Musée de l'Hôtel-Dieu de Mantes-la-Jolie, France.
• Schröder, Stefanie. *Ein starker verwundetes Herz – Niki de Saint Phalle. Ein Künstlerleben*, Herder Spektrum, Freiburg, Germany.

2003
• *Die Geburt der Nanas: Die Kunst der Niki de Saint Phalle in den 1960er Jahren*, exhibition catalogue, Sprengel Museum Hannover, Germany.
• *Niki de Saint Phalle*, exhibition catalogue, Zacheta Panstwowa Galeria Sztuki, Warsaw, Poland.
• *Champs Libres. Zoo Exquis*, exhibition catalogue, ORCCA, Epernay, France.
• *Niki de Saint Phalle. My Art – My Dreams*, exhibition catalogue, Prestel-Verlag, New York, USA.
• *Niki de Saint Phalle. La Grotte / The Grotto*, exhibition catalogue, Hatje Cantz Verlag, Ostfildern-Ruit, Germany.
• Krempel, Ulrich. *Niki's Welt / Niki's World*, Prestel Verlag, Germany/USA.
• Niemeyer-Langer, Susanne. *Der kreative Dialog der Künstlerin Niki de Saint Phalle*, Psychosozial-Verlag, Gießen, Germany.

2004
• *Niki de Saint Phalle: Frühe Werke und Druckgrafik aus der Sammlung des Musée d'Art moderne et d'Art contémporain in Nizza*, exhibition catalogue, Kunsthalle Nürnberg, Nürnberg, Germany.
• *Niki de Saint Phalle. Des Assemblages aux œuvres monumentales*, exhibition catalogue, Musées des Beaux Arts d'Angers, Angers, France.
• *The Pontus Hulten Collection…*, exhibition catalogue, Moderna Museet, Stockholm, Sweden.
• *Art Postal, Art Posté. Collection Michel Bohbot*, exhibition catalogue, Médiathéque Nancy, Nancy, France.

2005
• *Niki de Saint Phalle: Dreams of Midsummer*, exhibition catalogue, Macau Museum of Art, Macau, China.
• *Niki de Saint Phalle/Der Tarot Garten: Skulpturen, Entwürfe, Zeichnungen*, exhibition catalogue, Sprengel Museum, Hanover, Germany.
• *Niki de Saint Phalle. Vroege werken en grafiek uit het Musée d'Art moderne et d'Art contemporain in Nice*, exhibition catalogue, De Zonnehof, Amersfoort, Netherlands.
• *Niki & Jean. L'art et l'amour*, exhibition catalogue, Prestel, Munich, Sprengel Museum, Hannover, Germany.
• *Nana Power. Die Frauen der Niki de Saint Phalle*, Nicolai Verlag, Berlin, Germany.
• *Niki de Saint Phalle & Jean Tinguely: Posters*, exhibition catalogue, Prestel, Munich, Germany.

• *Les Jardins de Poppy. Le cahier de l'exposition 2005*, exhibition catalogue, Association Les Jardins de Poppy, Le Thor, France.

2006
• *Niki de Saint Phalle a Capalbio*, exhibition catalogue, Aión Edizioni, Firenze, Italy.
• *Niki de Saint Phalle : Vive L'Amour !*, exhibition catalogue, Palais Bénédictine, Fecamp, France.
• *Niki de Saint Phalle*, exhibition catalogue, National Museum of Contemporary Art Seoul & Culture Books, Seoul, South Korea.
• *Niki de Saint Phalle: A Retrospective*, exhibition catalogue, The Chunichi Shimbun, Nagoya City Art Museum, Japan.
• *Mass Production: Artist's Multiples & the Marketplace*, exhibition catalogue, Mary Schiller Myers School of Art (The University of Akron), Akron, Ohio, USA.
• *Eye on Europe: prints, books, and multiples/ 1960 to now*, exhibition catalogue, The Museum of Modern Art, New York, USA.
• *Sculptures: formes & couleurs*, exhibition catalogue, Domaine du Château de Seneffe, Belgium.
• Dempsey, Amy. *Destination Art*, Thames & Hudson, London, UK.

2007
• *Niki in the Garden*, exhibition catalogue, Chicago Department of Cultural Affairs / Chicago Office of Tourism, Chicago, USA.
• *Bejeweled Reveries: Niki de Saint Phalle's Outdoor Wonders*, exhibition catalogue, Chicago Department of Cultural Affairs/ Chicago Office of Tourism, Chicago, USA.
• *The World of Fantasy of Niki de Saint Phalle*, exhibition catalogue, National Museum of History, Taipei, Taiwan.
• *Niki de Saint Phalle*, United Daily News Group, Taipei, Taiwan.
• *WACK!: Art and the Feminist Revolution*, The MIT Press, Cambridge, Mass., USA.
• *Le Nouveau Réalisme*, RMN, Paris, France Saint Phalle, Niki de. *Harry and Me. The Family Years 1950–1960*, Benteli Verlags AG, Bern, Switzerland.
• Kuroiwa, Masashi. *The Tarot Garden. Niki de Saint Phalle*, BSS, Japan.
• Durozoi, Gérard. *Le Nouveau Réalisme*, Editions Hazan, Paris, France.
• Ueckert, Charlotte. *Niki de Saint Phalle. Magierin der runden Frauen*, Philo & Philo Fine Arts / EVA Europäische Verlagsanstalt, Hamburg, Germany.

2008
• *Niki de Saint Phalle*, Tate Publishing, UK.
• *Hommage à Niki de Saint Phalle. Le Jardin des Tarots*, La Coupole, France.
• *Galerie Pascal Lansberg. Biennale des Antiquaires 2008*, exhibition catalogue, Galerie Pascal Lansberg, Paris, France.
• *Niki de Saint Phalle : La fée des couleurs*, RNM, Paris, France.
• Amzallag-Augé, Élizabeth. *Niki de Saint Phalle et Jean Tinguely. La Fontaine Igor-Stravinsky*, Éditions du Centre Georges Pompidou, Paris, France.

2009
• *Niki de Saint Phalle : Joie de vivre*, Comediarting s.r.l. / Carlo Cambi Editore, Italy.
• *Niki de Saint Phalle: Mythen – Märchen – Träume*, Kulturform Würth / Swiridoff Publishing, Switzerland.

Solo Exhibitions

1956
• St. Gallen, Switzerland, Galerie Restaurant Gotthard. *Niki Mathews New York Gemälde, Gouachen.* 28 April – 19 May. First exhibition.

1961
• Paris, France, Galerie J. *Feu à Volonté.* 30 June – 12 July. Organized by Pierre Restany. Booklet with essay by Pierre Restany. First one-woman exhibition with shooting paintings.
• Copenhagen, Denmark, Køpcke Gallery. *Niki de Saint Phalle.* Officially opened on 15 September.

1962
• Los Angeles, California, USA, Everett Ellin Gallery. *Action de tir.* Everett Ellin Gallery sponsors Niki de Saint Phalle's shooting session at 4.00 pm on Sunday 4 March. The target is 6 meters away. Jean Tinguely and Ed Kienholz also take part. Niki de Saint Phalle's first shooting session in the United States.
• Malibu Hills, California, USA. A shooting session involving two targets: one 2.4 meters high at a distance of 5 meters, the other somewhat smaller. Sunday afternoon, late March or early April.
• Paris, France, Galerie Rive Droite. *Niki de Saint Phalle.* 15 June – 15 July. Catalogue.
• New York, USA, Alexander Iolas Gallery in collaboration with Jean Larcade, Paris. *Niki de Saint Phalle.* 15 October – 3 November. Booklets. Clockwork action for a shooting gallery, *Homage to Le Facteur Cheval,* by Jean Tinguely.

1963
• Los Angeles, California, USA, The Dwan Gallery. *King Kong.* The Dwan Gallery sponsors King Kong, a monumental "shooting painting" produced during the summer.

1964
• Los Angeles, California, USA, The Dwan Gallery in association with the Alexander Iolas Gallery. *Niki de Saint Phalle.* 5–31 January.
• Geneva, Switzerland, Galerie Alexandre Iolas. *Niki de Saint Phalle.* 1–22 April. Booklet with text by Georges Peillex.
• London, England, Hanover Gallery. *Niki de Saint Phalle: You Are My Dragon.* 23 September–17 October.

1965
• New York, USA, Alexander Iolas Gallery. *Niki de Saint Phalle.* 16 April – 1 May.
• Paris, France, Galerie Alexandre Iolas. *Niki de Saint Phalle.* 30 September – 30 October. Book by the artist. First 'nanas' exhibited.

1966
• New York, USA, Alexander Iolas Gallery. *Niki de Saint Phalle.* 29 March – 23 April. Book by the artist. Nanas exhibited in New York for the first time.

1967
• Amsterdam, Netherlands, Stedelijk Museum. *Niki de Saint Phalle: Les Nanas au pouvoir.* 26 August – 15 October. Under the curatorship of Ad Peterson. Catalogue. The first *Nana Dream House* was created for this retrospective.
• New York, USA, Alexander Iolas Gallery. *Papier-Mâché Animals in a Zoo.* March.
• Amsterdam, Netherlands, Galerie Espace. *Niki de Saint Phalle: Voir les mini-nanas en plâtre peint et aussi des dessins.* 26 August – 16 September.

1968
• Zurich, Switzerland, Gimpel & Hanover Galerie. *Niki de Saint Phalle.* 18 May – 6 July. Booklet.
• London, England, Hanover Gallery. *Niki de Saint Phalle.* 2 October – 1 November. Book by the artist.
• Paris, France, Galerie Alexander Iolas. *Flash Niki de Saint Phalle: Hier soir j'ai fait un rêve.* 24 October – 6 November.
• Düsseldorf, Germany, Kunstverein für die Rheinlande Westfalen. *Niki de Saint Phalle: Werke 1962-1968.* 19 November 1968 – 1 January 1969. Traveling exhibition. Travels to:
• Ludwigshafen, Germany, Reichert-Haus. 17 January 1969 – 16 February 1969.
• Hanover, Germany, Hanover Kunstverein, Künstlerhaus. 2 March 1969 – 2 April 1969. Catalogue.

1969
• Munich, Germany, Galerie Stangl. *Plastiken, Zeichnungen und Graphiken von Niki de Saint Phalle.* 6 May – 21 June. Booklet.
• Lucerne, Switzerland, Kunstmuseum. *Niki de Saint Phalle.* 27 July – 14 September.
• Beverly Hills, California, USA, Frank Perls Gallery. *New Lithographs and Sculptures.* July – August.
• Geneva, Switzerland, Galerie Alexandre Iolas. *Niki de Saint Phalle: Nana fontaine.* September.
• Amsterdam, Netherlands, Galerie Seriaal. *Niki de Saint Phalle: Grafieken en reliefs in Seriaal.* 20–29 September.
• London, England, Hanover Gallery. *Niki de Saint Phalle.* 10 December 1969 – 10 January 1970.

1970
• Paris, France, Galerie Alexander Iolas. *Niki de Saint Phalle: Le Rêve de Diane.* 5 – 28 February.
• Paris, France, Pavillon Baltard, les Halles. *Les Nanas.* February – March. Traveling exhibition. Travels to:
• Basel, Switzerland, Galerie Felix Handschin. March.
• Milan, Italy, Galleria Alexandre Iolas. *The Dream Machine.* October. Book by the artist.
• Paris, France, La Hune. *Niki de Saint Phalle: Nana Power.* 20 November – 4 December.
• Zurich, Switzerland, Gimpel & Hanover Galerie. *Niki de Saint Phalle zeigt neue Objekte und Serigraphien.* 3 December 1970 – 12 January 1971.

1971
• Bern, Switzerland, Kammerkunsthalle. *Niki de Saint Phalle: Serigraphien und kleine Skulpturen.* 27 February – 4 May.
• Rome, Italy, La Galleria – Cavalieri Hilton. *Niki de Saint Phalle: Serigrafie – Sculture.* 26 March – 17 April. Booklet with reprint of essay by Pierre Descargues.
• Stockholm, Sweden, Svensk-Franska Konstgallerier. *Niki de Saint Phalle: Nana Power polykroma skulpturer.* Opened on 6 May.
• Amsterdam, Netherlands, Galerie Espace. *Niki de Saint Phalle: "The Devouring Mothers" and other sculptures.* 6 September – 16 October.

• Amsterdam, Netherlands, Galerie Seriaal. *Niki de Saint Phalle: New Multiples & Graphics.* 4–25 September.

1972
• Paris, France, Galerie Alexandre Iolas. *Niki de Saint Phalle: Les funérailles du père.* 23 February – 25 March.
• Geneva, Switzerland, Galerie Bonnier. *Niki de Saint Phalle: Niki avant les Nanas, œuvres de 1963 et 1964.* 19 October – 16 November.
• London, England, Gimpel Fils. *Niki de Saint Phalle: The Devouring Mothers.* 4 December 1972 – 27 January 1973. Book by the artist. Traveling exhibition.
Travels to:
• New York, USA, Gimpel & Weitzenhoffer Gallery. 10 April 1973 – 5 May 1973.

1974
• Paris, France, Galerie Alexandre Iolas. *Niki de Saint Phalle: Projets et realizations d'architecture.* 5 February – 2 March. Book by the artist.
• Baden-Baden, Germany, Galerie Dr. Ernst Hauswedell. *Niki de Saint Phalle: Skulpturen, Zeichnungen, Graphik, Ballon-Nanas.* 12 June – 14 July.

1975
• Arles, France. Exhibition organized in association with the 1975 Festival d'Arles in the Romanesque rooms at the Monastère de Saint-Trophime. *Niki de Saint Phalle.* 9 July – 30 September. Booklet.
• New York, USA, Gimpel & Weitzenhoffer Gallery. *Niki de Saint Phalle: Silkscreens.* 7–25 December.

1976
• Rotterdam, Netherlands, Museum Boymans-van Beuningen. *Beelden, modellen en maquettes van Niki de Saint Phalle.* 21 July – 5 September. Book by the artist.
• Aalborg, Denmark, Nordjyllands Kunstmuseum. *Niki de Saint Phalles sculpturer.* 16 September – 24 October. Catalogue.
• Geneva, Switzerland, Galerie Bonnier. *Niki de Saint Phalle.* Opened on 23 September.

1977
• New York, USA, Gimpel & Weitzenhoffer Gallery. *Niki de Saint Phalle: Sculptures and Graphics.* 29 November 1977 – 21 January 1978.

1979
• Tokyo, Japan, Watari Gallery. *Niki de Saint Phalle.* 13 March – 4 April. Catalogue.
• New York, USA, Gimpel & Weitzenhoffer Gallery. *Niki de Saint Phalle: Monumental Projects, Maquettes and Photographs.* 3 April – 23 May. Booklet. Traveling exhibition.
Travels to:
• Columbus, Ohio, USA, Columbus Museum of Art. 27 May 1980 – 22 June 1980.
• St. Louis, Missouri, USA, Laumeier Sculpture Park. 25 February 1981 – 5 April 1981.
• La Jolla, California, USA, Mandeville Art Gallery, University of California at San Diego. 16 October 1981 – 25 November 1981.
• Palm Springs, California, USA, Palm Springs Desert Museum. 11 February 1982 – 10 April 1982.

1980
• Zurich, Switzerland, Galerie Bischofberger. *Niki de Saint Phalle: Werke 1960-1980.* 22 March – 15 April.
• Vienna, Austria, Bawag Fondation. *Niki de Saint Phalle: Objekte-Grafiken.* 22 April – 10 May.
• Ulm, Germany, Ulm Museum. *Niki de Saint Phalle: Das graphische Werk 1968–1980. Figuren.* 18 May – 6 July. Catalogue.
• Paris, France, Musée National d'Art Moderne, Centre Georges Pompidou. *L'exposition retrospective de Niki de Saint Phalle.* 3 July – 1 September. Under the curatorship of Pontus Hulten and Jean-Yves Mock. Catalogue. Traveling exhibition.
Travels to:
• Duisburg, Germany, Wilhelm-Lehmbruck-Museum. *Niki de Saint Phalle: Retrospektive 1954-1960.* 19 October – 30 November 1980. Catalogue.
• Linz, Austria, Neue Galerie. *Niki de Saint Phalle: Retrospektive 1954-1960.* 11 December 1980 – 31 January 1981.
• Nuremberg, Germany, Nuremberg Kunsthalle. *Niki de Saint Phalle: Retrospektive 1954-1960.* 20 February – 19 April 1981.
• Berlin, Germany, Haus am Waldsee. *Niki de Saint Phalle: Retrospektive 1954-1960.* 3 May – 14 June 1981.
• Hanover, Germany, Hanover Kunstmuseum with Sprengel Collection. *Niki de Saint Phalle: Retrospektive 1954-1960.* 28 June – 23 August 1981.
• Stockholm, Sweden, Moderna Museet. 12 September – 25 October 1981.
• Linz, Austria, Neue Galerie. *L'exposition retrospective de Niki de Saint Phalle.* 11 December – 31 January 1981.
• Tokyo, Space Niki (inaugural exhibition). *Niki de Saint Phalle (Space Niki Collection): Part 1 – Prints Nana Power.* 13 December – 15 February.
Part 2 – Posters and Film "Daddy". 21 March – 19 April. Catalogue.
Part 3 – Prints 'Ich' etc. 13 December – 28 April – 28 June.
Part 4 – Newly Imported Prints. 28 August – 18 October.
Part 5 – Portraits and Film "Daddy". 23 October – 15 November.
Part 6 – Sculptures. 20 November – 20 December.

1981
• Paris, France, Galerie Samy Kinge. *Niki de Saint Phalle.* 19 February – 21 March.
• Geneva, Switzerland. Galerie Bonnier. *Niki de Saint Phalle : Objets á apprivoiser.* May–July.

1982
• Tokyo, Japan, Watari Gallery. *Niki de Saint Phalle: Nana Object.* 28 January – 20 February.
• New York, USA, Gimpel & Weitzenhoffer Gallery. *Niki de Saint Phalle: New Works (My Skinnies).* 11 May – 5 June. Catalogue.
• London, England, Gimpel Fils. *My Skinnies.* 15 June – 31 July. Catalogue.
• Paris, France, Galerie Colette Creuzevault. *Niki de Saint Phalle.* 14 October – 12 November.
• Tokyo, Japan, Space Niki. *Niki de Saint Phalle.* 11 December 1982 – 28 February 1983.

1983
• Montreal, Canada, Galerie Esperanza (inaugural exhibition). *Niki de Saint Phalle: Sculptures et lithographies.* 12 April – 14 May. Booklet.

1985
• Basel, Switzerland, Galerie Klaus Littmann. *Niki de Saint Phalle 1962–1980: Retrospektive.* 30 May – 3 August. Catalogue.
• Knokke-le-Zoute, Belgium, Casino Knokke. *Niki de Saint Phalle.* 30 June – 1 September. Booklet with text by Pierre Restany.
• London, England, Gimpel Fils. *Niki de Saint Phalle: The Tarot.* 2 July – 14 September. Book by the artist.
• New York, USA, Gimpel & Weitzenhoffer Gallery. *Niki de Saint Phalle: New Sculptures Based on "The Tarot".* 3 September – 5 October.

1986
• Tokyo, Japan, Space Niki & Sagacho Exhibition Space. *Niki de Saint Phalle (Space Niki Collection): sculptures prints drawings films video performance talk-session.* 1 April – 28 June and 1–24 April respectively. Catalogues.
• Tokyo, Japan, Space Niki. *Niki de Saint Phalle (Space Niki Collection): Prints.* 2 – 15 July.
• Ohtsu, Japan, Seibu Department Store. *Niki de Saint Phalle (Space Niki Collection).* 30 October – 24 November. Booklet.
• Paris, France, Galerie Colette Creuzevault. *Cinq Vases par Niki de Saint Phalle.* 3–31 December. Catalogue.
• Helsinki, Finland, Kaj Forsblom Gallery. *Niki de Saint Phalle: Veistoksja ja reliefejä / Sculptures and reliefs.* 27 November 1986 – 4 January 1987. Booklet.

1987
• Munich, Germany, Kunsthalle der Hypo-Kulturstiftung. *Niki de Saint Phalle: Bilder – Figuren – Phantastische Gärten.* 26 March – 5 July. Book.
• Munich, Germany, Artcurial. *Niki de Saint Phalle: Skulpturen, Lithographien, Objekte,* 6 May – 30 June.
• Geneva, Switzerland, Galerie Bonnier. *Niki de Saint Phalle: Oeuvres récentes.* 29 September – October. Catalogue.
• Roslyn, New York, USA, Nassau County Museum of Art. *Fantastic Vision: Works by Niki de Saint Phalle.* 27 September 1987 – 3 January 1988. Under the curatorship of Phyllis Stigliano and Janice Parente. Catalogue.

1988
• London, England, Gimpel Fils. *Niki de Saint Phalle: The Wounded Animals.* 7 June – 10 September. Book by the artist.
• Canterbury, England, The Blackfriars, presented by The Canterbury Theatre and Festival Trust. *Sculptures by Niki de Saint Phalle.* 2–22 October.

1989
• Paris, France, Galerie de France and JGM.Galerie. *Niki de Saint Phalle: Œuvres des années 80.* 12 May – 17 June and 12 May – 24 June, respectively. Organized by Jean Tinguely. Catalogue. Traveling exhibition.
Travels to:
• Fécamp, France, Palais Bénédictine. 1 July – 10 September. Catalogue.

• Athens, Greece, Zoumboulakis Galleries. *Niki de Saint Phalle.* Opened on 19 October.
• Long Island, New York, USA, Schneider Children's Hospital. *Magic Tree Fountain.* Inauguration 12 November.

1990
• Munich, Germany, Galerie Wolfgang Ketterer. *Niki de Saint Phalle.* 11 April – 11 May.
• Paris, France, Galerie JGM and Galerie de France. *Niki de Saint Phalle: Tirs … et autres révoltes 1961-1964.* 26 June – 28 July. Text by Pierre Restany. Catalogue.
• Knokke-le-Zoute, Belgium, Guy Pieters Gallery. *Niki de Saint Phalle: Last Night I Had a Dream.* 8 September – 22 October. Booklet.
• New York, USA, Gimpel & Weitzenhoffer Gallery. *Niki de Saint Phalle: New Sculptures.* 3 October – 10 November. Booklet.
• Paris, France, Musée des Arts Décoratifs. *Niki de Saint Phalle: Lutte contre le sida.* 30 November 1990 – 28 January 1991. Book by the artist.

1991
• Palm Beach, Florida, USA, Hokin Gallery. *Niki de Saint Phalle: Sculptures.* 12 February – 9 March.
• Munich, Germany, Galerie Artcurial. *Niki de Saint Phalle: Skulpturen und Grafik.* 29 May – 30 June.
• Margaux, France, Château d'Arsac. *Niki de Saint Phalle au Château d'Arsac.* 7 June – 30 September.
• London, England, Gimpel Fils. *Gods.* 19 June – 7 September. Catalogue.
• Knokke-le-Zoute, Belgium, Guy Pieters Gallery. *Niki de Saint Phalle: Oeuvres récentes.* August. Catalogue.
• Winterthur, Switzerland, Galerie Hochwacht. *Niki de Saint Phalle: Signierte Original-Serigraphien.* 9 September – 12 October.

1992
• Duisburg, Germany, Galerie Reinhausen des Wilhelm Lehmbruck Museums Duisburg. *Niki de Saint Phalle: SIDA…Aids,* 29 April – 6 June.
• Zurich, Switzerland, Union Bank of Switzerland. *Niki de Saint Phalle.*
• Bonn, Germany, Kunst- und Ausstellungshalle. *Niki de Saint Phalle.* 19 June – 1 November. Traveling exhibition.
Travels to:
• Glasgow, Scotland, McLellan Galleries. *Niki de Saint Phalle: Her life and art.* 22 January 1993 – 4 April 1993.
• Paris, France, Musée d'Art Moderne de la Ville de Paris. *Niki de Saint Phalle: L'invitation au musée.* 24 June 1993 – 12 September 1993.

1993
• Knokke-le-Zoute, Belgium, Casino Knokke. *Le Cirque de papier de Niki.* 27 June – 29 August.
• Saint-Yrieix-la-Perche, France, Salle Attane. *Niki de Saint Phalle.* 9 July – 29 August.
• Amsterdam, Netherlands, Gallery Delaive. *Niki de Saint Phalle.* 19 September – 27 October.
• Geneva, Switzerland, Galerie Bonnier. *Niki de Saint Phalle: Oeuvres choisies.* 30 September – 30 October.
• Solothurn, Switzerland, Freitagsgalerie Imhof. *Niki de Saint Phalle.* 1 October – 20 November.
• Fribourg, Switzerland, Musée de l'Art et de l'Histoire. *Niki de Saint Phalle: Aventure Suisse.* 3 October – 9 January 1994.

• Lausanne, Switzerland, Musée Olympique. *Les Footballers.* 12 October.

1994
• Taipei, Taiwan, Dimensions Gallery. *Niki de Saint Phalle.* 16–31 July.
• Nasu, Japan, Niki Museum. *Niki de Saint Phalle.* Inaugurated September.
• New York, USA, Maxwell Davidson Gallery & James Goodman Gallery. *Niki de Saint Phalle: Tableaux éclatés + sculptures.* 27 October – 17 December.
• Ostermundigen, Switzerland, Galerie Bürki, *Niki de Saint Phalle.* 28 November 1994 – 31 January 1995

1995
• Luxembourg. *Niki de Saint Phalle. Un Univers à découvrir.* 30 May – 17 September.
• Munich, Germany, Galerie Artcurial. *Niki de Saint Phalle.* 8 September – 14 October 1995.
• Bern, Switzerland, Galerie Kornfeld. *Niki de Saint Phalle: Skulpturen, Gouachen, Serigraphie, Lithographien.* 13 September – 31 October 1995.
• Mexico City, Museo Rufino Tamayo. *Niki de Saint Phalle.* 7 November – 18 February 1996. Traveling exhibition.
Travels to:
• Caracas, Venezuela, Museo de Arte Contemporàneo de Caracas Sofia Imber. 31 March – 31 May 1996.
• Bogotá, Columbia, Museo de Arte Moderno. June–July 1996.
• Rio de Janeiro, Brazil, Fundação Casa França-Brasil. 9–26 January 1997.
• São Paulo, Brazil, Pinacoteca do Estado. 25 February – 25 March 1997.
• Buenos Aires, Argentina, Museo Nacional de Bellas Artes. April – 10 May 1997.
• Santiago de Chile, Chile, Sala de Exposiciones Edificio CTC. 18 June – 17 August 1997.

1996
• Nuremberg, Germany, Galerie Voight. *Niki de Saint Phalle,* 27 July 1996.
• Regensburg, Germany, Kunstkabinett. *Niki de Saint Phalle: Graphik und Skulpturen.* 1996 – 17 January 1997. Traveling exhibition.
Travels to:
• Kirchberg, Germany, Galerie Schönenberger. 9 March 1997 – 20 April 1997.
• Frankfurt, Germany, Galerie Wild. 5 November 1997 – 17 February 1998.
• Berlin, Germany, Galerie Rafael Vostell. *Niki de Saint Phalle.* 2 November 1996 – 21 January 1997.

1997
• Bayreuth, Germany, Kunst Raum. *Niki de Saint Phalle + Jean Tinguely.* 12 March – 12 April.
• Orbetello, Italy, Polveriera Guzman. *I Tarocchi di Niki de Saint Phalle.* 12 July – 10 September.
• Wolfsburg, Germany, Kunstverein. *Niki de Saint Phalle: Dear Diary.* 31 August – 26 October.
• Bern, Switzerland, Galerie Kornfeld. *Niki de Saint Phalle.* 7 November – 23 December.
• Zurich, Switzerland, Galerie Kornfeld. *Niki de Saint Phalle.* 19 November – 23 December.

1998
• Amsterdam, Netherlands, Galerie Delaive. *Niki de Saint Phalle.* 1 January – 1 February.
• Ingelheim, Germany, Kleine Galerie. *Niki de*

Saint Phalle – Neue Graphik. 1–31 May.
• San Diego, California, USA, Mingei International Museum. *Niki de Saint Phalle: Insider / Outsider World Inspired Art.* 24 May 1998 – 31 January 1999.
• Geneva, Switzerland, Galerie Bonnier. *Niki de Saint Phalle – Céramiques et mosaïques.* May – September.

1999
• Fribourg, Switzerland, Espace Jean Tinguely – Niki de Saint Phalle. *Niki de Saint Phalle.* 6 May – 26 September.
• Paris, France, JGM Galerie. *Traces.* 9 May – 31 July.
• Escondido, California, USA, City Hall. *Nana on a dolphin.* 13 June – 2000.
• San Diego, California, USA, San Diego Hall of Champions, Balboa Park. *Baseball Player & Basketball Player.* 24 September – 2008.
• Ulm, Germany, Ulmer Museum. *Niki de Saint Phalle – Liebe, Protest, Phantasie.* 26 September – 21 November. Traveling exhibition.
Travels to:
• Ludwigshafen-am-Rhein, Germany. 26 March 2000 – 14 May 2000.
• Emden, Germany, Kunsthalle Emden. 15 July 2000 – 3 September 2000.

2000
• El Cajon, California, USA, East County Cultural Zone. *Louis Armstrong* and *Miles Davis.* 8 February 2000 – 31 March 2004.
• San Diego, California, USA, Reuben H. Fleet Science Center. *Nana on a Dolphin.* 30 March – 30 September.
• London, England, Gimpel Fils. *Niki de Saint Phalle: Bronzes.* 5 May – 10 June.
• Hanover, Germany, Sprengel Museum. *La Fête. Die Schenkung Niki de Saint Phalle. Werke aus den Jahren 1952-2001.* 19 November – 25 February 2001. Traveling exhibition.
Travels to:
• Basel, Switzerland, Museum Jean Tinguely. *Niki de Saint Phalle: Werke aus den Jahren 1952-2001.* 26 September 2001 – 17 February 2002.
• San Diego, California, USA, Port of San Diego. *Nana on the Dolphin.* 3 October – 3 April 2001.

2001
• Stockholm, Sweden, Wetterling Gallery. *Niki de Saint Phalle.* 13 February – 25 March.
• West Hollywood, California, USA, Tasende Gallery. *Niki de Saint Phalle.* 9 June – 4 August.
• La Jolla, California, USA, La Jolla Elementary School. *Seals and Cat.* 20 June – 20 December.
• Cluny, France, Ecuries Saint-Hugues de Cluny. *Niki de Saint Phalle: Les dieux de la musique et du sport.* 28 July – 7 October. Traveling exhibition.
Travels to:
• Dijon, France, Le Consortium Dijon. Through 25 November.
• Davos, Switzerland, Galerie Iris Wazzau. *Niki de Saint Phalle.* 28 September – 20 October.
• Bern, Switzerland, Galerie Kornfeld. *Niki de Saint Phalle: Skulpturen Objekte Lithographien Serigraphien.* 28 September – 21 December.
• Paris, France, Musée de la publicité, Union des Arts Décoratifs. *Niki de Saint Phalle: La vie joyeuse des objets.* 9 October – 31 December.
• Amsterdam, Netherlands, Gallery Delaive. *Niki de Saint Phalle.* Opened on 10 October.
• San Diego, California, USA, San Diego

Convention Center, Port of San Diego. *Coming Together*. Inauguration on 25 October.
• Amsterdam, Netherlands, Gallery Delaive. *Niki de Saint Phalle: Recent Sculptures*. 17 November – 14 December.
• Davos, Switzerland, Galerie Iris Wazzau. *Niki de Saint Phalle*. 15 December – 5 February 2002.

2002
• Solana Beach, California, USA. Solana Beach Train Station. *Star Fountain (blue)*. 15 February 2002 – 17 January 2006.
• Nice, France, Musée d'Art Moderne et d'Art Contemporain. *Niki de Saint Phalle: La donation*. 17 March – 27 October.
• Riom, France, Musée Mandet. *Les Niki de Saint Phalle*. 15 June – 29 December.
• Neustadt am Rübengebirge, Germany, Schloss Landestrost. *Niki de Saint Phalle: Siebdrucke und Lithographien 1968 – 2001*. 19 October – 24 November.
• Carlsbad, California, USA, Poinsettia Park. *Guardian Lions*. 23 October – 10 November 2004.
• Escondido, California, Grape Day Park. *Seals and Cat*. 29 October – 20 May 2004.
• Hanover, Germany, Sprengel Museum. *Von Niki Mathews zu Niki de Saint Phalle – Gemälde der 1950er Jahre*. 10 December 2002 – 9 March 2003.

2003
• Paris, France, Galerie JGM. *Niki de Saint Phalle: La Machine à Rêver*. 7 March – 12 April.
• Budapest, Hungary, Ernst Múzeum. *Niki de Saint Phalle*. 16 March – 27 April. Traveling exhibition.
Travels to:
• Warsaw, Poland, Zacheta Panstwowa Galeria Sztuki. 10 May – 22 June.
• Krakow, Poland, National Museum. 4 July – 24 August.
• Odense, Denmark, Brandts Klaedefabric. *Niki de Saint Phalle*. 30 March – 9 June.
• Tokyo, Japan, Caretta Shiodome. *Homage to Niki de Saint Phalle*. 7 April – 8 June.
• Auménancourt, France, Eglise de Pontgivart. *Champs Libres. Zoo Exquis: L'arche Fantastique de Niki de Saint Phalle*. 26 April – 14 July.
• Saint Jean de Védas, France, Médiathèque Jules Verne. *Niki de Saint Phalle: de la couleur aux ecrites*. 20 May – 28 June.
• Los Angeles, California, USA, Herbert Palmer Gallery. *Niki de Saint Phalle*. 31 May – 15 October.
• Hanover, Germany, Sprengel Museum. *Niki de Saint Phalle: Die Geburt der Nanas*. 24 August – 2 November. Traveling exhibition.
Travels to:
• Vienna, Austria, KunstHaus Wien. 19 May 2004 – 12 September 2004.
• Escondido, California, USA, Mingei International Museum. *Niki de Saint Phalle Remembered*. 5 December – 1 June 2004.

2004
• Konstanz, Germany, Caritas Fotogalerie. *Tarot-Garten von Niki de Saint Phalle*. 27 February – 14 March.
• Paris, France, JGM.Galerie. *Nanas depuis 1965*. March – 17 April.
• Escondido, California, USA, California Center for the Arts Escondido Museum. *Niki de Saint Phalle: California Dreaming*. 5 May – 31 December.
• Angers, France, Musée des Beaux-Arts. *Niki de Saint Phalle, des assemblages aux œuvres monumentales*. 17 June – 15 September.
• Nuremberg, Germany, Galerie & Edition Bode GmbH. *Seltene Graphiken von NIKI DE SAINT PHALLE*. 24 July – 31 August.
• Ulm, Germany, Fischerplatz Galerie. *Niki de Saint Phalle – Skulpturen – Grafik – Unikate*. 7 August – 5 September.
• Nuremberg, Germany, Galerie Hafenrichter & Flügel (ex Galeria2000). *Niki de Saint Phalle*. 13 October – 15 December.
• Nuremberg, Germany, Kunsthalle Nürnberg. *Niki de Saint Phalle – Early works & prints from the collection of the MAMAC, Nice*. 21 October 2004 – 9 January 2005. Traveling exhibition.
Travels to:
• Amersfoort, Netherlands, De Zonnehof. 6 February – 24 April 2005.

2005
• Hanover, Germany, Sprengel Museum. *Niki de Saint Phalle: Der Tarot-Garten – Skulpturen, Entwürfe, Zeichnungen*. 13 February – 1 May.
• Berlin, Germany, Schloss Neuhardenberg. *Nana Power: Die Frauen der Niki de Saint Phalle*. 15 May – 18 September.
• Le Thor, France, Les Jardins de Poppy. *Niki de Saint Phalle*. 15 June – 16 October.
• Escondido, California, USA, California Center for the Arts. *Outdoor Sculptures*. 29 June – 15 March 2006.
• Escondido, California, USA, California Center for the Arts Escondido Museum. *Niki de Saint Phalle: Tableaux Eclates*. 4 November 2005 – 12 February 2006.
• Wetzlar, Germany, Galerie am Dom. *Niki de Saint Phalle: Grafik und Objekte*. 4 November – 4 December.

2006
• Umeda, Japan, Daimaru Museum Umeda. *Niki de Saint Phalle: Retrospective*. 29 March – 9 April. Traveling exhibition. Travels to:
• Tokyo, Japan, Daimaru Museum Tokyo. 11–22 May.
• Nagoya City, Japan, Nagoya City Art Museum. 17 June – 15 August.
• Fukui City, Japan, Fukui City Art Museum. 22 August – 24 September.
• Atlanta, Georgia, USA, Atlanta Botanical Garden. *Niki in the Garden: The Extraordinary Sculptures of Niki de Saint Phalle*. 29 April – 31 October. Traveling exhibition.
Travels to:
• Chicago, Illinois, USA, Garfield Park Conservatory. 4 May – 31 October 2007.
• St. Louis, Missouri, USA, Missouri Botanical Garden. *Niki*. 27 April 2008 – 31 October 2008.
• Fécamp, France, Palais Bénédictine. *Niki de Saint Phalle: Vive l'amour!* 24 June – 24 September.
• Macao, Republic of China, Macao Museum of Art. *Dreams of Midsummer: Works of Niki de Saint Phalle*. 7 July – October. Traveling exhibition.
Travels to:
• Seoul, Korea, Korean National Museum of Contemporary Arts. *Niki de Saint Phalle*. 17 November 2006 – 21 January 2007.
• Taipei, Taiwan, National Museum of History. *The World and Fantasy of Niki de Saint Phalle*. 9 February 2007 – 29 April 2007.

• Taichung, Taiwan, National Taiwan Museum of Fine Arts. *The World and Fantasy of Niki de Saint Phalle*. 26 May 2007 – 9 September 2007.
• Capalbio, Italy, Palazzo Aldobrandeschi. *Niki de Saint Phalle a Capalbio*. 23 July – 3 September.
• Fribourg, Switzerland, Espace Jean Tinguely – Niki de Saint Phalle. *Niki de Saint Phalle: L'œuvre graphique*. 18 October 2006 – 4 February 2007.
• Morat, Switzerland, City of Morat. *Niki de Saint Phalle – En Ville de Morat*. 11 November 2006 – 30 April 2007.

2007
• Escondido, California, Mingei International Museum. Selected works. Installed in February.
• Eltville, Germany, Galerie im Turm der Kurfürstlichen Burg zu Eltville. *Tarot-Garten Niki de Saint Phalle – Photographien*. 12–30 May.
• Paris, France, Galerie Deyrolle. *Niki de Saint Phalle chez Deyrolle: Curiosités naturelles*. 13 June – 21 July.
• Zurich, Switzerland, Zurich Train Station. *Blauer Engel schwebt seit 10 Jahren*. 7 August – 30 September 2007.
• Schwalenberg, Germany, Städtische Galerie. *Niki de Saint Phalle – Siebdrucke aus dem Sprengel Museum Hanover*. 14–19 August.
• Ulm, Germany, Fischerplatz Galerie. *Niki de Saint Phalle*. 23 October – 17 November.
• Escondido, California, USA, California Center for the Arts. *Niki de Saint Phalle: A Spiritual Path*. 10 November 2007 – 27 January 2008.

2008
• La Jolla, California, Salk Institute. *Niki de Saint Phalle*. 8 January – 7 May.
• Liverpool, England, Tate Liverpool. *Niki de Saint Phalle*. 1 February – 5 May.
• Paris, France, La Coupole. *Hommage à Niki de Saint Phalle. Le Jardin des Tarots*. 10 April – 15 August. Catalogue.
• Paris, France, Musée en Herbe. *Les boîtes à secrets de Niki*. 16 April 2008 – 2 January 2009. Catalogue. Travels to:
• Lausanne, Switzerland, Vallée de la Jeunesse. 20 January – 21 June 2009.

2009
• Évora, Portugal, Fundação Eugénio de Almeida. *Niki de Saint Phalle: Joie de Vivre – Alegria de Viver*. 23 Jan – 24 May. Catalogue. Travels to:
• Massa Marittima, Italy, Palazzo dell'Abbondanza. *Niki de Saint Phalle: Joie de Vivre*. 31 May – 28 June 2009.
• Amiata, Italy, Castello Aldobrandesco di Arcidosso. 4 July – 19 August 2009.
• Sorano, Italy, Fortezza Orsini. 22 August – 27 September 2009.
• Gottorf, Germany, Schleswig-Holsteinisches Landesmuseum Schloss Gottorf. *Niki de Saint Phalle*. 22 February – 18 June.
• Chur, Switzerland, Kulturforum Würth. *Niki de Saint Phalle: Mythen – Märchen – Träume*. 27 June – 17 January 2010.
• Cologne, Germany, Kunsthandlung Osper. *Niki de Saint Phalle*. 17 July – 29 August.
• Saint-Paul-de-Vence, France, Galerie Guy Pieters. *Niki de Saint-Phalle*. 19 July – 30 September.

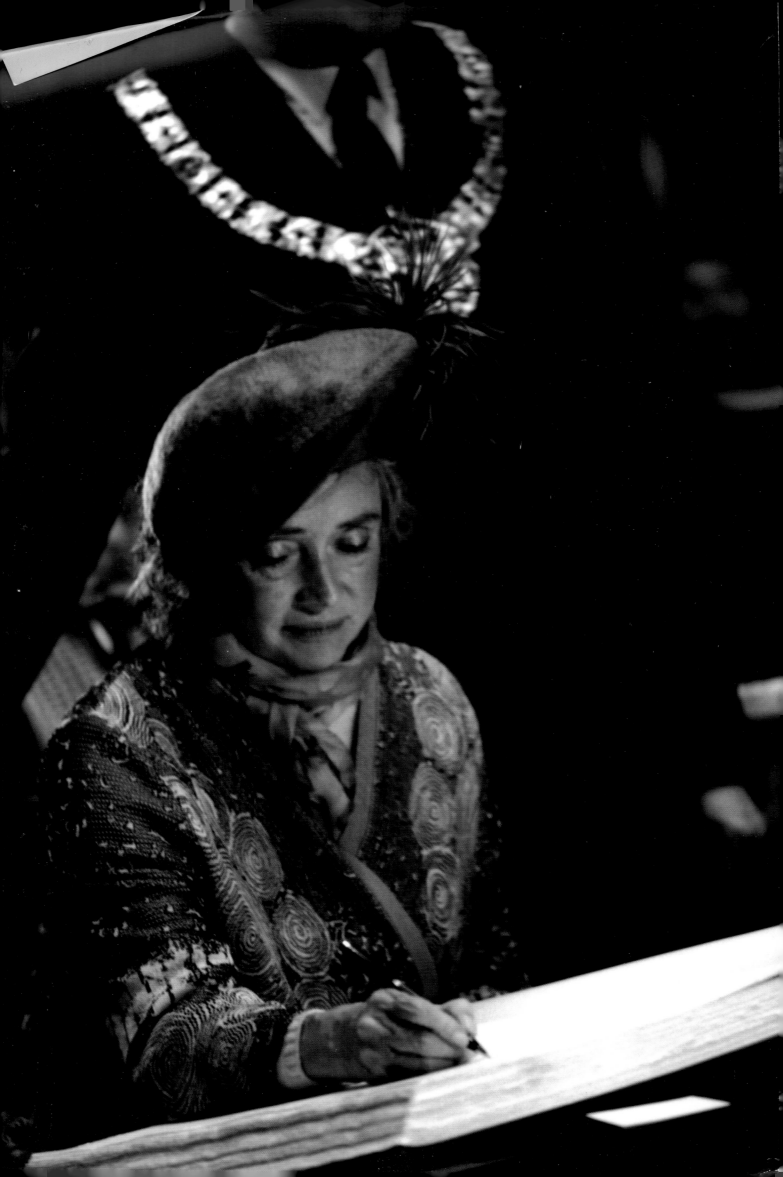